World Wisdom
The Library of Perennial Philosophy

The Library of Perennial Philosophy is dedicated to the exposition of the timeless Truth underlying the diverse religions. This Truth, often referred to as the *Sophia Perennis*—or Perennial Wisdom—finds its expression in the revealed Scriptures as well as the writings of the great sages and the artistic creations of the traditional worlds.

Symbol of Divine Light: The Lamp in Islamic Culture and Other Traditions appears as one of our selections in the Sacred Art in Tradition series.

Sacred Art in Tradition

The aim of this series is to underscore the essential role of beauty and its artistic expressions in the Perennial Philosophy. Each volume contains full-color reproductions of masterpieces of traditional art—including painting, sculpture, architecture, and vestimentary art—combined with writings by authorities on each subject. Individual titles focus either on one spiritual tradition or on a central theme that touches upon diverse traditions.

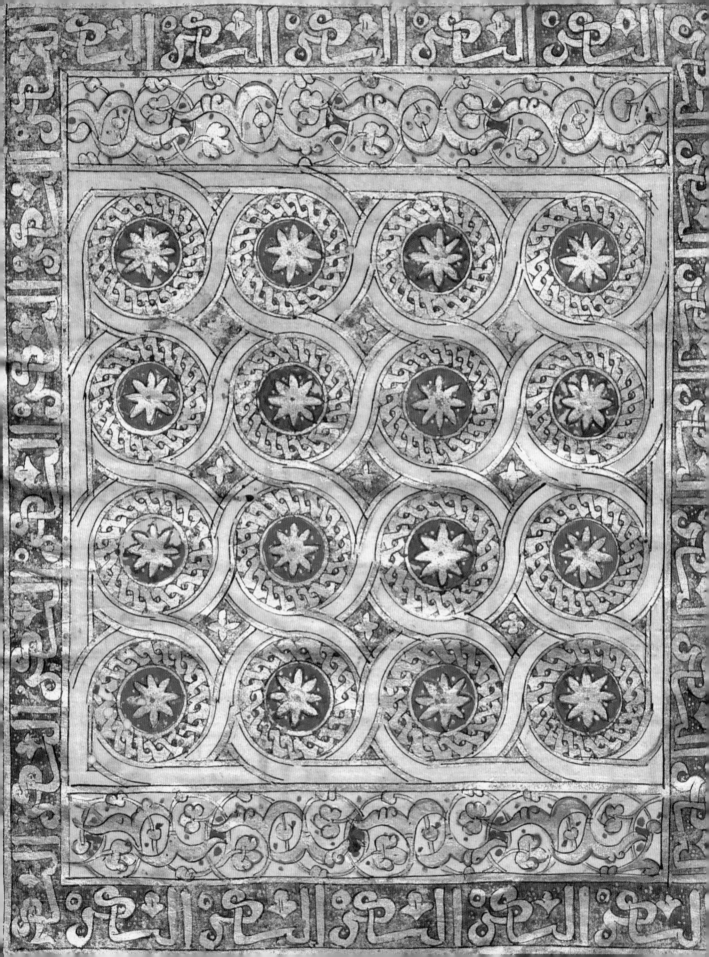

Symbol of Divine Light

The Lamp in Islamic Culture & Other Traditions

by

Nicholas Stone

World Wisdom

Library of Congress Cataloging-in-Publication Data

Names: Stone, Nicholas, author.
Title: Symbol of divine light : the lamp in islamic culture and other
traditions / by Nicholas Stone.
Description: Bloomington, IN : World Wisdom, [2018] | Series: The library of
perennial philosophy | Includes bibliographical references and index. |
Identifiers: LCCN 2017027170 (print) | LCCN 2017028084 (ebook) | ISBN
9781936597574 (epub) | ISBN 9781936597567 (pbk. : alk. paper)
Subjects: LCSH: Light--Religious aspects--Islam. | Lamps. | Light--Religious aspects.
Classification: LCC BP190.5.L47 (ebook) | LCC BP190.5.L47 S86 2018 (print) |
DDC 297.3--dc23
LC record available at
https://url.serverdata.net/?aQIGj4lOvUgMGIEdjJ2U_yEdOSMjvWRhCNcMoZ8qUTq8~

Cover:
Design based on glazed fritware panel with mosque lamp
motif and representation of the Prophet's sandals
at Darwish Pasha Mosque, Damascus, Syria.

Frontispiece:
Carpet page from a Maghrebi Koran manuscript, dated 1306.

Printed on acid-free paper in China.

For information address World Wisdom, Inc.
P.O. Box 2682, Bloomington, Indiana 47402-2682
www.worldwisdom.com

Contents

II. History of the Lamp

Preface

The present study grew out of research undertaken several years ago in connection with the design of lamps for a new mosque project, in which an attempt was made to integrate elements of traditional Islamic architecture. As a part of the design process we examined the history of the mosque lamp and, finding this to be a particularly rich topic, have since continued this research, exploring the cultural significance of the mosque lamp in greater depth. It is striking that almost everywhere one finds the mosque lamp mentioned, reference is made to the Koranic Verse of Light. This is due to the fact that the Koran, in the famous *āyat al-nūr*, refers to a lamp in a niche as a symbol of the Divine Light. This makes the lamp more than a purely functional accessory within the architecture of the mosque; it is a form endowed with symbolism and has therefore become an object of great importance in Islamic culture.

The art of the mosque lamp thus developed and throughout Islamic history generated many expressions of great beauty. Mosque lamps and other architectural elements are often ornamented with inscriptions from the Verse of Light. The lamp in a niche is also an image which recurs time and again in the decorative motifs which adorn mosques throughout the Islamic world.

Thanks to this Koranic verse, the mosque lamp acted as an evocative symbol. Living, as we now do, in an age where attention is focused on almost exclusively on the physical plane and higher levels of reality are all but denied, it is hard for us to comprehend the role of symbolism in traditional cultures. However, to grasp the cultural significance of the mosque lamp, it is essential to understand this. By way of explanation, we make reference to the writings of authors usually classified as belonging to the so-called "Traditionalist school," who one finds give the most authentic exposition of the traditional perspective on the role of symbols and the higher truths they can communicate.

Consequently, before examining the historical development of the mosque lamp, this study firstly explains the concept of symbolism. The symbolism of Light in Islam and in other traditions is examined and thereafter a considerable part of the text is devoted to a study of the significance of the other key elements in the Verse of Light. These are explored in depth, separately and individually, because each of these elements may be regarded as an important symbol in its own right and, before embarking on a study of the Verse of Light, the intention

1. Perforated brass mosque lamp, designed 2003.

is to immerse the reader in an awareness of related spiritual and cultural connotations, which in turn can provide the necessary context for a fuller understanding of the verse. The topics are examined from the standpoint of the Islamic tradition. However, parallels are drawn with other traditions; differences between the perspectives of the different traditions are noted, as well as common elements, which point to a universal symbolism.

The meaning of the Verse of Light is then explored, referring to diverse interpretations that have been given. The fact that the symbolism of Light and of the lamp in the niche is a subject treated by many commentators makes it a topic which should hopefully be of deeper interest to the reader. The way in which the Verse of Light has been interpreted by spiritual authorities throughout the ages is examined with a view to offering a broader understanding of its meaning and spiritual importance, as this is essential if one is to understand the cultural significance of the mosque lamp.

In the second part of the book, the history of the mosque lamp is studied. An attempt is made to gain a picture of how the earliest Islamic lamps would have looked, making reference to surviving examples and drawing on descriptions and references in early historical accounts going back to time of the Prophet, who endorsed their use. To establish an historical context, accounts of lamps and lighting in pre-Islamic sacred architecture are cited—for example in Christian sanctuaries in Jerusalem and in the Byzantine church of Hagia Sophia. Descriptions in a number of travel accounts from the first centuries of the Islamic era are quoted. The development throughout Islamic history of different forms of mosque lamp made from various materials is traced. A compilation of related images is presented, including photographs of surviving lamps, depictions in historical illuminated manuscripts, drawings and paintings made by orientalists and archaeologists. Whereas such lamps are often seen as objects out of context in a museum setting, the way they would have

functioned and the type of light they would have emitted are considered. These observations lead one to draw some conclusions about the lighting of mosques and places of worship in the contemporary context.

It may seem that an in-depth study of the historical development of the mosque lamp and considerations about its practical architectural applications are topics of limited interest to the general reader. However, it is hoped that the broader significance will be apparent not just to art-historians and architects—that the mosque lamp may be seen as an example illustrating how over the centuries traditional craftsmanship was inspired and shaped by sacred scriptures, resulting in many beautiful manifestations, and how Islamic culture and civilization were enriched, being infused with profound meaning by the revealed symbolism in the Koran.

Our study concludes that the primary function of the mosque lamp was symbolic. It is described how some types of "lamp" were non-functional as lighting devices and thus purely symbolic; furthermore, the extensive use of the mosque lamp as a decorative motif in Islamic architecture is explored, as this likewise indicates the importance of the mosque lamp as a symbol, acting as a reminder of the Verse of Light. However, for such reminders to be of benefit, it presupposes that one appreciate the meaning of the Koranic verse. Therefore, rather than just focusing on one single aspect of this topic, our intention has been to give as broad a picture as possible of the significance of the mosque lamp. Apart from offering a comprehensive account of the many forms of mosque lamp that developed in different historical periods, it is hoped that the first part of the study may be of value in giving the reader an opportunity to contemplate the message contained within the Verse of Light, as well as the symbolism of Light, the lamp and related topics, in Islam and other sacred traditions, as a basis for a more complete understanding of the mosque lamp.

I.

Symbolism of Light and the Lamp

2. Embroidered panel with calligraphic inscription of the *Asmā al-Ḥusnā*, 1980s, Egypt.

Chapter I
The Verse of Light

In Islam the Divinity is known not only by the name *Allāh*, but also by many other names. There are ninety-nine such names in the Koran, referred to as the Beautiful Names—in Arabic the *asmā'-al-ḥusnā*. The Koran says "and to God belong the Beautiful Names, so invoke Him by them."[1] One of these names is *al-Nūr*, meaning "Light." This name is mentioned in the Koran in chapter (*sūrah*) twenty-five, verse (*āyah*) thirty-five, which begins "God is the Light of the heavens and the earth." The significance of this verse is such that the chapter as a whole—the *sūrat al-nūr*— takes its name from it and the verse itself is renowned as the "Verse of Light" or *āyat al-nūr*. As a result of this, *al-Nūr* is counted as one of the Beautiful Names. It is the one and only occurrence of this term in the Koran where it is used to denote the Divinity. Elsewhere in the Koran the word *nūr* is used to refer to the light *of* the Divinity, *from* the Divinity, or *sent by* the Divinity,[2] but nowhere else is the Divinity described as Light as such. It is therefore particularly significant in offering a description of the divine nature—or one aspect of it.

Following the initial statement, "God is the Light of the heavens and the earth," a second reference to light appears later in the same verse: "God guides to His Light whom He will." This suggests a two-fold signification: *God is Light* and also *God is the possessor of light*. The expression "Light of the heavens and the earth" likewise brings out a two-fold aspect. The Divine is intrinsically equated with Light of a transcendent nature, but His light also radiates on the earthly plane. The manner in which God's light radiates is explained in the verse by means of a parable. It describes a lamp in a niche as a symbol of the divine Light:

God is the light of the heavens and the earth. The symbol of His light is as a niche wherein is a lamp, (the lamp is in a glass, and this glass is as it were a radiant star) kindled from a blessed olive tree, neither of the east nor of the west, whose oil would all but glow though fire touch it not; Light upon light. God guideth to His light whom He will and God citeth symbols for men, and God is the Knower of all things.

There have been many interpretations of this parable given by Koranic commentators, explaining it in different ways. The *āyat al-nūr* is for many a key Koranic passage. One of the most noteworthy commentaries on it is the *Mishkāt al-Anwār* (the "Niche of Lights") of al-Ghazālī (d. 1111). However, many other interpretations of this verse have been given and up to the present day commentators have continued to expound the depths of its meaning.

3. *Sūrat Āl 'Imrān* [3]:7, from Koran manuscript, North Africa, 1306.

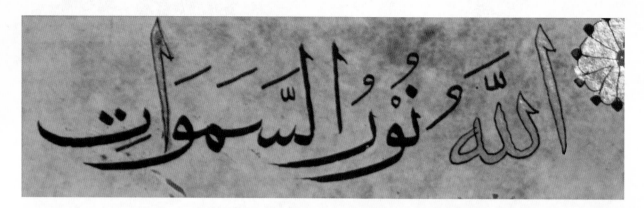

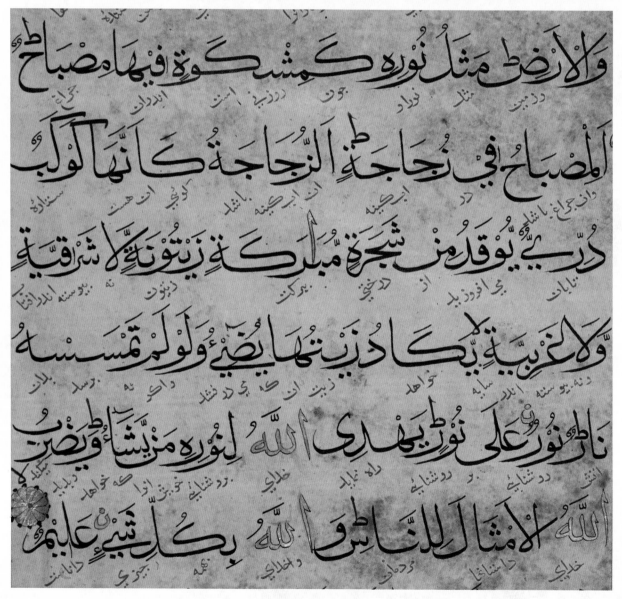

4A & B. *Āyat al-Nūr* (*Sūrat al Nūr* [24]:35), from a large-format Timurid Koran, Northern India, 15th century.

Koranic Exegesis

The Koran itself tells us that besides verses with clear dogmatic meanings (*āyāt muḥkamāt*), it contains also verses, which have allegorical meanings (*āyāt mutashābihāt*):

> He it is Who hath revealed unto thee [Muhammad] the Scripture wherein are verses which are clear prescripts— they are the substance of the Book— and others [which are] allegorical.
> (*Sūrat Āl ʿImrān* [3]:7)

Furthermore, it is understood that the Koran has multiple levels of meaning, besides the literal, immediately apparent meaning. A hadith of the Prophet states: "Every verse [in the Koran] has an outer aspect and inner aspect."[3]

To understand these allegorical verses and subtle levels of meaning involves interpretation. The process of Koranic exegesis is known in Arabic as *tafsīr*. Many works of *tafsīr* have been written by Koranic commentators since early Islamic times.

Particularly in allegorical verses one finds language used in which the imagery is initially seen to relate to the outer or macrocosmic plane (the world), however, the interpretation of the verses reveals meanings relating to the inner or microcosmic plane (the human soul). Such interpretations and the message conveyed by such allegories give verses of this kind a particular significance in the context of the spiritual path. The correspondences that exist between the macrocosmic and microcosmic planes are not arbitrary, but are the very basis upon which symbolism is founded. Many such interpretations of verses of the Koran go back to the Prophet himself.[4] Frithjof Schuon likewise explains that the "historical and symbolical narratives and eschatological imagery" in the Koran can be interpreted in an inward or "microcosmic" sense:

> [The] content of the Koran . . . concerns ourselves in quite a concrete and direct way, for the "disbelievers" (the *kāfirūn*), and the "associates" of false

5A & B. *Sūrat Fuṣṣilat* [41]:53: *"We shall show them Our signs on the horizons and in their own souls . . ."* from a Koran written in *muḥaqqaq* script, commissioned by Sultan Uljaytu, Mosul, 1310.

6. *Sūrat Ibrāhīm* [14]:25, from an illuminated Koran manuscript written in *naskh* script, Iran, 16th century.

divinities with God (the *mushrikūn*), and the hypocrites (the *munāfiqūn*) are within ourselves; likewise that the Prophets represent our Intellect and our consciousness, that all the tales in the Koran are enacted almost daily in our souls, that Mecca is our heart and that almsgiving, the fast, the pilgrimage, and the holy war are so many virtues, whether secret or manifest, or so many contemplative attitudes. . . .

. . . Semites, and Eastern peoples in general, are lovers of verbal symbolism and read "in depth." The revealed phrase is for them an array of symbols from which more and more flashes of light shoot forth the further the reader penetrates into the spiritual geometry of the words: the words are reference points for a doctrine that is inexhaustible; the implicit meaning is everything, and the obscurities of the literal meaning are so many veils highlighting the majesty of the content.[5]

The Koran frequently employs allegories, saying:

Verily We have coined for mankind in this Koran all kinds of similitudes. . . . (*Sūrat al-Rūm* [30]:58)[6]

And God coineth similitudes for men that they may remember. (*Sūrat Ibrāhīm* [14]:25)

As for these similitudes, We coin them for mankind, but none will grasp their meanings except the wise. (*Sūrat al-ʿAnkabūt* [29]:43)

7. *Sūrat al-ʿAnkabūt* [29]:43, from volume 6 of an 8-volume Maghrebi Koran, 15th century.

Chapter 2
Symbolism

To understand the Verse of Light it is necessary to grasp the way in which symbolism is used to convey its message. René Guénon states:

> [E]very real symbol bears its multiple meanings within itself, and this is so from its very origin; for it is not constituted as such in virtue of human convention but in virtue of the law of correspondence which links all the worlds together. If some see these meanings while others do not, or see them only partially, they are none the less really there: it is the "intellectual horizon" of each person that makes all the difference. Symbolism is an exact science and not a daydream in which individual fantasies can have a free run.[1]

Sacred scriptures in almost every tradition make use of symbolism to express the highest and innermost truths. Man is endowed with faculties which enable him to grasp realities which lie beyond the reach of his physical senses. However, language is sometimes inadequate to express them.[2] It is for this reason that he makes use of imagery that enables him to express them by use of analogy and comparison with familiar experiences. This means of expression is possible because it is in the nature of reality that there exist multiple levels of being and these are all interrelated by an inherent unity. René Guénon states elsewhere:

> First of all, symbolism seems to us to be quite specially adapted to the needs of human nature, which is not exclusively intellectual but which needs a sensory basis from which to rise to higher levels. . . . [S]ymbolism in the strict sense is essentially synthetic and thereby as it were intuitive, which makes it more apt than language to serve as a support for intellectual intuition which is above reason. . . . It is thus that the highest truths, which would not be communicable or transmissible by any other means, can be communicated up to a certain point when they are, so to speak, incorporated in symbols which will hide them from many, no doubt, but which will manifest them in all their splendour to the eyes of those who can see.[3]

The Verse of Light is an example of symbolism, *par excellence*. The Arabic word *mathal* is used at the start of the verse to explain that the description which follows is precisely a symbol of God's Light. The verse concludes with the statement: "and God citeth symbols (*amthāl*) for men, and God is the Knower of all things."

The symbol in the verse is itself relatively complex, being comprised of a number of different elements: Light (*nūr*), the Niche (*mishkāh*), the Lamp or Wick (*miṣbāḥ*), the Glass (*zujājah*), the Blessed Olive Tree, neither of the East nor of the West, (*shajaratin mubārakatin zaytūnatin*), and its Oil. Each one is a symbol in its own right. These elements are examined individually in greater depth in the following pages, since an understanding of their significance is a necessary pre-requisite if one is to grasp the full depth of meaning of the Verse of Light.

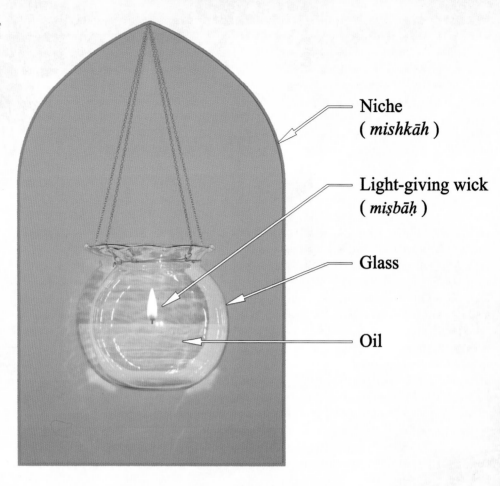

Niche
(*mishkāh*)

Light-giving wick
(*miṣbāḥ*)

Glass

Oil

8. Diagram representing the main constituent elements of the *Āyat al-Nūr*

Light

When considering the meaning of the Verse of Light, first of all one must consider the significance of Light. In contemporary physics, light represents something superlative, the speed of light being considered to be the maximum speed at which all energy and matter in the universe can travel.[4] In this context light is therefore something of remarkable significance—an expression of the absolute in the domain of the relative. The following selection of quotations from diverse sources serves to indicate the central importance of Light as a symbol.

'Abdullah Yusuf 'Ali writes that "We can only think of Allah in terms of our phenomenal experience, and in the phenomenal world, light is the purest thing we know. . . ."[5] Light, for Ibn

'Arabī, is "that which in the phenomenal world is least separated from the divine."[6] Mullā Ṣadrā Shīrāzī writes in his commentary on the Light Verse: "it [light] is the most manifest of things."[7] Guénon writes: "Light is the traditional symbol of the very nature of the Spirit."[8]

Frithjof Schuon writes in a poem: "Light is everything. God created the universe, / And the multitude of sentient beings, for the light."[9] Elsewhere he writes: "There is something in the soul which by its nature ascends and which lives from Truth; it is the element of light."[10] And also:

> [T]he most important sensation—or let us say the one which is intellectually the most explicit—is undeniably light, whatever might be the importance of primordial sound, and of spiritual

perfumes, tastes and touches. Sight alone communicates to us the existence of immeasurably remote heavenly bodies that are perfectly foreign to our vital interests, and it could therefore be said that it alone is essentially "objective." Consequently it is only natural to compare light to knowledge and darkness to ignorance, and this is what explains the wide usage made by the most diverse languages, and especially by the sacred Scriptures, of the symbolism of light and sight on the one hand, and of darkness and blindness on the other.[11]

"Seeing the Light" is a metaphor for spiritual realization and enlightenment is the goal of the spiritual path.[12] The *Mathnawi* of Jalaluddin Rumi begins by equating the unveiling of

9. The conversion of St Paul on the road to Damascus, heralded by an apparition of light, by Fra Angelico, c. 1430. See Note 12 on page 151

mysteries with enlightenment and by making direct reference to the Light described in the *āyat al-nūr*. Elsewhere in the *Mathnawi* come the verses:

> The light which gives light to the eye is in truth the light of the heart: the light of the eye is produced by the light of hearts.
>
> Again, the light which gives light to the heart is the Light of God, which is pure and separate from the light of intellect [mind] and sense [reason].[13]

The Light of God hath no opposite in (all) existence, that by means of that opposite it should be possible to make Him manifest. . . .[14]

Man's original food is the Light of God
. . . .[15]

'Tis God's light that illumines the
 senses' light,
That is the meaning of "Light upon
 light,"
The senses' light draws us earthwards,
God's light carries us heavenwards. . . .[16]

Jacob Boehme (1575-1624) writes: "In the next world we shall have no need of the sun, for we shall see with divine vision, by the light of our own nature."[17] Saint Catherine of Siena writes:

> We have been endowed by God with a natural, inborn light enabling us to distinguish between good and evil, perfection and imperfection, purity and impurity, light and darkness, and between the infinite and the finite. It is the one selective power which God has placed in our hearts and experience shows us repeatedly that we do possess this ability.[18]

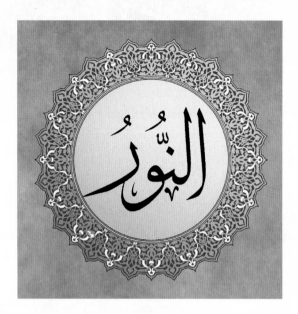

10. The Divine Name, *al-Nūr*.

Light in the Islamic Doctrines of Creation

Apart from its general symbolism, Light has a particular significance in Islam. As mentioned above, *Al-Nūr* is one of the Divine Names. The term "*nūr*" occurs forty-three times in the Koran, but only in the Verse of Light is God explicitly called "the light of the heavens and the earth" (*nūr al-samāwāti wa'l-ard*). Seyyed Hossein Nasr writes of the significance of light in Islam:

> "God is the Light of the Heavens and the Earth," the Quran asserts and a prophetic saying adds a cosmogonic and cosmological dimension to this verse by adding, "The first being created by God was light." . . . [I]n fact the primal man in every man yearns for light which is ultimately a symbol of Divine Presence, the Light which shines upon the whole cosmos from the central *axis mundi* that is neither of the East nor of the West. Throughout the centuries Sufis have sung and written of the significance of light as a spiritual substance. A special school of Islamic philosophy, the school of

ishrāq or illumination, based specifically on the symbolism of light was founded by the Persian theosopher and Sufi, Suhrawardī, and developed over the centuries by such later masters as Shams al-Dīn Shahrazūrī, Qutb al-Dīn Shīrāzī, Ibn Turkah, and Mullā Sadrā. Arabic and Persian literature, and even everyday language, are replete with expressions which identify light with joy of the soul and correct functioning of the intellect while even old tales told to small children are often based on the primal symbolism of light as truth and felicity, a symbolism which is so powerfully reconfirmed in the Islamic tradition and of course also asserted by many other older religions, especially Mazdaeism.[19]

A hadith states:

> I heard the Messenger of Allah say: "Allah created His creation in darkness, then on the same day He sent His Light upon them. Whoever was touched by His Light on that day will be guided and whoever was missed will be led astray."[20]

In a chapter entitled *An-Nūr*,[21] Schuon describes Islamic doctrines relating to Creation and cosmic manifestation and the role played by Light:

> According to a teaching (*hadīth*) of the Prophet, "the first of the things *Allāh* created (that is to say: the first unmanifested Reality in the Divine tendency to manifestation, or the first Divine self-determination with a view to creation) is the Pen (*Qalam*) which He created of Light (*Nūr*), and which is made of white pearl; its length is equal to the distance which is between the sky and the earth (the dis-

tance which separates them, that is to say: the incommensurability between formless—or supra-formal—and formal Manifestation). Then He created the Tablet (*Lawḥ*, or *Lawḥ al-maḥfūz*, the 'guarded Tablet'), and it is made of white pearl, and its surfaces are of red rubies; its length is equal to the distance which is between the sky and the earth, and its width stretches from the East to the West" (it embraces all the possibilities of Manifestation).

Schuon also quotes other *aḥadīth* of the Prophet, indicating that *Allāh* created the Pen and then the Tablet fifty thousand years ("a symbolical number expressing the incommensurability between the principial order and the manifested order") before He created the heavens (formless Manifestation) and the earth (formal Manifestation). He emphasizes that the word "created" here has the meaning not of "manifested," but "determined." Referring to this bi-polarization of the ontological Principle from which cosmic manifestation proceeds, Schuon describes how the "two divine Instruments" are expressed in various traditions. The Pen and the Tablet coincide respectively with the two principles which Hindu doctrine calls *Purusha* and *Prakriti*,

11. Arabic letters *alif* and *ba*.

the two unmanifested poles of all manifestation. He also mentions: "Ibn 'Arabi says that the infinitely glorious Throne (*Al-'Arsh al-majīd*) is uncreated Intellect (*Al-'Aql*, which is identical to the supreme Pen), and the immense Throne (*Al-'Arsh al-azim,*) is the uncreated Soul (*An-Nafs*) which is the guarded Tablet." The Pen and the guarded Tablet also correspond symbolically to the letters *alif* and *bā* in the Arabic alphabet and the first drop of Ink which fell from the Pen corresponds to the diacritical point under the *bā*, which is symbolically the point from which emanate all the "letters" which constitute the totality of the manifested Universe.[22] Light is also the substance from which certain beings in the manifested order are made:

As for the "Light" (*Nūr*), which we see simultaneously attributed—like the character of "creature"—to Divine, and therefore unmanifested, realities, and to cosmic, and therefore manifested, realities (or more precisely to realities belonging to formless Manifestation), it must be appreciated that the cosmos comprises three fundamental degrees: firstly, "earth" (*ṭīn*), secondly "fire" (*nār*) and thirdly "light" (*nūr*); the human body, like the whole sensory order (*'ālam al-mulk*, in Sanskrit *sthūla-sharīra*), is made of "earth," beings of the "subtle state" (*'ālam al-malakūt*, in Sanskrit *sukshma-sharīra*)—that is to say "spirits" (*jinn*)—are made of "fire," and the Angels and the whole formless order (*'ālam al-jabbarūt*, in Sanskrit *vijñānamaya-kosha*) are made of "light." These three "cosmic substances," if one can so call them, are "static" expressions of the "qualities" or "tendencies" inherent in the cosmos,—the *gunas* of Hindu doctrine—in the sense that the "earth" (or more exactly the "dust of the ground" from which the body of Adam was made) or gross

manifestation is "obscurity" or "igno-rance" (*tamas*), "fire" or subtle mani-festation is "expansion" or "passion" (*rajas*) and "light" or formless mani-festation is "the tendency towards Reality" or "conformity to Being" (*sat-tva*); but if the summit of the cosmos is "light" by reason of its conformity to Being, Being Itself will be a forti-ori "Light" (*'Alam al-'izzah* or *'Alam al-ghayb*, in Sanskrit *Ānandamaya-kosha*), for the "luminosity" of the Heavens can derive its origin only from the "Light" of God; to say that the Heavens are "created" of "Light" can therefore signify only one thing, namely that they are alone in being directly "conformable" to the Divine "Light," and consequently in being identified with this "Light" in the sense of an "essential identity." God is necessarily the Archetype of all light: "Allāh is the Light of the Heavens and of the earth" (Koran, *Sūrat an-Nūr*, XXIV, 35).[23]

Schuon notes the distinction that is made in the Koran between the Angels, who are created of Light, and men and *jinn*, "literally . . . the two heavy ones [see *Sūrat al-Raḥmān* [55]:31], that is to say those who are not created of Light like the Angels, but of earth in the one case and of fire in the other, elements whose materiality is expressed by the idea of heaviness."[24]

Muhammad as the Embodiment of Light

The Koran refers to light in the literal sense of the word but also in a symbolic and metaphorical sense. Used in the context of the phrase "from the darkness to the light" (*min al-ẓulumāt ilā 'l-nūr*) which appears frequently in the Koran, it is metaphorically associated with guidance, from ignorance to "illumination." Divine Light is thus equated with the guidance offered by the sacred, revealed scripture. This is expressed in the Verse of Light by the words: "*God guideth to his light whom he will.*" By extension, this attribute applies to the Prophet who conveys guidance and who in the Koran is referred to explicitly as a source of light: "an inviter to God by his leave, and a light-giving lamp." Annemarie Schimmel writes:

> In the early days of Koranic interpre-tation, scholars believed that Muham-mad was intended as the "niche" of which the Light Verse speaks, as the Divine light radiates through him, and again, the Koran had called him *sirāj munīr*, "a shining lamp" (Sura 33:46). As such, he is charged with leading people from the darkness of infidelity and error towards the light.[25]

The Light of Muhammad is an important concept in Islamic cosmology, according to which the whole cosmos emanates from the

12. *Sūrat al-Aḥzāb* [33]:43: ". . . from the darkness to the Light," from a 14th-century Koran, Egypt.

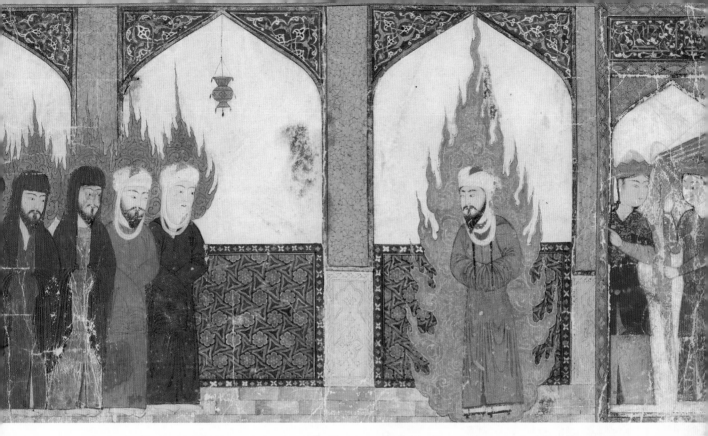

13. Persian miniatures portray the Prophet surrounded by an aura of light: With five prophets at *Masjid al-Aqsa*, in *Mi'rajnama* of Mirheydar, Herat, 1436.

nūr muḥammadī.[26] This doctrine is supported by two important hadith traditions, in which the Prophet states that: "the first thing God created was my light" (*awwal mā khalaqa Allāh nūrī*) and: "I am [made] of God's light and all created beings [are made] of my light" (*anā min nūri Allāhi wa'l-khalqu kulluhum min nūrī*).[27] There are many subsequent references in classical Islamic sources that reinforce this concept of the *nūr muḥammadī*, from which the entire universe came into existence prior to the Prophet's physical appearance on earth. Schimmel writes in this connection:

> It would be correct to compare the *nūr muḥammadī*, the Muhammadan Light or the *ḥaqīqa muḥammadiyya* to the active intellect of Helenistic philosophy. One can say in this context that the whole world is created from the light of Muhammad.[28]

Numerous accounts of the Prophet associate apparitions of light with his person. A hadith states that whenever he went in darkness, he had light shining around him like the moonlight; accounts from various companions of the Prophet state: "When he spoke, it was like light issuing from between his teeth." And likewise: "I have not seen anything more beautiful than the Messenger of God. It was as if the sun were shining in his face."[29] It is recounted that the light of prophethood, inherited from prophets before him, shone on his father's forehead when Muhammad was begotten and that his birth was marked by a luminous radiation that enabled his mother to see as far as the castles of Bostra in Syria (*Buṣrā al-Shām*). It is related that the Prophet would recite the following *du'a*:

> O Allah, place light in my heart, light in my tongue, light in my hearing, light in my sight, light behind me, light in front of me, light on my right, light on my left, light above me and light below me; place light in my sinew, in my flesh, in my blood, in my hair and in my skin; place light in my soul and make light abundant for me; make me light and grant me light.

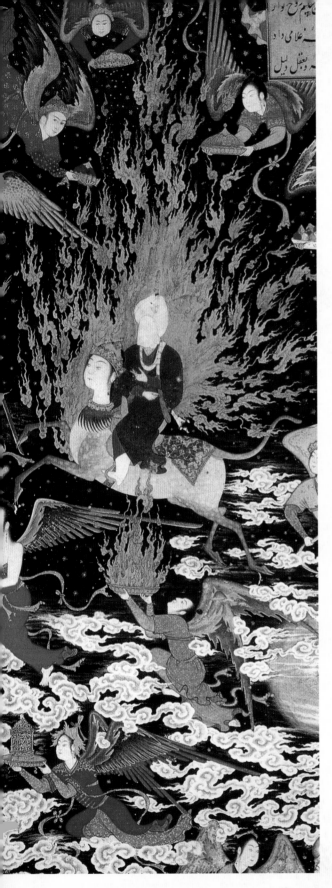

14. Detail from miniature depicting the *Mi'rāj* with the Prophet surrounded by an aura of light, from *Khamsa of Nizami*, ascribed to Sultan Muhammad, dated 1539-43.

Many other versions of similar prayers exist, in which the Prophet prays for light to be bestowed on different parts of his person.

Light and the Mystery of the Veils

The manner in which the divine Light radiates is linked to the mystery of "veils" in the created order. A large part of al-Ghazālī's work *Mishkāt al-Anwār*, after his detailed commentary on the Verse of Light, is dedicated to an exposition of the symbolism of a hadith known as the Veils tradition, which states: "Allah hath Seventy Thousand Veils of Light and Darkness: were He to withdraw their curtain, then would the splendours of His Aspect surely consume everyone who apprehended Him with his sight."[30] Chittick comments:

> Especially noteworthy in this hadith is that light is a veil. This is already paradoxical, because light is that which allows us to see. But light can also be bright enough to blind us, and this is manifestly so in the case of God. . . . When the Prophet was asked if he had seen God when he journeyed to Him in his ascent (*mi'rāj*), he replied, "He is a light. How could I see Him?"[31] Thus, in the earliest texts, along with the idea that a veil is something that prevents the vision of God, we also have the idea that the most basic of veils is the superabundance of God's light.[32]

In *Sūrat al-Nūr* [24]:43, a few verses after the Verse of Light, there comes the following passage: "The flashing of His lightning all but snatcheth away the sight." Frithjof Schuon writes:

> If it is impossible to understand the Absolute, it is because its luminosity is blinding; on the contrary, if it is impossible to understand the Relative, it

15. The Prophet Muhammad, helped by angels, crossing seventy thousand veils, from *Mi'rajnama* of Mirheydar, Herat, 1436.

is because its obscurity offers no reference to mark. . . . There is nothing but Light; the veils of necessity originate in the Light itself, they are prefigured in it. They do not come from its luminosity, but from its radiation; not from its clarity but from its expansion. The Light shines for itself, then it radiates to communicate itself, and by radiating, it produces the Veil and the veils; by radiating and spreading out it creates separation, veils, gradations. The intrinsic tendency to radiation is the first Veil, that which later defines itself as creative Being, and then manifests itself as cosmos. Esoterism or gnosis, being the science of Light, is thereby the science of veilings and unveilings, and necessarily so since on the one hand discursive thought and the language that expresses it constitute a veil, while on the other hand the purpose of this veil is the Light. . . . God and the world do not mix; there is but one sole Light, seen through innumerable veils; the saint who speaks in the name of God does not speak by virtue of a divine inherence, for Substance cannot be inherent in accidence; it is God who speaks, the saint being only a veil whose function is to manifest God, "as a light cloud makes the sun visible," according to a comparison used by the Moslems. Every accident is a veil which makes visible, more or less indirectly, Substance-Light.[33]

Elsewhere he writes that "even the shadows bear witness to the Light."[34]

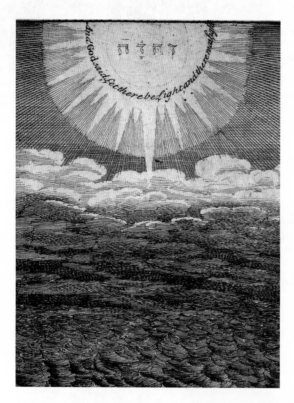

16. First Day of Creation by Czech artist Wenceslas Hollar (1607-1677). The Divine Principle represented by the *Tetragrammaton* surrounded by the words: *"And God said, Let there be light: and there was light."*

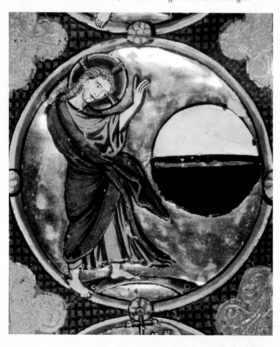

17. Illumination in a Bible history with moralizing interpretations, by artists of the Paris school, mid-13th century, depicting the account in Genesis, in which God divided the Light from the darkness.

The Symbolism of Light in the Judeo-Christian Traditions

The reference to Light as a symbol of the Divine is not unique to Islam; indeed it is such an evocative symbol that it is used almost universally in sacred traditions throughout the world. In the other Semitic monotheistic traditions, Judaism and Christianity, it features equally strongly, as indicated by the following selection of passages from the Bible, from both the Old and New Testaments.

> In the beginning God created the heaven and the earth. And the earth was without form, and void; and darkness [was] upon the face of the deep. And the Spirit of God moved upon the face of the waters. And God said, Let there be light: and there was light. And God saw the light, that [it was] good: and God divided the light from the darkness. And God called the light Day, and the darkness he called Night. And the evening and the morning were the first day. (Genesis 1:1-5)[35]

Here we see how prominently Light features in the biblical account of creation: that the very first divine utterance was "Let there be Light" and thereafter the first stage of cosmic differentiation was of light from darkness. Elsewhere Light serves as a symbol of the guidance offered to man by God.

> The LORD is my light and my salvation; whom shall I fear? the LORD is the strength of my life; of whom shall I be afraid? (Psalms 27:1)

> The sun shall be no more thy light by day; neither for brightness shall the moon give light unto thee: but the Lord shall be unto thee an everlasting light, and thy God thy glory. (Isaiah 60:19)

18. Psalm 27 [Vulg. 26]:1 from the late 13th century "Cologne Psalter-Hours."

19. Psalm 27 [Vulg. 26]:1 from the mid-13th century "Carrow Psalter."

20. Psalm 27 [Vulg. 26]:1, from a breviary, Autun or Dijon, ca. 1470.

21. Psalm 27 [Vulg. 26]:1 from a psalter, northeastern France, ca. 1250-75.

22. Psalm 27 [Vulg. 26]:1 from the "Howard Psalter," ca. 1308-c 1340.

23. Psalm 27 [Vulg. 26]:1 from the "St. Louis Psalter," 1270-1274.

All images show the beginning of Psalm 27 [26]: "*Dominus illuminatio mea et salus mea; quem timebo?* . . ."
Illuminated initial "D" of Dominus with representations of King David addressing the Divine Light.

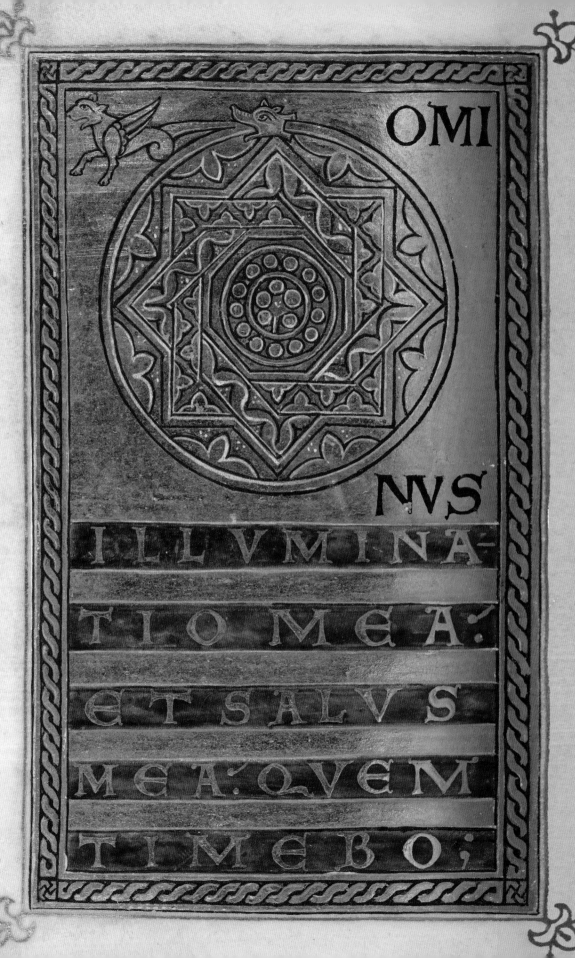

OMI

NVS

ILLVMINA-

TIO MEA:

ET SALVS

MEA. QVEM

TIMEBO;

The entrance of thy words giveth light; it giveth understanding unto the simple. (Psalms 119:130)

In the Christian context the Light by which guidance is offered to man by God passes through the Logos:

In the beginning was the Word, and the Word was with God, and the Word was God. The same was in the beginning with God. All things were made by him; and without him was not any thing made that was made. In him was life; and the life was the light of men. And the light shineth in darkness; and the darkness comprehended it not. There was a man sent from God, whose name [was] John. The same came for a witness, to bear witness of the Light, that all [men] through him might believe. He was not that Light, but [was sent] to bear witness of that Light. [That] was the true Light, which lighteth every man that cometh into the world. (John 1:1-9)

Then spake Jesus again unto them, saying, I am the light of the world: he that followeth me shall not walk in darkness, but shall have the light of life. (John 8:12)

I am come a light into the world, that whosoever believeth on me should not abide in darkness. (John 12:46)

This message is given visual expression in Christian art in icons depicting Christ as *Photodotis*, the "Giver of Light." Representations of Christ, holding an open book in which one can read the words from John 8:12—"I am the Light of the world"—are to be seen in architectural examples: over the imperial door in the narthex of Hagia Sophia, and also in the apse of the twelfth century Cathedral of Cefalu in Italy. Thus we see that in the Judeo-Christian context, as in Islam, Light features prominently in the account of creation and then subsequently serves as a symbol of the guidance offered to man by God—either directly or through the Logos. The New Testament, however, also

25. Psalm 119 [Vulg. 118]:130 from a psalter dated 1265-1270. *"Declaratio sermonum tuorum illuminat: et intellectum dat parvulis . . ."*

Opposite: 24. Beginning of Psalm 27 [Vulg.26] from the "Melisende Psalter," dated 1131-1143.
"Dominus illuminatio mea et salus mea; quem timebo? . . ."

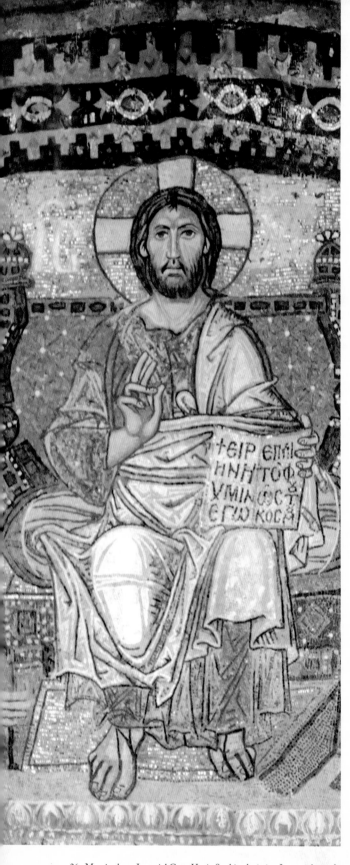

26. Mosaic above Imperial Gate, Hagia Sophia, depicting Jesus enthroned.
Written in Greek on the Bible in his hand are the words:
"I am the light of the world."

contains a passage, with a formulation similar to that in the Koranic Verse of Light, in which God is equated in essence with Light:

> This then is the message which we have heard of him, and declare unto you, that God is light, and in him is no darkness at all. (1 John 1:5)

The Burning Bush

In one particular instance in the Bible, in Exodus Chapter 3 (1-5, 13-14), Light plays a very significant role when God appears to Moses in the form of the Burning Bush:

> Now Moses kept the flock of Jethro his father in law, the priest of Midian: and he led the flock to the backside of the desert, and came to the mountain of God, [even] to Horeb. And the angel of the LORD appeared unto him in a flame of fire out of the midst of a bush: and he looked, and, behold, the bush burned with fire, and the bush [was] not consumed. And Moses said, I will now turn aside, and see this great sight, why the bush is not burnt. And when the LORD saw that he turned aside to see, God called unto him out of the midst of the bush, and said, Moses, Moses. And he said, Here [am] I. And he said, Draw not nigh hither: put off thy shoes from off thy feet, for the place whereon thou standest [is] holy ground. And Moses said unto God, Behold, [when] I come unto the children of Israel, and shall say unto them, The God of your fathers hath sent me unto you; and they shall say to me, What [is] his name? what shall I say unto them? And God said unto Moses, I AM THAT I AM: and he said, Thus shalt thou say unto the children of Israel, I AM hath sent me unto you.[36]

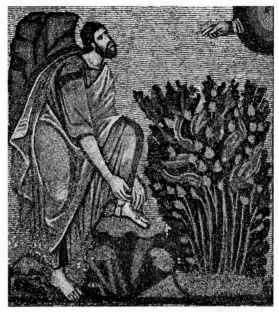

27. Moses and the Burning Bush, Byzantine mosaic, St Catherine's Monastery, Sinai.

Left: 28. Mosaic mural depicting the Burning Bush, Kykkos Monastery, Cyprus.

Rumi makes reference to the Burning Bush in one poem in his *Mathnawi*: "From the Bush he was hearing (the words), 'Lo, I am Allah,' and together with the words there appeared (Divine) lights."[37]

In a poem Frithjof Schuon emphasizes that the essence of the flame of the burning bush was not fire but light: "The thorn-bush burned, yet it was not consumed; / The burning was not fire, but light / From God's Being. A light not to be measured / But a sign, a miraculous power— / of Him Who is."[38] It may be recalled in this context that the Arabic words for fire (*nār*) and light (*nūr*) are both derived from the same verbal root.

Schuon writes that in Islam "it is taught that at the end of time light will become separated from heat, and heat will be hell whereas light will be Paradise; the light of heaven is cool and the heat of hell dark."[39] He writes elsewhere: "God is 'Light' 'before' He is 'Heat,' if it may be so expressed."[40] And also: "Heat and light symbolize respectively the animic and angelic states."[41]

Also related to Moses is the account, found in both the Bible and the Koran of how he put his hand into his breast and then withdrew it "white and without harm."[42] Schuon writes about this: "The commentators say that the hand of Moses shone with light; and when the inward, the heart, is purified—they say—— then our activity is white like the hand of Moses."[43]

29. Depiction of fire altar with priests wearing masks to maintain the purity of the sacred fire, Sogdian Zoroastrian ceramic ossuary, Mulla-Kurgan, Samarkand region, 7th-8th century.

Symbolism of Light in Other Religious Traditions

The symbolism of Light is likewise expressed in religious traditions outside the Semitic world. In Zoroastrianism, physical light is seen as the visible expression of the realm of Ahura Mazda, the eternal principle of Light and Righteousness. When Zoroastrians worship, they turn towards a flame (*atash*) or a source of light, which can come from a natural source such as the sun, an oil lamp or a wood fire, and which they see as "a spark of the endless light which is the abode of the infinite, a physical epiphany of the realm of Ahura Mazda Himself," bringing wisdom that dispels the darkness of ignorance and displaces unrighteousness.[44]

In Hinduism light also plays a central role. The *Bhagavad Gita* states:

> The effulgence which emanates from the sun illuminating the entire universe, and which is in the moon, and in fire—know this effulgence to be Mine.[45]

The *Brahmarahasya Upanishad* states:

> Brahma is the Light of lights. He is Self-luminous. He is Supreme Light (*Param Jyoti*). He is infinite Light (*Anata Jyoti*). He is an embodiment of Light (*Jyotih-Svaroopa*). By His Light all these shine.[46]

30. Baku Fire Temple, from *A Journey from London to Persepolis: Including Wanderings in Daghestan, Georgia, Armenia*, by John Ussher, 1865.

The Supreme Lord Krishna is known as the Lord of Light. Light is equated with the Self, as illustrated in the following quotations:

> The heart and mind can find peace and harmony by contemplating the transcendental nature of the true self as supreme effulgent light.[47]

> Gleaming as the earth and all the spheres
> Oh Thou expanse of matchless Effulgence!
> In radiant forms of Light art Thou beheld Oh Formless One![48]

> The light that shines above the heavens and above this world, the light that shines in the highest world, beyond which there are no others—that is the light that shines in the hearts of men.[49]

Niche

The Cave

The first revelation of the Koran came to the Prophet Muhammad in a cave close to Mecca.[50] Moses is said to have waited to receive the Ten Commandments in a cave at the summit of Mount Sinai (Mount Horeb).[51] Certain apocryphal Christian traditions describe the nativity of Jesus in a cave, as is frequently represented in icons in the Eastern Church; furthermore, the Church of the Nativity in Bethlehem is built over a cave which is traditionally believed to be the place of his birth.[52] Other similar examples include the tradition that the Book of the Apocalypse was revealed to Saint John in a cave on the island of Patmos. The Buddha is said to have dwelled and meditated in caves and this practice became common wherever Buddhism spread. For example, the great eleventh-century Tibetan Buddhist saint Milarepa spent many years of his life in caves. Likewise in Christianity, many saints and monks lived as hermits in caves.[53] Symbolically the Niche is the equivalent of the Cave.

The cave, analogous to the womb of Mother Earth, is associated with birth and regeneration. Caves frequently feature in mythological stories. There is the tale of the Seven Sleepers, recounted in both Christian traditions and the Koran[54] (giving the Chapter of the Cave in the Koran—the *sūrat al-kahf*—its name). In the classical tradition the Greek god Zeus was born in a cave on Mount Ida. Before there were temples, religious rites took place in caves. The Naos (Greek ναός/Latin *cella*) at the center of the classical temple was a windowless, dark, cave-like space.

31. Cave-temple dedicated to the Greek god Pan, Banias (Paneas), Caesarea Philippi.

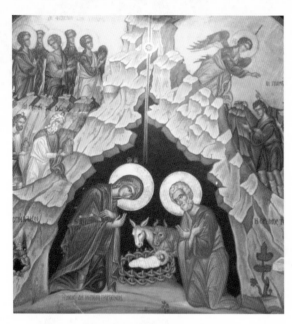

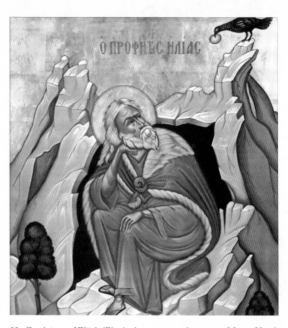

32. Depiction of the nativity in a cave, hanging above the altar in the Church of the Nativity in Bethlehem, built over a cave traditionally believed to be the birthplace of Jesus.

33. Greek icon of Elijah (Elias) who returns to the cave on Mount Horeb where Moses received the Ten Commandments.

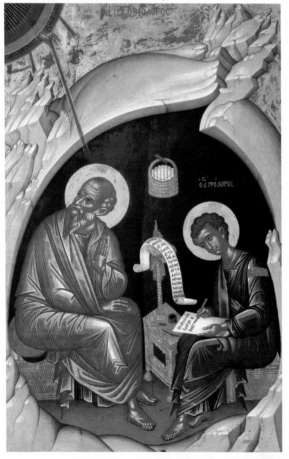

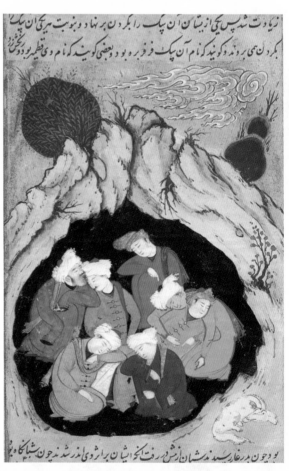

34. Icon depicting St John and his disciple, Prochoros, recording St John's visions.

35. Miniature painting of the Seven Sleepers in the cave at Ephesus, by Agha Reza, Qazwin, ca. 1590.

Martin Lings writes of the niche: [55]

"In all sacred architecture the niche is a form of the 'Holy of Holies,' the place of the epiphany of God, whether that epiphany be represented by an image in the niche or by an abstract symbol, or not suggested by any sign other than the purely architectural form."[56] Relevant is also what Titus Burckhardt says elsewhere, in connection with "the niche-like apse" at the East end of the nave of the early Romanesque churches whereby the whole building takes on the aspect of a cave: "According to a tradition well-known in the Christian East as well as in the Western Middle Ages, Christ was born in a cave, and this cave was understood both as a metaphor for this world of darkness and as an image of the heart. This indeed is the meaning of every sacred cave: it is the universe turned inward, the secret world of the heart . . . which is illumined by the Divine sun of the Spirit."[57] The niche is "the reduced image of the cave,"[58] . . . the microcosmic "universe turned inward." But like the cave, it stands also and beyond all for . . . the abode of the Self, [which] is "the secret world of the Heart." The prayer-niche must therefore be added, in this its deepest aspect, to what was previously mentioned, with regard to the mosque, as a symbol of the true Subject.

There can be no question, in Islam, of representing the epiphany by any anthropomorphic image. But the prayer-niche is nonetheless "illumined by the divine Sun" through its association with the Qur'ān's Verse of Light. . . . Especially relevant to our context of inward depth are the different degrees of brightness which increases in proportion to its interiorization, first the niche, then the glass, then the oil, then the flame itself—the inwarder the brighter.

In the book *Fundamental Symbols*, a collection of René Guénon's writings, three chapters are dedicated to different aspects of the symbolism of the cave: "The Cave and the Labyrinth," "The Heart and the Cave," and "The Mountain and the Cave." Here he writes:

The truth is that, far from being a place of darkness, the initiatic cave is illuminated from within, and it is outside the cave that darkness reigns, the profane world naturally being likened to the "outer darkness" and the "second birth" being at the same time an "illumination." If it be asked why the cave is considered in this way from the initiatic point of view, the answer is that on the one hand the cave, as symbol, is complementary to the mountain, while on the other hand the symbolism of the cave is closely related to that of the heart.[59]

[T]he close relationship between the symbolisms of the cave and that of the heart . . . explains the initiatic function of the cave as spiritual centre. In fact, the heart is essentially a symbol of the centre, whether it be the centre of a being or, analogously, of a world, that is, whether the standpoint be microcosmic or macrocosmic. It is therefore natural, given such a relationship, that the same meaning should be likewise attached to the cave. . . . The "cave of the heart" is a well known traditional expression. The Sanskrit word *guhā* generally designates a cave, but it is used also of the internal cavity of the heart, and consequently to the heart itself. This "cave of the heart" is the vital centre in which resides not only

jīvātmā but also unconditioned *Atmā*, which in reality is identical with *Brahma* itself. . . . The word *guhā* is derived from the root *guh*, meaning "to cover" or "conceal" or "hide," as does another similar root, *gup*, whence *gupta* which applies to everything of a secret character, everything that is not externally manifested. This is the equivalent of the Greek *kruptos* that gives the word "crypt," which is synonymous with cave. These ideas are related to the centre insofar as it is considered as the most inward and consequently the most hidden point.[60]

The Mihrab

Titus Burckhardt writes of the niche:

> The prayer-niche, or *miḥrāb*, is indisputably a creation of sacred art. . . . [T]he sacred niche derives from a worldwide symbolism, and . . . this symbolism is implicitly confirmed by the Koran. Its very shape, with its vault corresponding to heaven and its piedroit to the earth, makes the niche a consistent image of the "cave of the world." The cave of the world is the "place of appearance" (*maẓhar*) of the Divinity, whether it be a case of the outward world as a whole or the inner world, the sacred cave of the heart. All oriental traditions recognize the significance of this. . . .
>
> The form of the *miḥrāb*—discounting its name—calls to mind . . . the "verse of light," where the Divine Presence in the world or in the heart of man is compared to a light from a lamp placed in a niche (*mishkāh*). . . . The analogy between the *miḥrāb* and the *mishkāh* is clear; it is emphasized, moreover, by hanging a lamp before the prayer-niche.[61]

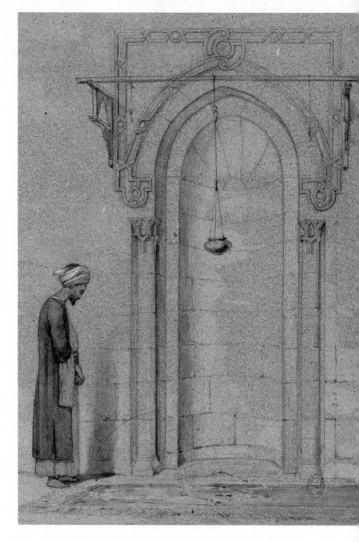

36. Man in prayer at the Zawiyah of Abd al-Rahman Kiahiyah, from *Scenes of Modern Life in Egypt II*, by Emile Prisse d'Avennes.

Burckhardt writes elsewhere:

> In Islamic art the niche is the *miḥrāb* oriented towards Mecca and the place where the imam stands while reciting the ritual prayers. Its form is reminiscent of that of a choir or apse, the "Holy of Holies," the general shape of which it reproduces on a small scale. This analogy is further confirmed in the field of symbolism by the presence of a lamp hung in front of the niche of prayer recalling as it does the "niche of

light" of which it is said in the Koran: "God is the light of the heavens and of the earth. His light is like a niche where there is a lamp" (*Surah of Light*, v. 35). To turn however to the acoustic function of the prayer-niche: it is by virtue of its reverberations of the Divine Word during prayer that the *miḥrāb* is a symbol of the Presence of God, and for that reason the symbolism of the lamp becomes purely accessory, or one might say "liturgical" for the "descent" or "divinity" in Islam is the Divine Word directly revealed in the Koran and "actualized" by ritual recitation.[62]

To establish the symbolism of the *miḥrāb* in its Islamic perspective, it must be related to its Koranic context. The word means, literally, "refuge"; the Koran in particular uses this word to describe a secret place in the Temple at Jerusalem where the Holy Virgin entered into a spiritual retreat and was nourished by angels. It is identified by certain Arab commentators with the Holy of Holies, the *debir* of the Temple at Jerusalem, and this interpretation, which does not appear to take into account the Judaic laws governing access to the *debir*, accords in fact with the Patristic tradition and the liturgy of the Greek Orthodox Church.[63] The inscriptions round the arch of the *miḥrāb* are frequently such as to recall the Koranic story in question, especially in Turkish mosques, starting with the *miḥrāb* of the Hagia Sophia, thereby confirming its dedication to the Holy Virgin. The link between the *miḥrāb* and Sayyidatna Maryam (Our Lady Mary) leads us again to the analogy between the prayer-niche and the heart: it is in the heart that the virgin-soul takes refuge

to invoke God; as for the nourishment miraculously bestowed there, it corresponds to grace.[64]

The Prayer Niche and the Virgin Mary

Frithjof Schuon further describes the connections between the prayer niche, the Verse of Light and the Virgin Mary:

The idea of recollectedness evokes all the symbols of contemplative immobility, all the liturgical signs of adoration: lamps or votive candles, bouquets or garlands of flowers, in short, all that stands before God and offers itself to His Presence which is Silence, Inwardness, Beauty, and Peace. It is this atmosphere that is suggested and created in mosques by the prayer niche (*miḥrāb*)—often adorned with a lamp recalling the tabernacle of the Blessed Sacrament in Catholic churches—the same prayer niche which is the abode of the Virgin Mary, according to the Koran; now Mary personifies mystical retreat and prayer, hence the mystery

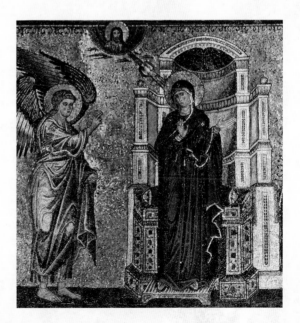

37. Mosaic depicting the Annunciation, by Jacopo Torriti, Santa Maria Maggiore, Rome, 1296.

of recollection. All this refers to that holy repose (*iṭmi'nān*, "appeasement of hearts") of which the Koran conveys the echoes.[65]

One of the most important passages, both from the generally Islamic as well as from the specifically Marian point of view, is the Verse of Light along with the three verses that follow it. . . . [A]fter this famous passage [the Verse of Light], come the following verses: "(This lamp is found) in houses which Allah hath allowed to be exalted and that His name shall be remembered therein. Therein do offer praise to Him at morn and evening. Men whom neither merchandise nor sale beguileth from remembrance of Allah and constancy in prayer and paying to the poor their due; who fear a day when hearts and eyeballs will be overturned; That Allah may reward them with the best of what they did, and increase reward for them of His bounty. Allah giveth blessings without stint to whom He will" (Surah of "Light", 24:35-8).

This group of verses evokes first of all the symbolism of the prayer-niche—a symbol itself of the mysteries of the Divine Light and of its modes of presence or immanence—and closes with the key-phrase of the Marian message, the words on Generosity. One likewise encounters an allusion to the Name of God and another to fear; finally, the Verse of Light contains the virginal symbols of the crystal, the star, the blessed tree,[66] and oil, which refer respectively to purity or the virginal body, to the *Stella Matutina* or the *Stella Maris*, to spiritual maternity, and to the luminous fruitfulness or the blood of Mary—blood which, pertaining to the Divine Substance, shines by its own nature.

In its intrinsic meaning, the Verse of Light refers to the doctrine of the Self and Its refractions in cosmic manifestation; the connection with the Virgin is plausible since she personifies the receptive or passive aspects of Universal Intellection, and thus Beauty and Goodness; but she likewise incarnates—by virtue of the formless and indefinite nature of the Divine Prakriti—the ineffable essence of wisdom or sanctity and as a result the supra-formal and primordial reality, at once virginal and maternal, of the saving coagulations of the Spirit.[67]

The same words on Generosity, to which Schuon refers, appear in the Koran also at the end of the Verse of the Mihrab (*Sūrat Āl 'Imrān* [3]:37), describing the miraculous divine nourishment which Zakariyyā found with Maryam whenever she prayed in the sanctuary. The part of this verse mentioning the mihrab is frequently inscribed above the prayer niche in mosques, emphasizing this association with her. Describing the symbolism of this verse, Schuon comments that the mihrab is the Heart; Maryam is the inner soul, withdrawn from the world; Zakariyyā is the outer soul, which recognizes that the inner soul is nourished by the infinite Center and this nourishment is unlimited—given "without reckoning."

38. *Sūrat Āl 'Imrān* [3]:37, from a large-format Timurid Koran, Northern India, 15th-century.

39. Epigraphic inscription from the "Verse of the Mihrab" above the mihrab of Hagia Sophia.

Sayyidatunā Maryam . . . is the personification of perfect *faqr*. It is for this reason that she could say: "Verily God gives sustenance to whom He will beyond all reckoning." For where there is perfect *faqr*, there also is *rizq*, just as a crystal attracts light; indeed *rizq* is already contained in *faqr* in a certain manner, for "its oil shines without the flame having touched it."[68]

The mihrab is likewise identified with the "eastern place"—the source of light or illumination—to which Maryam withdrew (*Sūrat Maryam* [16]:16). Here we again encounter Light as a recurring theme. It is noteworthy that Maryam is referred to by the Arabic name *Umm al-Nūr* (the Mother of Light).[69] Schuon on occasion refers to her by the name *Nūr al-Miḥrāb* and comments:

> The *Miḥrāb* evokes the Niche (*Mishkāt*) in the Verse of Light; Maryam is the "resplendent Star" (*Kawkabun durrī*); she is the Light of God.

Etymology of the Word *Mishkāh*

There is an element of ambiguity surrounding the word *mishkāh* in the Koranic Verse of Light. The word occurs only once in the Koran and is customarily translated as "Niche." According to Muslim scholars, the word was in common use during the Prophet Muhammad's time and described a small recess in a wall in which a lamp could be placed in order to reflect the light from an elevated position. Various Western scholars believe the term to be of Ethiopic origin, meaning a "window."[70] Some believe it is of Abyssinian Christian origin and suggest that the Prophet may have heard it from his cousin, Ja'far b. Abī Ṭālib, after he had met with an Ethiopian ruler.

Other interpretations ascribe an alternative meaning to the term, taking it to refer to a perforated lamp body that can enclose a suspended lamp, a meaning which is still in current use in contemporary Arabic and Persian, possibly deriving from its concave form.[71] This use of the term *mishkāh* is discussed by the

40. Mihrab of Hagia Sophia.

French archaeologist Clermont-Ganneau in his article *La lampe et l'olivier dans le Coran*, describing this as "[o]ne of the current views of the ancient commentators of the Koran . . . [who] are, indeed, far from being in agreement with each other."

> If, for the majority, the *mishkāh* is a niche, for others it is a support in the form of a column on which one placed the actual lamp (*miṣbāḥ*); for others, it is a certain device for the suspension of the lamp; for others, on the contrary, it is an integral part of the lamp itself, in particular the metal wick holder, or the tube used for this purpose in glass lamps.[72]

Clermont-Ganneau ultimately concludes that studying the etymology of the word *mishkāh*— and attempts to make comparisons with other words in Abyssinian and Aramaic—does not enable one to resolve definitively the intended meaning of the term in the Verse of Light.

Lamp

The symbolic connection between the Niche and the Lamp is seen already in pre-Islamic art. An arch or a niche was understood as a symbolic doorway to the next world and a lamp lit the way for the soul on its path of return. A lamp within a niche or above an altar features in the religious iconography of Judaism and Christianity.[73] The imagery conveyed by the Verse of Light established this form in the iconography of Islam and Islamic architecture.

While the Arabic term *qandīl* is generally used to refer to a single hanging lamp, the word used to describe the lamp in the Verse of Light is *miṣbāḥ*. This word (pl. *maṣābīḥ*) occurs three

41. *Mishkāt al-Masābiḥ*, a popular hadith collection by Khatib Al-Tabrizi (d. 741 H/1340).

42. *Sūrat al-Aḥzāb* [33]:45-47, in which the Prophet is compared to a luminous lamp, from a 12th century Maghrebi Koran.

43. "*Nūr, sirāj, miṣbāḥ, hudā*": Some of the noble names of the Prophet Muhammad mentioned in *Dalā'il al-khayrāt*, from a 17th century Ottoman manuscript.

times in the Koran, once in the singular in the *āyat al-nūr* and twice in the plural, in *Sūrat Fuṣṣilat* [41]:12 and *Sūrat al-Mulk* [67]:5. Both of these two latter verses state: "We decked the nether heaven with lamps." Here the term is used figuratively to designate the sun and moon and the other light-emitting heavenly bodies. A hadith states that:

> The Messenger of Allah said: "Hearts are of four kinds: the heart that is clear like a shining lamp; the heart that is covered and tied up; the heart that is upside-down; and the heart that is clad in armor. As for the clear heart, it is the heart of the believer in which is a lamp filled with light."[74]

The word used for "lamp" in this hadith is *sirāj*, which occurs four times in the Koran. In three out of four of these the term refers to the sun.[75] However, in *Sūrat al-Aḥzāb* [33]:46 it is the Prophet who is compared to a luminous lamp (*sirāj munīr*): "O Prophet, We have sent thee as a witness, and good tidings to bear and warning, calling unto God by His leave, and as a light-giving lamp." The terms *sirāj* and *miṣbāḥ* are both among the "sacred names" of the Prophet, commonly used in litanies and prayers.

As light is equated with knowledge, the lamp symbolically represents dissemination of this light. The term *miṣbāḥ* is used in this sense in the title of the well-known hadith collection *mishkāt al-maṣābīḥ* (A Niche for Lamps) which itself is an expanded version of Al-Baghawī's *maṣābīḥ al-sunnah* (Lamps of the Sunnah). In the Islamic world, the significance of the Lamp is expressed in popular culture in *The Story of 'Ala-ed-Din and the Wonderful Lamp*. Certain passages in the story echo the iconography and symbolism in the Verse of Light.[76]

In Islamic culture it was considered meritorious to hang lamps in mosques and shrines, this practice finding support in a hadith which states: "He who lights up a light in a mosque for seven nights running, God will keep him away from the seven doors of Hell and illuminate his tomb on the day he is laid down in it. On Resurrection Day, there shall be a light in front of him, and there shall be light behind him, and there shall be light on his right, and there shall be light on his left."[77] The lighting of a lamp has a symbolic significance, synonymous with manifesting the divine presence in the form of Light.

The Oil Lamp in Religions Around the World

Besides their role in Islam, oil lamps and candles have a place in many of the world's religions, including Judaism, Christianity, Hinduism, Buddhism and Zoroastrianism (Mazdaism).

Judaism

The oil lamp in Jewish Scriptures most often symbolizes God lighting the way for the chosen people, as indicated by the following selection of verses from the Bible:

> Thy word is a lamp unto my feet and a Light unto my path. (Psalms 119:105)

> For thou [art] my lamp, O LORD: and the LORD will lighten my darkness. (2 Samuel 22:29)

> For the commandment [is] a lamp; and the law [is] light. (Proverbs 6:23)

> For thou wilt light my lamp: the LORD my God will enlighten my darkness. (Psalms 18:28)

44. Psalm 18 [Vulg. 17]:28, from the late 13th century "Fieschi Psalter."

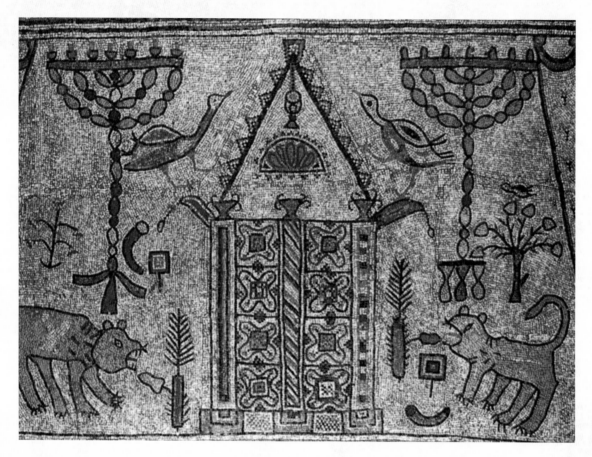

45. Mosaic floor of 6th-century Beth Alpha synagogue, depicting Torah Shrine with hanging lamp suspended from its gabled roof.

When his lamp shined upon my head, [and when] by his light I walked [through] darkness. (Job 29:3)

The light of the righteous rejoiceth: but the lamp of the wicked shall be put out. (Proverbs 13:9)

Perhaps the best-known symbol of Judaism and one of the best-known lamp symbols in all religions is the Jewish Menorah, the seven-branched candelabrum. In the book of Exodus, God commands the people to bring olive oil so that a lamp can burn continually in the tabernacle. In the Book of Numbers, God tells the people to light the seven lamps of the Menorah in conjunction with the rededication of the temple after it was looted.[78]

And thou shalt make a lampstand [of] pure gold: [of] beaten work shall the lampstand be made: his shaft, and his branches, his bowls, his knops, and his flowers, shall be of the same. And six branches shall come out of the sides of it; three branches of the lampstand out of the one side, and three branches of the lampstand out of the other side: Three bowls made like unto almonds, [with] a knop and a flower in one branch; and three bowls made like almonds in the other branch, [with] a knop and a flower: so in the six branches that come out of the lampstand. And in the lampstand [shall be] four bowls made like unto almonds, [with] their knops and their flowers. And [there shall be] a knop under two branches of the same, and a knop under two branches of the same,

according to the six branches that proceed out of the lampstand. Their knops and their branches shall be of the same: all it [shall be] one beaten work [of] pure gold. And thou shalt make the seven lamps thereof: and they shall light the lamps thereof, that they may give light over against it. (Exodus 25:31-37)

And the LORD spake unto Moses, saying, Command the children of Israel, that they bring unto thee pure oil olive beaten for the light, to cause the lamps to burn continually. Without the vail of the testimony, in the tabernacle of the congregation, shall Aaron order it from the evening unto the morning before the LORD continually: [it shall be] a statute for ever in your generations. He shall order the lamps upon the pure lampstand before the LORD continually. (Leviticus 24:1-4)[79]

In Jewish culture the Menorah has an elaborate symbolism. Josephus, the first-century Romano-Jewish historian and hagiographer, says that its seven branches represent the sun, moon, and planets, also the seven days of the week, the seven stars of Ursa Major, and the seven cycles or forces in the world.[80]

Christianity

The lamp holds an equally important place in Christianity. In the Orthodox Church an oil lamp is lit at the time a church is consecrated and is never allowed to go out. Likewise in the Eastern Catholic Church, an oil lamp burns constantly on the altar. Referred to as the sanctuary lamp or altar lamp, its use goes back to the command in

46. Aaron the Priest pouring oil in the Menorah; from a miscellany of biblical and other texts, France, 1278-1298.

47. *Right*: An altar with two candlesticks and a lamp above, detail from late 13th century manuscript of "The Abingdon Apocalypse."

the book of Exodus that a lamp filled with the purest oil of olives should always burn in the tabernacle. The sanctuary lamp symbolizes the presence of God.[81] Charles Rohault de Fleury writes that "in the year 787 the second council of Nicea sanctioned the already popular usage of maintaining lamps before sacred images."[82] *La Messe*, Rohault de Fleury's illustrated work on the Catholic Mass, includes a whole volume dedicated to lamps, in which he describes in detail the historical development of lighting in the Christian context. He writes by way of introduction to this comprehensive work:

> When travelling our public roads, now splendidly illuminated at night, we no longer think that the origin of this city lighting began with the lamps that the faithful hung in devotion in front of the Madonnas at street intersections. There, as everywhere, we forget the beneficent hand of the Church that

spread the seeds of our civilization. Christians, indeed have always loved religious illuminations, which reminded them of Christ, *lux mundi*, and seemed to repel the devil, the prince of darkness.[83]

Rohault de Fleury meticulously compiles references in historical accounts over the centuries, and the illustrations he provides of light fixtures depicted in ancient manuscripts and of surviving examples offer valuable insights. [84] He describes how this development culminates in the appearance of larger light fixtures described as "crowns of light," with particularly notable examples dating from eleventh- and twelfth-century France and Germany. Of these he writes:

> From this time there survive interesting monuments known by the name of "crowns of light." We have shown,

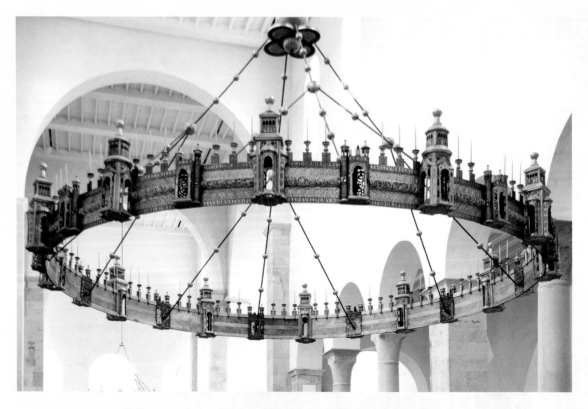

48. Romanesque "crown of light" chandelier, Cathedral of Hildesheim, Germany, 11th-century.

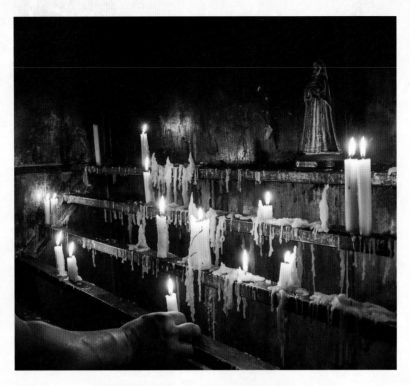

49. Votive candles used in Christian worship.

referring to the lamps of the Basilica of Saint John Lateran, that this kind of light fixture was used from the fourth century onwards. . . . The Eastern Church made use of crowns of light, as we have indicated by reference to the one hanging in the Holy Sepulchre. In the Church of the Ascension in Jerusalem, above a wheel of bronze, there also shone a great lamp that never went out. . . . These crowns had a symbolic meaning, but somewhat different from that which the Latins applied to them; according to Simeon of Thessalonica, the lights represented the sky and the stars with which it is filled, the crown represented the area of the planets. The lights varied in significance according to their number: seven lights were the gifts of the Holy Spirit, twelve the number of the apostles, and the light in the center Jesus Christ himself.[85]

In Christianity candles are lit to indicate one's intention to say a prayer, the candle symbolizing that prayer. Candles are lit to pray for the dead as well as to ask for saintly intercession. In the Eastern Orthodox Church and some Eastern Catholic Churches, the Feast of Candlemas is one of the twelve Great Feasts; it is celebrated also in the Roman Catholic Church and is perhaps the most ancient festival of the Blessed Virgin, celebrating the Feast of the Presentation of Christ in the Temple. The term Candlemas originates in the tradition of blessing candles on this feast and carrying them in procession as a symbol of the "Light to Lighten the Nations." The priest, after blessing the candles at the altar, distributes them to the clergy and laity, whilst the choir sings the "*Nunc dimittis*," in which the words from Luke 2:32 are repeated after every verse: "*Lumen ad revelationem gentium et gloriam plebis tuae Israel*" (A light for the revelation of the Gentiles: and for the glory of Thy people).

50. *Dīpa* oil lamps arranged in a Rangoli pattern, to celebrate the Hindu festival of *Deepawali*.

Hinduism

The lamp is an important element in Hindu worship. Oil lamps are lit within Hindu temples and homes and the *puja* prayer ceremony makes use of an oil lamp. Hindus are instructed to light a lamp each day to drive evil from their homes and invite in the light of the Almighty. During the festival of Diwali (*Diyawali*, from *diya*, light), temples and houses are illuminated with countless lamps. The lighting of a lamp is referred to as *deeparadhana* and a strict protocol is followed in its lighting. The following is written about the importance of the lamp in Hinduism:

> The lamp has its own special place in Hindu *Dharma*. It is a form and a symbol of *Tej* (Absolute fire principle). The lamp . . . leads man from darkness towards light.
>
> It burns only to give message of peace and light to man. The lamp is an important article of *puja*. The following *mantra* which is recited during the ritual of *puja* explains its significance:

> O Deity of lamp, you are of the form of *Brahman* (the absolute

truth). You are full of radiance. You never wither. Please bestow me health and good progeny and please fulfill my wishes.[86]

Hinduism accords great importance to *deeparadhana* or the lighting of oil lamps, made of clay, brass, or gold. Natural oils, such as sesame seed oil, castor oil, and cow ghee are used in the lamp. No function starts without first lighting a lamp. A lamp is lit after sunrise and in the evening. The Oil Lamp represents Mother Lakshmi. To the left of the lamp is kept a small picture of Lord Vishnu or Narayana. As the lamp is lit the following mantra is chanted:

> *Deepajyothi parabrahma*
> *Deepa sarva tamopahaha*
> *Deepena saadhyate saram*
> *Sandhyaa deepo namostute*
>
> I prostrate to the lamp;
> whose light is the Knowledge Principle
> (the Supreme Lord),
> which removes the darkness of
> ignorance
> and by which all can be achieved in
> life.[87]

51. Butter lamps used in Tibetan Buddhist worship.

52. Fragment of Buddhist sculpture showing a female devotee worshipping a lamp held up by a monk, photograph taken in Peshawar District, by Henry Hardy Cole, ca. 1883.

53. Statue of Amitabha Buddha, Kek Lok Si Temple, Air Itam, Penang, Malaysia.

Buddhism

The Lotus Sutra compares Shakyamuni Buddha to a bright lamp of wisdom.[88] One of the main accomplishments of the great Indian master Atisha Dipamkara Shrijnana, who in the eleventh century was responsible for re-establishing Buddhism in Tibet, was the writing of a text entitled *A Lamp for the Path to Enlightenment*. The Dalai Lama gives the following explanation:

> The title, *A Lamp for the Path to Enlightenment* [*Jang-chub lam-gyi drön-ma*] has a profound meaning. . . . *Jang-chub chen-po*, "great enlightenment," is an epithet for the Buddha's enlightened state. . . . The metaphor of the lamp is used because just as a lamp dispels darkness, the teachings in this text dispel the darkness of misunderstanding with respect to the path to enlightenment.[89]

A lamp, light, or lantern was regarded as an important offering to the Buddha. The offering of *dipa* was believed to be a meritorious deed that brought benefit to the donor. The Sutra on the Wise and the Foolish tells the story of a poor woman who wished to offer an oil lamp to Shakyamuni Buddha. She went out begging, but could gain only one coin. With that coin, she obtained a single oil lamp and offered it to the Buddha. That night, though all the lamps offered by kings and other people went out, her lamp alone continued to burn throughout the night.

A traditional chant when offering lighted lamps to an image of the Buddha is: "With this lamp lit with camphor that dispels all darkness, I worship the Perfectly Enlightened One who is a lamp unto the three worlds and is the dispeller of darkness."[90]

The epithet *Tiloka-dīpaṃ* ("lamp unto the three worlds") as applied to the Buddha, the dispeller of the darkness of ignorance, is particularly significant in the context of

नमो अमिताभाय बुद्धाय

54. The invocatory formula of the Pure Land school in Sanskrit: *Namo 'mitābhaya Buddhāya* (I take refuge in the Buddha of Infinite Light).

the present study. This epithet has notable similarities to the formulation "Light of the heavens and earth" in the Koranic Verse of Light. However, in the one case the reference is to three worlds and in the other to two. The apparent contradiction may be explained by an understanding of how the same fundamental realities can be described variously in different terms.

William Stoddart makes reference to the "Five Divine Presences," described in the writings of Frithjof Schuon,[91] and explains how in Buddhism, these appear in the form of the

three "hypostases" or "bodies" (*trikāya*) of the Buddha.[92] Elsewhere, however, he explains how the same Five Levels of Reality can be grouped in different ways, according to other relationships, and are seen to be equivalent to Heaven and Earth, as indicated in the diagram below.[93] It is therefore evident that the two formulations, Buddhist and Islamic, are expressions of the same fundamental realities.

The principal Buddha in the Pure Land branch of Mahāyāna Buddhism is Amitābha, this term signifying Infinite Light.

1	2	3	4	5
the Divine Essence	the Personal God (uncreated Logos)	Spirit or Intellect (created Logos)	Soul	Body
"BEYOND-BEING"	"BEING"	SPIRITUS, INTELLECTUS	ANIMA	CORPUS
ABSOLUTE (*Ātmā*)	RELATIVE (*Māyā*)			
DIVINE		HUMAN		
IMMORTAL				MORTAL
HEAVEN			EARTH	
Dharmakāya "universal body"	*Sambhogokāya* "body of felicity" Logos	*Nirmānakāya* "body of impermanence"		

55. Diagram representing the "Five Divine Presences."

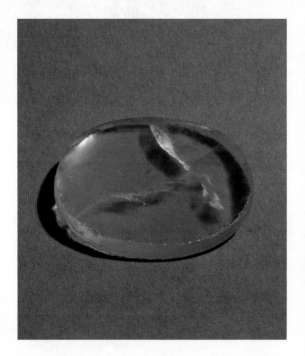

56. The "Nimrud Lens," found in excavations at the North West Palace, Nimrud, Iraq, 750-710 B.C. Rock-crystal, ground and polished, diameter 4.2 cm, thickness 0.25 cm.

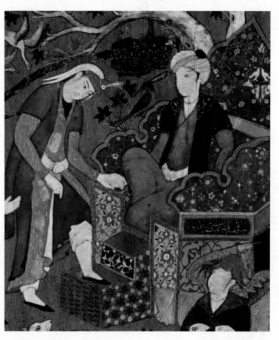

57. Detail from lacquered panel depicting Bilqis, Queen of Sheba, lifting her dress to cross the crystal floor of Sulayman's palace, mistaking it for a pool of water, Iran, 15th century. See Note 94 on page 155.

Glass

The Verse of Light describes a lamp consisting of a burning wick contained within a glass. Functionally the glass in a lamp would have protected the flame from being put out by gusts of wind, while at the same time allowing the light to shine forth.

Glass occurs naturally in the form of rock crystal and also as a man-made material, derived by heating silica to high temperatures. It is characterized by a highly reflective surface, giving it a brilliant, glittering appearance.[94] This attribute is expressed in the Verse of Light when it states: "The lamp is in a glass. The glass is as it were a shining star." There are different interpretations of the Arabic word translated as "shining" or "radiant." Some authorities pronounce the word *durriyyun*, which means pearly, i.e., as if it were a star made of pearls (*durr*). Others pronounce it *dirri'un* or *durri'un*, which is related to the word *dir'*, meaning reflection.

The key characteristics of glass are its transparency and translucency, both of which are properties related to the way in which the material transmits light. Its role in optics was documented as early as the tenth century by the Muslim scholar Ibn al-Haytham (965–1040) in his seven-volume treatise *The Book of Optics* (*Kitāb al-Manāẓir*). The material's attributes are exploited to intensify man's vision—whether by the use of the simple magnifying glass and spectacles or by the microscope and the telescope. Maybe not unrelated is the association of the material with divination, such as the use of the crystal ball, believed to enable a clairvoyant to see into dimensions beyond the range of the physical eye. In a lamp, the glass would also have acted as a lens, particularly as it was usually filled with water up to the thin layer of oil. Optically this would have magnified the flame when seen from below. The visual effect achieved when such lamps were lit must have been striking.[95]

58. The olive, illustration from 1819.

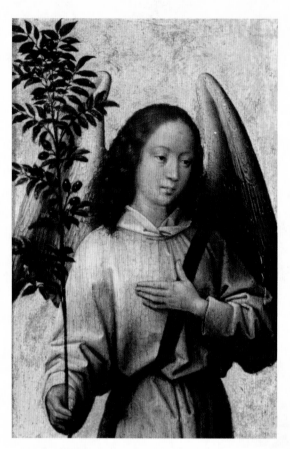

59. Angel Holding an Olive Branch, by Hans Memling, 1475-80.

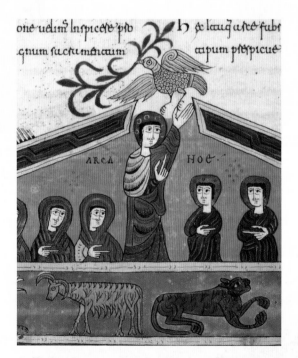

60. The Dove Returning to Noah, from "Silos Apocalypse," by Beatus of Liébana, illustrated by Petrus, Spain, 1109.

Oil

The Verse of Light describes a lamp kindled from the oil of a blessed olive tree. The sacred character of the olive is emphasized in a hadith, in which the Prophet said: "Eat olive oil and anoint yourselves with it, for it comes from a blessed tree."[96]

The primary uses of olive oil are: 1) for nourishment, 2) for anointing, and 3) for lamps. Other *aḥadīth* prescribe the use of olive oil in the treatment of various ailments.[97] The olive tree is described in the Koran as "a tree issuing from the Mount of Sinai that bears oil and seasoning for all to eat" (*Sūrat al-Mu'minūn* [23]:20). At Mount Sinai the olive is known to have been cultivated by the monks in the monastery of Saint Catherine,[98] which dates back to 527, just forty-three years before

the birth of the Prophet.[99] The olive is also associated with Jerusalem where the Mount of Olives is located. The olive tree is characterized by its longevity, usually living for two to three hundred years and occasionally as much as two thousand years. The biblical account of the dove bringing back a sprig of olive to Noah to herald the end of the flood (Genesis 8:11), establishes the olive as a symbol of peace—coinciding with its significance in classical antiquity. Thus "holding out an olive branch" is synonymous with seeking peace.

Olive Oil for Food

The olive is mentioned in the Koran seven times. In many of these passages the emphasis is on the abundance of God's provision (e.g. *Sūrat al-An'ām* [6]:99). Olive oil also appears as a symbol of God's provision in the biblical account of Elisha and the Widow's Oil (2 Kings 4:1-8) in which a widow cries out to the prophet Elisha, having been left in debt, with nothing but a jar of oil. The oil miraculously fills all of the vessels that her sons bring from the neighborhood until no more can be brought and she is thus able to pay off her husband's debts, save her sons from slavery, and then support her family.

Olive Oil for Anointing

The use of olive oil for anointing, mentioned in the hadith quoted above, refers to a custom which pre-dates Islam. In Judaism anointing with oil was an integral part of the consecration of the articles of the Tabernacle and the temple in Jerusalem:

> And the LORD spake unto Moses, saying, On the first day of the first month shalt thou set up the tabernacle of the tent of the congregation. And thou shalt bring in the table, and set in order the things that are to be set in order upon it; and thou shalt bring in the lampstand, and light the

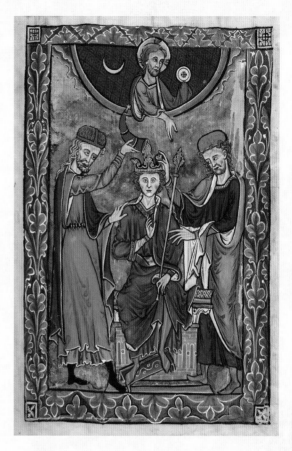

61. The Anointing of David by Samuel, "The Evesham Psalter," 1246-1325.

> lamps thereof. And thou shalt take the anointing oil, and anoint the tabernacle and all that [is] therein, and shalt hallow it, and all the vessels thereof: and it shall be holy. (Exodus 40:1-2,4,9)

Anointing played an essential role in the ordination of priests and then later its use was extended to include kings, although the holy anointing oil was forbidden for use on any common persons. The term "*Messiah*," which is a transliteration of the Hebrew term "*Mashiach*," means "the anointed one" and relates to anyone anointed to be king. The Greek equivalent of *Messiah*, used in the New Testament, is Χριστός—*Christos*—likewise meaning "the anointed one."

The use of olive oil in anointing is still practiced in Christianity in the rite of baptism and other sacraments, which involve anointing with "chrism," a mixture of olive oil and balsam, blessed by a bishop in a special manner. The blessing conferred by anointing is often related to healing. This role features in the biblical account of Jesus sending forth his twelve disciples: "And they cast out many devils, and anointed with oil many that were sick, and healed them."[100]

Oil for Lamps

Clermont-Ganneau notes that prior to the advent of Islam the oil used in lamps was not from the olive but from sesame—a practice going back to the Nabatean and Babylonian periods—pointing out that the Arabic word for lamp (*sirāj*) is derived from the word for sesame oil.[101] The olive was not indigenous to the region and, according to Guy Le Strange, was introduced to Palestine by the ancient Greeks, a fact which he says was mentioned by Ibn al-

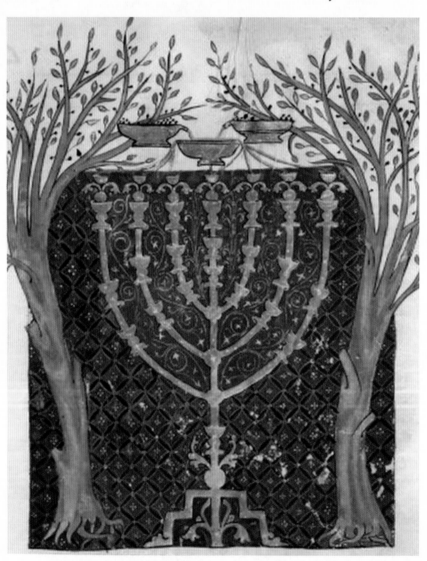

62. Depiction of the Menorah with olive trees on the right and on the left side, from Jewish Cervera Bible, Joseph Asarfati, 1299.

Faqīh in 903.[102] Clermont-Ganneau mentions the role of Tamīm al-Dārī, in introducing from his native Palestine not just the practice of using oil lamps in the mosques of Medina and Mecca, but also the olive oil to fuel them. Tamīm al-Dārī was himself a merchant of oil and lamps and, after his conversion to Islam, he and his descendants were granted a fiefdom over the region of Hebron, renowned for its olive oil. In one of the documents relating to the caliphate of 'Abd al-Malik (the fifth Umayyad Caliph who reigned from 685–705) we are told that the oil in the lamps of the Dome of the Rock had such a pleasing smell that pilgrims perfumed themselves with it.[103]

> On the authority of Abu Bakr ibn al Hārith, it is reported that, during the Khalifate of 'Abd al Malik, the Sakhrah was entirely lighted with [oil of] the Midian Bān [the Tamarisk, or Myroba-lan] tree, and oil of Jasmin, of a lead color. [And this, says Abu Bakr, was of so sweet a perfume, that] the chamberlains were wont to say to him: "O Abu Bakr, pass us the lamps that we may put oil on ourselves therefrom, and perfume our clothes"; and so he used to do, to gratify them.[104]

Clermont-Ganneau remarks on the parallels between the Verse of Light and fourth chapter of Zechariah in the Bible, in which the seven-branched Menorah lampstand is described with an olive tree to its left and right, and he comments on the significance of the presence of the olive tree in both cases:[105]

> And the angel that talked with me came again, and waked me, as a man that is wakened out of his sleep, And said unto me, What seest thou? And I said, I have looked, and behold a lampstand all [of] gold, with a bowl upon the top of it, and his seven lamps thereon, and seven pipes to the seven lamps, which [are] upon the top thereof: And two olive trees by it, one upon the right [side] of the bowl, and the other upon the left [side] thereof. So I answered and spake to the angel that talked with me, saying, What are these, my lord? Then the angel that talked with me answered and said unto me, Knowest thou not what these be? And I said, No, my lord. Then he answered and spake unto me, saying, This is the word of the Lord unto Zerubbabel, saying, Not by might, nor by power, but by my spirit, saith the Lord of hosts. Then answered I, and said unto him, What [are] these two olive trees upon the right [side] of the lampstand and upon the left [side] thereof? And I answered again, and said unto him, What [be these] two olive branches which through the two golden pipes empty the golden [oil] out of themselves? And he answered me and said, Knowest thou not what these [be]? And I said, No, my lord. Then said he, These [are] the two anointed ones, that stand by the Lord of the whole earth. (Zechariah 4:1-6, 11-14)

This theme is taken up in Revelation 11: 3-4

> And I will give [power] unto my two witnesses, and they shall prophesy a thousand two hundred [and] three-score days, clothed in sackcloth. These are the two olive trees, and the two lampstands standing before the God of the earth.

The identity of these two "witnesses" is enigmatic, as is borne out by Zechariah's repeated questions about the two olive trees and branches that feed the lamp with oil, and the angel's cryptic answers. This has led commentators to interpret who or what is referred to. As mentioned above, anointing played an essential

role in the ordination of priests and kings and the reference in Zechariah 4 to "the two anointed ones" therefore seemed to point to the two leaders at the time of Zechariah: Joshua, the high-priest, and Zerubbabel, the governor of Israel, and thus by extension to kingly and priestly authority. Interpreting the passage in Revelation, Christian commentators understood this as a reference to the Law and the Gospel, the Old and New Testaments, a view reinforced by the fact that the lampstand in Zechariah 4 had become two lampstands in Revelation 11. This two-fold aspect evidently expresses a bi-polarization, with its own distinct symbolism. However, the Koran speaks last and the emphasis in the Verse of Light that it is a single Blessed Olive Tree "neither of the East nor of the West" that feeds the lamp, stresses the essential underlying unity, over and above the dualistic aspect accentuated in the two Biblical accounts. As Schuon explains in his commentary on the Verse of Light, the Blessed Olive Tree is an expression of the *Religio perennis*, the one primordial truth at the heart of all sacred traditions.

The Symbolism of Oil

Schuon describes the symbolic characteristic of oil whereby it combines the two alchemical elements of Fire and Water:

> In adopting the alchemist's distinction between a "dry path" and a "moist path," the first corresponding to "knowledge" and the second to "love," it is important to realize that the two poles "fire" and "water"—to which these paths correspond—are both reflected in each path, so that "knowledge" necessarily contains an aspect of "moisture" and "love" an aspect of "dryness." . . .
>
> The combination of the two principles "fire" and "water" is

none other than "wine," which is both "liquid fire" and "igneous water"; liberating intoxication comes precisely from this alchemical and as it were miraculous combination of opposite elements. Wine, not fire, is thus the most perfect image of liberating *gnosis* considered not only in its total amplitude but also in the equilibrium of its virtual modes, for the equilibrium between discernment and contemplation can be conceived at every level. Another image of this equilibrium or concordance is oil; it is moreover through oil that fire is stabilized and becomes the calm and contemplative flame of the lamps in sanctuaries. Like wine, oil is an igneous liquid, which "would almost glow forth (of itself) though no fire touched it," according to the famous Verse of Light (*āyat an-Nūr*). . . .

> [L]ike wine, oil is igneous by its very nature, but at the same time it does not correspond exactly to wine except when combined with the flame that it feeds, whereas wine has no need of any complement to manifest its nature.[106]

Schuon makes numerous references to the symbolism of oil:

> The symbolism of the lamp teaches us the relationship between Truth and Faith: the light is Truth, and the oil is Faith. The oil—see the Verse of Light—is somehow already endowed with luminosity in its substance; this is innate Truth, inborn in us and inherent in our deepest nature.
>
> What alone matters essentially is that God be present; that God be present in place of our ego, and in place of the world as experienced by

the ego; that the soul, as oil in a lamp, give itself to this luminous Presence of God and not to the world. The soul's vocation is to be the vehicle of God.

The invoking soul is the nourishing oil, the Name invoked is the enlightening flame. Herein lies the function of the soul within the world: to give itself to the Light in order that the Light radiate. May this be our principal concern; the rest is in the Hands of God.[107]

It is noteworthy how this image expresses the fact that the soul is "already endowed with luminosity in its substance," as its innate vocation is to be "the vehicle of God" in order that the Light may radiate within the world, however in offering itself up to the divine Flame, the oil becomes burnt up and the individual soul is thus effaced.

Tree

The Blessed Olive Tree in the *āyat al-nūr* is described as being neither of the East nor of the West. This denotes its central position in the cosmic order and symbolically it is thus identical with the world axis. This axial symbolism is also the key characteristic of the tree in the Garden of Eden, whose fruit was forbidden to Adam and Eve. Martin Lings refers to the tree in the Verse of Light, saying: "Inasmuch as it is *neither of the East nor of the West*, the sacred olive is the tree of *wheresoever ye turn* . . . , that is, the tree of Gnosis."[108] Frithjof Schuon writes on the symbolism of the tree:

> Esoterically, the tree-symbol is the universal centre that offers the fruits of diverse possibilities; by its trunk, which is vertical, it suggests ascension and thereby also descent; by its branches, it acts as a ladder. In addition, the tree provides shelter against the

63. Tree of Life mosaic in the courtyard arcade of the Great Mosque, Damascus, Syria, 706-715.

heat of the sun: it gives shade, and in this aspect it suggests a place of refuge, safety, rest, freshness; shade is one of the gifts that the blessed enjoy in the Moslem Paradise. But the most important aspects of the symbolism of the tree are without doubt its axial position and its fruits.[109]

64. Mosaic depicting Adam and Eve, the serpent, and the Tree of the Knowledge of Good and Evil,
Monreale Cathedral, Palermo, Sicily.

This is clearly expressed in the Koran, where the symbol of the tree is employed:

> Seest thou not how God citeth a symbol: A good word is as a good tree, its root firm, its branches in heaven. Giving its fruit at every season by the leave of its Lord. God citeth symbols for men that they may remember. (*Sūrat Ibrāhīm* [14]:24-25).

To quote René Guénon again:

> We have already spoken of the World Tree on a number of occasions and of its axial symbolism. . . . In the *sūrat al-nūr*, a "blessed tree" is mentioned, that is, a tree charged with spiritual influences, that is "neither of the East nor of the West," which clearly defines its position as central or axial; and this is an olive tree of which the oil feeds the light of a lamp; this light symbolizes the light of *Allāh*, which is really *Allāh* himself, for, as it is said at the beginning of the same verse, "*Allāh* is the Light of the heavens and of the earth." It is obvious that if the tree is here an olive, it is because of the illuminating power of the oil which is drawn from it, and therefore because of the luminous and igneous nature inherent in it. Thus the reference is indeed here yet again to the "Tree of Light." On the other hand, in at least one of the Hindu texts that describe the inverted tree, that tree is expressly identified with *Brahma*; if it is identified with *Agni* elsewhere, there is no contradiction, for in the Vedic tradition *Agni* is one of the names and aspects of *Brahma*. In the Qur'anic text, it is *Allāh* under the aspect of Light who illumines all the worlds; it would indeed be difficult to push the parallelism further, and we have in this one of the most striking examples of the unanimous agreement of all the traditions.[110]

Guénon adds in a note that:

> According to what follows in the text [of the *sūrat an-nūr*] , this Light is "light upon light," therefore a double light, superposed, which evokes the superposition of the two trees of which we spoke above. Again one finds there "one essence," that of a single Light, and "two natures," that above and that below; or the manifested and the unmanifested, to which correspond respectively the light hidden in the nature of the tree and the visible light in the flame of the lamp, the first being the essential "support" for the second.[111]

Kurt Almquist writes that "every human being may be seen as a tree, a 'little world-tree.'"[112] Frithjof Schuon likewise writes of its microcosmic symbolism:

> A tree has a root and a crown, and similarly, the human Microcosm comprises a cardiac root and a mental crown, symbolized respectively by the "Heart" (seat of the pure Subject) and the "Forehead" (mirror of the pure Object).[113]

65. Calligraphic inscription from the *Āyat al-Nūr*, by Yusuf Sezer, Turkey, 1992.

Chapter 3
Commentaries on the Verse of Light

To reiterate in brief the observations made in the opening chapters, the Koran itself tells us that apart from verses with clear dogmatic meanings (*āyāt muḥkamāt*), it contains also verses which have allegorical meanings (*āyāt mutashābihāt*). Particularly in the allegorical verses one finds language used in which the imagery is initially seen to relate to the outer or macrocosmic plane (the world), however, the interpretation of the verses reveals meanings relating to the inner or microcosmic plane (the human soul). Such interpretations give verses of this kind a particular significance in the context of Islamic spirituality and mysticism. The correspondences that exist between the macrocosmic and microcosmic planes are not arbitrary, but are the very basis upon which symbolism is founded. The Koran frequently employs allegories, in order to speak to man through the language of symbolism. The Verse of Light is one of the foremost examples of such a use of symbolism.

Such allegories are able to express in figurative terms supra-rational meanings, which is their merit but also an inherent danger, since they must be grasped intuitively and not everyone is endowed with the necessary faculties of discernment. The Koran contains general injunctions to meditate on its meanings. However, in referring to its allegorical verses, warns of discord (*fitna*) that can result from ill-founded interpretations:

> [Here is] a Book which We have sent down unto thee, full of blessing, so that men may ponder over its messages, and that those who are endowed with insight may take them to heart. (*Sūrat Ṣād* [38]:29)

He it is Who has sent down to thee the Book: In it are verses basic or fundamental (of established meaning); they are the foundation of the Book: others are allegorical. But those in whose hearts is perversity follow the part thereof that is allegorical, seeking discord, and searching for its hidden meanings, but no one knows its hidden meanings except God. And those who are firmly grounded in knowledge say: "We believe in the Book; the whole of it is from our Lord": and none will grasp the Message except men of understanding. (*Sūrat Āl ʿImrān* [3]:7).

66. *Sūrat Āl ʿImrān* [3]:7, from a 14th-century Koran, Egypt.

67. *Sūrat Ṣād* [38]:29, from volume 7 of an 8-volume 14th century Maghrebi Koran.

Therefore to understand allegorical verses and the subtle levels of meaning they encompass involves well-founded interpretation. The process of Koranic exegesis, known in Arabic as *tafsīr*, has been undertaken by Koranic commentators since early Islamic times and many interpretations of the Verse of Light have been given from the first centuries of Islam up until the present day.[1] In the following chapter we will touch on a few of the interpretations given. Concerning the diversity among the interpretations, it must be understood that it is in the nature of symbols that they may have a multiplicity of meanings, simultaneous and in no way mutually exclusive. René Guénon refers to "the harmonious multiplicity of meanings which are included in all symbolism."[2] It is therefore not surprising that the Verse of Light expresses truths that can be understood in different ways.

Interpretations of the inner meanings of the Verse of Light existed from the earliest era; one of the earliest commentaries is that of al-Ṭabarī and in it one finds varying interpretations, contrasting the outer, literal meanings and the inner, symbolic meanings inherent in the verse. For example, the *mishkāh* or niche is understood literally to mean a windowless recess in the wall of a house, but is interpreted symbolically to mean the breast of the believer holding the lamp of faith.[3]

Controversies occasionally arose, based on disagreement about whether or not certain interpretations were permissible, depending on differences of perspective, and the commentator's attitude with regard to the inner mystical dimension. Interestingly, one of the main controversies centered not on whether a particular interpretation was too "far-fetched"; rather, it was a question whether the key phrase *God is the light of the heavens and the earth* could be accepted in its literal sense. Most classical non-Sufi commentators insisted that it had to be interpreted, since to them God is incomparable and could therefore not be equated with Light, which is created. Al-

Zamakhsharī and other Muʾtazila commentators like al-Rāzī instead preferred to describe God as the illuminator (*munawwir*) of the heavens and the earth. However, the two-fold signification expressed in the verse—that *God is Light* and also *God is the possessor of light*—was not found to be contradictory by all commentators.

In contrast to commentaries that tended to focus primarily on the exoteric meanings of the Koran, Sufi commentaries were concerned more with the esoteric or microcosmic level of meaning, understanding the language as symbolic and metaphorical, particularly in relation to man's inner dimension and the transformation of the soul on the path of spiritual realization. Various sayings from ʿAli and Jaʿfar al-Ṣādiq emphasize the different levels of meaning in the Koran, and a hadith of the Prophet, transmitted by Ibn Masʿūd, supports the idea that there are in the Koran exoteric (*ẓāhir*) and inner, esoteric (*baṭin*) levels of meaning open to interpretation.[4]

Commentaries on the Verse of Light by Sufi authorities, with diverse interpretations, include those of Abū Saʿīd al-Kharrāz, Sahl al-Tustarī, Ibn ʿAṭāʾ and Manṣūr al-Ḥallāj, all of them contemporaries of Junayd and his circle in Baghdad, as well as later authorities, such as Abu ʿAlī al-Jūzajānī, Qushayrī and Daylamī.[5]

In the following pages we summarize various interpretations of the Verse of Light, from the early centuries of Islam up until the present day, including those of recent traditionalist writers, all of which provide valuable insights.

Al-Ghazālī

Probably the most famous commentary on the Koranic Verse of Light is the *Mishkāt al-Anwār* of Abū Ḥāmid Muḥammad al-Ghazālī (c. 1058-1111).[6] In this work he discusses the significance of Light, comparing what he describes as various grades of Light. He sees a hierarchical relationship between different manifestations of Light, initially contrasting physical Light with the Eye, which is that which makes things

visible, and finds that the latter is more worthy of the term Light. However, by listing seven defects related to the physical eye, he sees that it is the Intelligence that is more properly called Light, because it transcends these defects. He then considers the role of divine revelation, and the Koran in particular, in enabling the intelligence to see actually rather than just potentially and therefore above all it is the Koran that is most properly called Light. Next he observes that everything that sees self and not-self deserves more properly the name of Light. Ultimately he concludes that these degrees of light rise to a "final Fountain-head who is Light in and by Himself"; that Allah is the source of all forms of light, the highest and the ultimate Light, and that "Allah alone is the Real, the True Light, and beside Him there is no light at all." He goes on to explain how Allah is in Himself the Light of heavens and earth, since, just as everything is manifest to man's sight by means of phenomenal, visible light, so everything is manifest to man's Insight by means of Allah.

Al-Ghazālī expounds the science of symbolism, demonstrating the relationship between the world of our senses and the Supernal Realm and that "there is not a single thing in this world of sense that is not a symbol of something in yonder one." He then proceeds to give an explanation of the symbolism of the Niche, the Lamp, the Glass, the Tree, and the Oil, demonstrating their relationship respectively to the five faculties of the human soul—firstly the sensory spirit, secondly the imaginative spirit, thirdly the intelligential spirit, fourthly the discursive spirit, and fifthly the transcendental prophetic spirit—and how these "lights of the human spirit are graded rank on rank," the existence of this graded succession of Lights explaining the words: "Light upon Light."[7]

68. *Āyat al-Nūr* and subsequent verses,
from a Koranic manuscript, made in Bust in the year 1111.

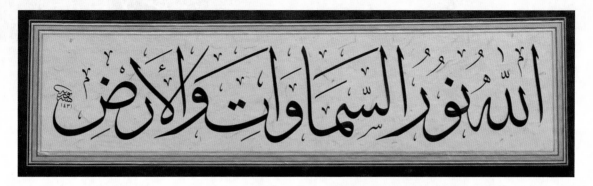

69. Calligraphic inscription of the first line of the *Āyat al-Nūr* by Nuria Garcia Masip.

Mullā Ṣadrā

Mullā Ṣadrā (Ṣadr al-Dīn Muḥammad Shīrāzī), c. 1571–1641 was the principal figure in the revival of philosophy in Iran in the sixteenth and seventeenth centuries. He was the author of over forty works, including four works of commentary on the Koran; his commentary on the Verse of Light was completed in 1030H/1620. Following on from the earlier Peripatetic philosophy of Ibn Sina and the Illuminationist (*ishrāqī*) philosophy, originated by Shihāb al-Dīn Suhrawardī in the twelfth century, Mullā Ṣadrā's interpretation of the meaning of "light" goes deeper than that of al-Ghazali by equating Light with Existence; he interprets God's Light as *nūr muḥammad*, which is identical with the First Intellect, and the divine Name "Allah."[8] Peerwani summarizes Mullā Ṣadrā's interpretation of the Verse of Light as follows:

> The lamp is the similitude of the light of guidance of God in the heart of the believer, which is placed in the glass of his psychic spirit, which is placed in the niche of his heart. The lamp is kindled from the oil of the [spiritual] states and stations, which are as if kindled from the inner being (*bāṭin wujūd*) of the spiritual wayfarer although the fire of (divine) epiphany has not touched it. It is awakened (*inbi'āth*) from the blessed tree of the righteous acts; this latter light, which is the result of the righteous acts and the inheritance of pure transactions (*al-mu'āmilāt*), is twice as powerful as the first light, which is the light of [divine] guidance occurring at the beginning inviting [him] to servitude and obedience [to God's guidance]. When the light at the end joins the light at the beginning, it becomes "light upon light."[9]

Dārā Shikūh

Ananda Coomaraswamy writes in the chapter: "Philosophy of Persian Art":[10]

> [T]here are few, if any, productions of Persian art more beautiful than the mosque lamps; and here we can be sure that every Muslim must have known the interpretation given in the Koran [in the Verse of Light]. Some would have been familiar, also, with the further exegesis according to which, as Dārā Shikūh says, the niche represents the world, the light is the Light of the Essence, the glass through which it shines is the human soul, the tree is the Self of Truth, and the oil is the timeless Spirit.

In his *Majma'-ul-Baḥrain* (*Mingling of the Two Oceans*), Dārā Shikūh (1615-1659), dedicates the ninth of a total of twenty-two discourses to Light (*Nūr*), quoted in part below:

[W]hat this *faqīr* has understood, [from the Verse of Light], is that *Mishkāt* (or, niche) applies to the world of bodily existence, *Miṣbāḥ* (or, the lamp) to the Light of the Essence and *Shīsha* (or, glass) to the (human) soul which is like a shining star and that, on account of this lamp (*miṣbāḥ*); the *Shīsha* (or, glass) also appears like a lamp (or *Miṣbāḥ*). And: "*That lamp is lit,*" applies to the Light of the Essence; while the "*Sacred tree*" (*Shajar-i-Mubārak*) refers to the Self of the Truth,[11] Holy and Exalted is He, who is free from the limitations of the East and the West. By *Zait* (olive-oil) is meant "the Great [Spirit]" (*Rūḥi-A'ẓam*), which is neither of Eternity past nor of Eternity to come, in that the *Zait* is luminous and resplendent by itself, for the reason that it possesses great elegance and purity, and does not require to be lighted. . . . This light of *Zait* (olive-oil) is "light upon light" (*nūr-un-'alā nūr*), which signifies that, on account of its extreme purity and brightness, it is light full of light; and no one can behold Him with this light, unless He guides (and directs) him with the Light of His unity. So the main purport of a combination of all these verses is that God, the Most High and Holy, is manifest, with the Light of His Essence, in elegant and refulgent curtains and there is no veil or darkness concealing Him. Now, the Light of (His) Essence is manifest in the curtain of [Spirit of Spirits] (*Abul-Arwāḥ*), the [Spirit of Spirits] in the curtain of [Spirit] (*Rūḥ*) and the [Spirit] in the curtain of Body—(exactly) in the manner in which the "lamp" is luminous and manifesting itself within the cover of "glass"; the glass being placed in a niche (*ṭāqcha*), deriving its illumination from the Light of His Essence and thus adding light to light (*nūr-un-'alā nūr*).[12]

70. Calligraphic inscription of *Nūr 'alā nūr*, "Light upon light," by Nuria Garcia Masip, 2008, based on *jali thuluth* composition by Ismail Hakki Altunbezer (1871-1946).

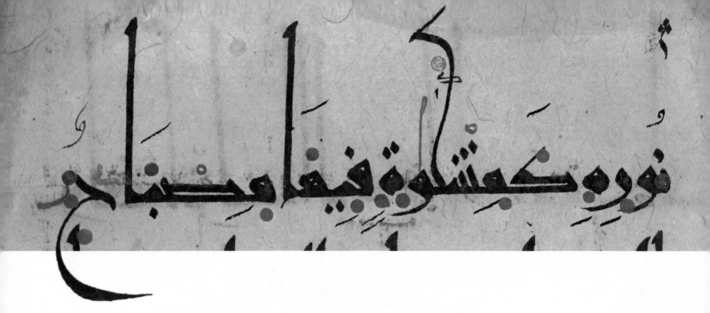

Shaykh Maḥmūd Shabistarī

The *Gulshan-i Rāz* or Rose Garden of Secrets, written in 717H/1317 by Shaykh Maḥmūd Shabistarī (1288-1340) and considered to be one of the greatest works of classical Persian Islamic mystical poetry, begins with the verse:

In the name of Him who taught the soul to think,
And kindled the heart's lamp with the light of soul;
By Whose light the two worlds were illumined. . . .

One of the subsequent passages, written in rhyming couplets, in response to the philosophical question: "What am I?" employs the metaphor of the *mishkāh*:

Again you question me, saying, "What am I?"
Give me news of myself as to what "I" means.
When Absolute Being has to be indicated
Men use the word "I" to express it.
When "The Truth" is set in evidence in a phenomenon
You express it by the word "I,"
"I" and "you" are the accidents of Very Being.
The lattices of the niches of the lamp of Necessary Being.
Know bodies and spirits are all the One Light,
Now shining from mirrors, now from torches.[13]

71A & B. Beginning of *Āyat al-Nūr* from an 11th or 12th-century Koran, from Iraq or Persia, written in the Qarmatian style of eastern Kufic script.

In related notes Whinfield, the translator of this work, elaborates on the concept expressed in the latter part of the passage, explaining: "The one Light shines with many rays through the lattices of various personalities." What is described here is the principle of individuation, whereby the Spirit, or One Light, is refracted on the plane of manifestation into a multiplicity of individual spirits or lights. However, his translation of *mushabak-hā-ye mishkāt* as "the lattices of the niches of the lamp" does not correctly seem to express the image intended. Particularly in the Persian context it is clearer if *mishkāt* is understood to mean the perforated body of the lamp—like the brass lamps which are still now popular in Iran, and which are commonly referred to as *mishkāt*—and the term "lattices" (Persian: *mushabak-hā*) is translated as "perforations." When interpreted in this way, the image portrayed is that of light emanating from the flame of the Spirit at the center of the lamp and shining out from it through a multiplicity of minute perforations, which seen from the outside resemble points of light, like stars in the night sky.[14] It should be noted that this process of individuation is not a question of a fragmentation of the one light at the source; instead, in the same way that the pin-hole camera functions, each differentiated ray projects an image of the totality of the Spirit, of "Necessary Being."

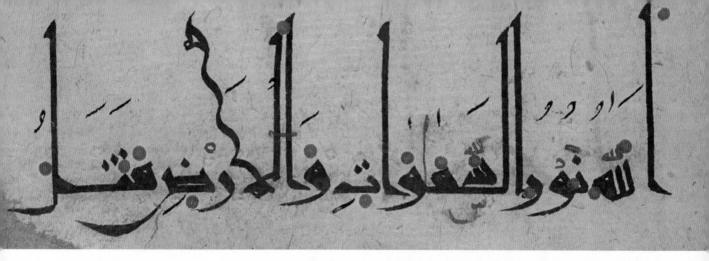

Ṣafī ʿAlī Shāh Niʿmatullāhī

Ṣafī ʿAlī Shāh, who was born at Isfahan in 1251H/1835-6, lived in India, and ended his days in Tehran in 1316H/1898-9 surrounded by many disciples, left a monumental mystical *tafsīr* of the Koran in verse. In his commentary on the *āyat al-nūr*, Ṣafī ʿAlī Shāh equates the Lamp with the Spirit, the Glass with the Heart, the Tree with the Soul, and the *mishkāh* with the Body. He then goes on to compare the holes in the *mishkāh* through which light passes with the five physical senses. It is evident from this that he too uses the word *mishkāh* to mean a perforated lamp body, rather than a niche in a wall. As mentioned above, in the context of Shabistarī's commentary, it is significant in this respect that "*mishkāt*" is indeed the word used in Persia to denote the perforated brass or copper lamps, which are made there. In his *Tafsīr*, Ṣafī ʿAlī Shāh equates Light with the divine Essence (*dhāt*), through which all possibility comes into being. All creatures are manifest because of light and nothing is apparent without it. Nothing can be seen without a *miṣbāḥ* or *fānūs*. However, God is present in both darkness and light.

71C. The words *nūr ʿalā nūr*, from the same manuscript.

Abū Bakr Sirāj al-Dīn (1909-2005)

The Book of Certainty by Abū Bakr Sirāj al-Dīn concludes with the following commentary on the Verse of Light, interpreting it as a metaphor for the spiritual path:

> *God is the Light of the Heavens and the earth. The symbol of His light is as a tabernacle wherein is a lamp. The lamp is in glass. The glass is as it were a gleaming planet. The lamp is kindled from a blessed tree, an olive that is neither of the East nor of the West, whose oil well nigh blazeth in splendour even though the fire hath not yet touched it. Light upon light!*

The tabernacle is the earth, that is, this world or, in respect of the microcosm, the soul, which in itself is dark. The first part of the spiritual journey may be likened to the placing of the lamp, as yet without oil, within the tabernacle. The glass of the lamp, gleaming like a planet with reflected light, is the Heart, and thus the soul is lit with the Eye of Certainty. The second part of the journey may be likened to the filling of the lamp with the oil of benediction, and the blessed olive tree from which the oil is taken is the Spirit itself. It is neither of the East nor of the West in virtue of its centrality and exaltation, for this olive tree is an aspect of that which the lote-tree of the uttermost boundary is also an aspect; but in the fruit of both, as in the fruit of the date palm, "the kernel of the individuality remaineth." There is now *light upon light*, the light of the oil upon the light of the glass, the light of the Sun of the Spirit upon the light of the Moon of the Heart, and such is the condition of the righteous; but the lamp has yet to be lit.

> *God leadeth to His light whom He will, and God citeth symbols for men, and God of all things hath Knowledge.* (Qoran, XXIV, 35)[15]

72. *Āyat al-Nūr*, from a 10th-12th-century Koran manuscript.

Frithjof Schuon (1907–1998)

Frithjof Schuon gives the following commentary on the Verse of Light:[16]

God is the Light . . .
God is pure Intelligence, pure Truth; He is infinite Consciousness, the Self.

of the heavens and the earth.
He manifests His Quality of Intelligence and of Truth in the celestial world and in the terrestrial world. . . .

The similitude of His Light . . .
The microcosmic reflection of His Light or of His Radiation . . .

is a niche . . .
is the Breast (place of *inshirāḥ*) insofar as it is receptacle of the invoked Name; hence during the *dhikr* and in a state of illumination.

wherein is a lamp.
There is in it a luminary, or more precisely a wick, which is not other than the divine Name; the *alif* of the latter is like the image of this luminary, the fire being the divine Presence, or the divine Spirit.

The lamp is in a glass.
The Name is situated in the Heart (place of *iṭmi'nān*).

The glass is as it were a shining star.
The Heart thus illumined is as a shining planet.

(This lamp is) kindled from a blessed tree, an olive . . .
The olive tree, which symbolizes the Universal Intellect (*Rūḥ*), is the prototype both of the oil and of the wick, that is to say of the soul in the state of spiritual virginity, and of the

Name; herein are the two aspects of *Salām* and *Ṣalāt*, or of the Virgin (*Maryam*) and the Spirit (*Rūḥu'Llāh*, *'Isā*). The blessed tree—the Spirit—is "vertical," symbolically speaking, whereas the oil—the Virgin—is "horizontal." The tree is at once "Intellect" and "Soul."

neither of the East nor of the West . . .
The olive tree—the blessed tree—is central and primordial (*Religio perennis*) (*Spiritus autem ubi vult spirat*).

whose oil would almost glow forth (of itself) though no fire touched it.
The Intellect, from which the Name is nourished so to speak, is kindled in principle without any external luminous power having to touch it, so pure is it by its substance (= Virgin); in fact, it is kindled—or illuminated—by Revelation, of which the Name is the support and the form (= the Spirit).

Light upon light, . . .
God in Himself and in His reverberations. But what is in question is also the complementary opposition "oil-luminary" or *Salām-Ṣalāh*, or "Virgin-Spirit."

God guideth unto His light whom He will.
Man does not attain to Knowledge without divine Grace (*tawfīq*).

And God speaketh to mankind in allegories, . . .
Revelation furnishes the symbols of the Truths (*ḥaqā'iq*).

for God is the Knower of all things.
God, being the Light, encompasses all science.

73. Calligraphic inscription of the *Āyat al-Nūr*, by Muhammad Badawi Derani, Damascus, 1360H/1941.

Schuon elsewhere elaborates on the meaning of the first line of the Verse of Light. He describes how the Divine is intrinsically equated with Light of a transcendent nature, but how His light also radiates on the earthly plane:

> Each verse of the Koran, even if it is not metaphysical or mystical in itself, includes a meaning in addition to its immediate sense that pertains to one or the other of these two domains. . . . The following verses—and many others as well—have an esoteric signifi-cance that is at least certain and there-fore legitimate even if it is not always direct; or more precisely, each verse has several meanings of this kind, if only because of the difference between the perspectives of love and *gnosis* or between doctrine and method. "God is the Light of the heavens and of the earth" . . . , that is, the Intellect at once "celestial" and "terrestrial," which is to say principial or manifested, macro-cosmic or microcosmic, the transcen-dent or immanent Self[17]

In other writings he makes reference to the Verse of Light:

> The Blessed Tree of the Verse of Light is the *Sophia Perennis*, and that is why this Tree is "neither of the East nor of the West" and that "its oil shineth though fire hath not touched it." The Niche of Lights is either the Tradition or the Heart.

> To be man is to invoke God. One has to remember here the Verse of Light: to offer the soul to the divine Name as the oil offers itself to the flame of the lamp. The lamp is the Heart-sanctuary, the flame is the Invocation, the light is the Name.[18]

Other Interpretations

One further means of interpreting the Verse of Light is based on its quasi-geometrical symbolism. A striking aspect of the allegorical description of the Lamp is the way in which the main constituent elements are arranged in concentric order. First there is the Niche; within the Niche is the Glass; within the Glass is the Oil; and in it the Wick. From the standpoint of traditional doctrines of metaphysics and cosmology, this concentric arrangement can easily be understood as a representation of the multiple levels of Being. This is related to the doctrine of the Five Divine Presences, explained by Frithjof Schuon, as follows:[19]

> From the point of view of the world, the Divine Principle is hidden behind a number of envelopes, the first of which is matter. . . . The various degrees of reality contained within the Divine Principle . . . are in ascending order the following: first, the gross or material state, which can be designated also as corporeal or sensorial; secondly, the subtle or animic state; thirdly, formless or supra-formal manifestation, namely, the celestial or angelic world; fourthly, Being, which is the "qualified," "self-determined," and ontological Principle and which for this reason we may call, paradoxically but adequately, the "relative" or "extrinsic Absolute"; and fifthly, Non-Being or Beyond-Being, which is the "non-qualified" or "non-determined" Principle, and which thus represents the "intrinsic" or "Pure Absolute." . . .

> In Sufism, these universal degrees are called the "Five Divine Presences" (*khams al-ḥadharāt al-ilāhiyah*). In Sufi terminology they are: the "human realm" (*nāsūt*), that is, the domain of the corporeal, since man is created out of "earth"; then the "realm of royalty" (*malakūt*), so called because it immediately dominates the corporeal world; next comes the "realm of power" (*jabarūt*), which, macrocosmically, is Heaven and, microcosmically, the created or human intellect, that "supernaturally natural" Paradise which we carry within us. The fourth degree is the "Realm of the Divine" (*Lāhūt*), which is Being and which coincides with the uncreated Intellect, the *Logos*; the final degree—if provisional use can be made of such a term—is none other than "Quiddity" or "Aseity" or "Ipseity" (*Hāhūt*, from *Hua*, "He"), in other words, the Infinite Self. . . .

> To understand correctly the Arabic terminology mentioned above (*nāsūt, malakūt, jabarūt, Lāhūt, Hāhūt*), it must be appreciated that the Universe is considered as a hierarchy of divine "dominions," which is to say that God is "most present" in the supreme degree and "least present"—or the "most absent"—on the corporeal plane. . . .

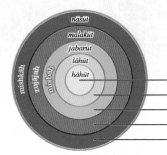

MICROCOSMIC (HUMAN) "WAY OF SEEING"

1. BEYOND-BEING (THE "NON-QUALIFIED" PRINCIPLE / THE "INTRINSIC" ABSOLUTE)
2. BEING (THE "QUALIFIED" ONTOLOGICAL PRINCIPLE / THE "EXTRINSIC ABSOLUTE")
3. FORMLESS OR SUPRA-FORMAL MANIFESTATION (CELESTIAL OR ANGELIC WORLD)
4. THE SUBTLE OR ANIMIC STATE
5. THE GROSS OR MATERIAL STATE (CORPOREAL OR SENSORIAL)

MACROCOSMIC (DIVINE) "WAY OF SEEING"

1. THE GROSS OR MATERIAL STATE (CORPOREAL OR SENSORIAL)
2. THE SUBTLE OR ANIMIC STATE
3. FORMLESS OR SUPRA-FORMAL MANIFESTATION (CELESTIAL OR ANGELIC WORLD)
4. BEING (THE "QUALIFIED" ONTOLOGICAL PRINCIPLE / THE "EXTRINSIC ABSOLUTE")
5. BEYOND-BEING (THE "NON-QUALIFIED" PRINCIPLE / THE "INTRINSIC" ABSOLUTE)

74. Two concentric diagrams representing the Five Divine Presences.

The theory of the Five Presences could be represented by two diagrams each containing five concentric regions, one showing the Principle in the center and the other situating It on the periphery: these would correspond respectively to the microcosmic and macrocosmic or to the human and divine "ways of seeing."[20]

The following related observations were made by Mahmud Bina-Motlagh[21] in conversations with the author about the Verse of Light, which he links to the doctrine of the Divine Presences:

In the Koran a likeness is given: the likeness of His light is like a "*mishkāh*." The word *mishkāh* has two different meanings: one is the metallic body of a lamp perforated with holes and the other is translated as "prayer niche." The former translation of *mishkāh* is preferable, because in a lamp the *miṣbāḥ* and *mishkāh* are two parts of a single entity, whereas the prayer niche is part of a building and separate from the lamp. The word *miṣbāḥ* is derived from *ṣubḥ*: meaning that which gives light. It is a *nomen instrumenti*—that with which one can light or illuminate. *Al-miṣbāḥ fī zujājah* [the lamp is in a glass]. There are therefore three different constituent elements: the outer body, or *mishkāh*, within it is the *zujājah,* which actually means glass, and then within it is the *miṣbāḥ*, the part that gives the light. The normal (mystical) interpretation is that this signifies the three degrees of Being: gross manifestation, subtle manifestation, and supra-formal manifestation, which correspond within the human to the body, the soul, and the spirit. The spirit gives the light, the soul transmits it, and the body, through its "apertures," propagates the light. The body [*mishkāh*] is gross, in contrast to the soul [*zujājah*], which is "transparent" and subtle; and then there is the part which gives light [*miṣbāḥ*].

There is a saying of Sayyidunā Ja'far al-Ṣādiq: "God has created this world as a likeness of *malakūt* and has created *malakūt* upon the likeness of *jabarūt*."[22] He can guide us through the *mulk* to *malakūt* and through *malakūt* to *jabarūt* and through *jabarūt* to Himself. The metaphysical foundation of symbolism is that God has said: "I was a hidden treasure and wanted to be known so I created the world in order to be known," therefore every single thing in the world is an aspect of God. This is the basis for symbolism: just as the *jabarūt* is the manifestation of God in the supra-formal world, so the *malakūt* is a projection of *jabarūt* in the animic world, and *mulk* or *nāsūt* is the projection of *malakūt*.

Discussing other aspects of the Verse of Light, Mahmud Bina-Motlagh explains:

"This oil is so pure . . ." is normally interpreted as the *nafs al-muṭma'innah*. The *nafs* has three aspects, just like the three *gunas* [of Hinduism]: *tamas, rajas, satva*. The *satvic* aspect is the *nafs al-muṭma'innah*, then the *nafs al-lawwāmah*, then the *nafs al-*ammārah. The *nafs al-ammārah* is the lowest part and should be controlled.[23] The *nafs al-muṭma'innah* is almost of the nature of the Spirit. In the Koran it says: *yā ayatuha-n nafs al-muṭma'innah irji'i ilā rabbiki rāḍiyyatan marḍiyyah*.[24] When the soul is in this pure state, it has the invitation to return to God and it is the nature of the *nafs al-muṭma'innah* that it is almost luminous of itself without being already touched by the fire of the Spirit—*wa lau lam tamsashu nār*. So it is "light upon light"—*nūr 'ala nūr*—the natural light (the naturally supernatural light) possessed by the *nafs al-muṭma'innah* and the light of the Spirit. When Schuon refers to the passage "the lamp is fed by an olive tree, by the oil of an olive tree which is pure," he says that the function of the soul is to feed the flame of invocation. Because the oil feeds the flame, the soul—our life— should be there to feed the flame of invocation. When we invoke and the Name is pronounced, God's presence is there and the light of the presence of God is there. A life is well spent when it feeds the flame of the invocation.

75. Detail of calligraphy at apex of dome, Hagia Sophia, Istanbul.

Chapter 4

The Verse of Light in Islamic Art and Architecture

The importance of the Verse of Light in Islamic culture led to its use in Islamic art and architecture. Frithjof Schuon writes:

> [T]he verses of the Koran . . . are not merely sentences which transmit thoughts, but are in a way beings, powers, or talismans. The soul of the Muslim is as it were woven of sacred formulas; in these he works, in these he rests, in these he lives, and in these he dies.[1]

Burckhardt likewise writes of the Koran:

> The language of the Koran is omnipresent in the World of Islam; the entire life of a Muslim is filled with Koranic formulae, prayers, litanies, and invocations in Arabic, the elements of which are drawn from the Sacred Book; innumerable inscriptions bear witness to this. It could be said that this ubiquity of the Koran works like a spiritual vibration—there is no better term to describe an influence which is both spiritual and sonorous—and this vibration necessarily determines the modes and measures of Muslim art; the plastic art of Islam is therefore, in a certain way, the reflection of the word of the Koran.[2]

Jean-Louis Michon writes:

> The "Verse of Light" is one whose symbolic imagery has never ceased to feed the imagination of Muslim artists. This verse alone, over and above any reference to historic "loans," explains why the niche, in the form of the *miḥrāb*, has been adopted to indicate the direction of Mecca and mark the locus of the mosque. A lamp is often hung in front of the *miḥrāb*, reinforcing the importance of this architectural element as a support for concentration, in accordance with the literal meaning of the Verse of Light. As concerns the text of this verse, it is at times inscribed on mosque lamps, the finest of which were produced during the Mamluk period in Syrian and Egyptian workshops. The motif of the *miḥrāb*, whether or not accompanied by that of the lamp, has reached beyond the domain of architecture to imprint itself on many artifacts of metal, wood, or ceramics and, particularly, on carpets and wall hangings.[3]

Apart from its frequent use on mosque lamps, the *āyat al-nūr* is used decoratively in Islamic architecture. The first part of the verse is inscribed as a monumental radial calligraphic composition at the apex of the great dome of the Hagia Sophia mosque, dominating the whole space.[4] Another particularly appropriate usage of the *āyat al-nūr*, also in Istanbul, is found in the stained-glass windows above the mihrab of the Süleymaniye Mosque, attributed to the master craftsman Sarhoş İbrahim, which gives direct expression to the image of the divine light entering the mosque.[5] One of the earliest examples of a monumental inscription of the *āyat al-nūr* is on the minaret of the congregational mosque at Damghan, Iran (450-500H/1058-1106).[6]

76A & B. Stained glass window with Verse of Light in qibla wall of
Süleymaniye Mosque, Istanbul.

The symbolism of the "lamp within a niche" led to the use of the verse on mihrabs, such as the carved gypsum mihrab in Masjid Ḥaydariyah in Qazwin, dating from the Seljuk period (twelfth century).[7] A much later mihrab from Isfahan, dating from the early seventeenth century during the Safavid period, is surrounded on three sides by an epigraphic inscription of the *āyat al-nūr* and the following verse from the Chapter of Light (*Sūrat al-Nūr* [24]:35-36).[8]

Besides its use on mihrabs, another notable example is in the mosque of al-Aqmar in Cairo (519H/1125), a major architectural monument of the Fatimid period, where the Verse of Light is inscribed in the epigraphic decorations that outline some of the keel-shaped arches around the inner courtyard, or *ṣaḥn*. The verses from *sūrat al-nūr* that follow on after the Verse of Light (*Sūrat al-Nūr* [24]:36-38) are inscribed in a frieze running across the external façade of al-Aqmar Mosque. The same verses also appear on the ornate stucco mihrab in the Mosque of al-Guyūshī, otherwise known as the Mashhad of Badr al-Jamālī, another Fatimid monument in Cairo.[9] A further example is the monumental inscription in the main entrance vault of the Sultan Hasan Madrasa in Cairo. However, in all the latter examples it is incorrect to refer to these as inscriptions of the *āyat al-nūr*.[10]

Apart from the epigraphic inscriptions mentioned above, one also finds in the mosque of al-Aqmar a visual representation of the Lamp in the Niche. On the upper left corner of the external façade of the mosque there is a rectangular panel containing an arched form, from the apex of which is suspended a lamp motif. Such representations of the Lamp in the Niche as a decorative motif are very frequently encountered in Islamic architecture, and their use is described in a subsequent chapter.

Opposite: 77. Mihrab, height 2.90 m x width 2.45 m, with
epigraphic inscription of *Sūrat al-Nūr* [24]:35-36,
Isfahan, Iran, Safavid period, early 17th century.

78. Epigraphic inscription of *Āyat al-Nūr* on the minaret of the congregational mosque at Damghan, Iran.

79. Detail of epigraphic inscription of *Āyat al-Nūr* surrounding mihrab, Masjid Haydariyah, Qazwin, Iran.

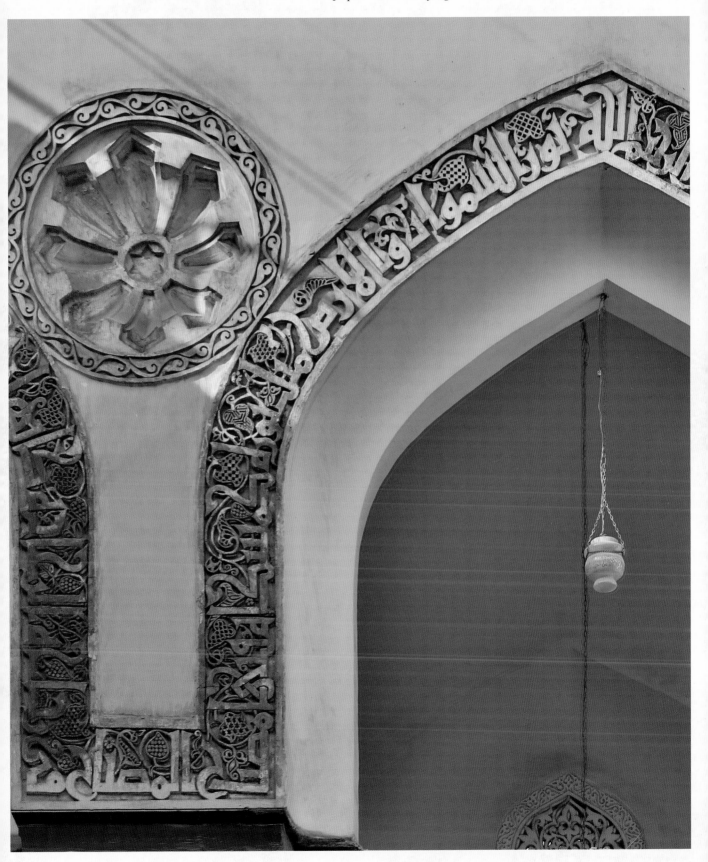

80. Epigraphic inscription from *Āyat al-Nūr*, on *ṣaḥn* (courtyard) arches of Al-Aqmar Mosque, Cairo.

II.
History of the Lamp

Chapter 5
The Historical Context

The lamp described in the Verse of Light is an oil lamp. Oil lamps date back to approximately 4500 BCE with examples existing from the Chalcolithic, Bronze, and Iron Ages and thereafter from Persian, Greek, and Roman antiquity. The earliest were simple, open, saucer-like bowls, sometimes with a pinched spout or spouts to hold the wick. Later examples, such as the classical "slipper" lamp, were usually enclosed, with holes for the wick and for filling the oil. Subsequently these were superseded by other types, such as the vase lamp; the classical Mosque Lamp generally falls into this category of hanging lamp.

The *āyat al-nūr* describes in words a lamp suspended in a niche. These words conjure up a certain image in our mind, which we probably derive from associations with images familiar to us in our present-day context. However, it is interesting to consider how lamps in the time of the Prophet would have looked and therefore what image the description in the *āyat al-nūr* would have evoked in that context. The lamp described must correspond in some way to a contemporary historical reality, as parables are to a certain extent invariably founded on fact.

Documentary evidence is scarce, but an attempt may be made to determine what forms existed at the time. The French archaeologist Clermont-Ganneau suggests that the Verse of Light describes an actual type of lamp that the Prophet had seen with his own eyes or otherwise had described to him by someone who had. He argues that the type of lamp described—with a container of glass, containing oil and a floating wick—cannot have been in Mecca or Medina, as it is documented that palm fronds were burnt as torches to illuminate the mosque at night and such lamps as existed were simple clay lamps,

burning sesame oil not olive oil. (The word *sirāj* is derived, he says, from the word for sesame oil). Referring to the emphasis in the Koranic description on the glass and the brilliance of the light, he maintains that it is a more sophisticated type of lamp that is described and concludes: "The apparatus would be classified then in the category of these lamps made entirely of glass, in the shape of vases, employed in the Byzantine sanctuaries."[1] He goes on to say he is inclined to believe that it was in some church or Byzantine basilica in the region of Syria that the Prophet or one of his companions may have seen such lamps and he refers to contemporary accounts of lamps in Christian sanctuaries of this time, which deployed an incredible variety of lighting fixtures, from simple lamps and candles, to floor lamps, and even actual chandeliers. He mentions that the use of glass also played a large part in the manufacture of these rich lighting devices.[2] He cites examples in Jerusalem and in the monastery of Saint Catherine in Sinai, as described in the accounts of pilgrims, attributed to the fourth century, but which he considers to be representative of religious life and practices in Jerusalem at least up to the capture of the Holy City by the Persians in the year 616:

> What is particularly interesting for us is the mention of many glass lamps, large in size, which were suspended everywhere "*candelae vitreae ingentes ubique pendent.*" There is no possible doubt about what is meant here by *candela.* . . . [I]t is not a candle—which in this case would have been in a lantern with glass sides—but a lamp, a real oil lamp.[3]

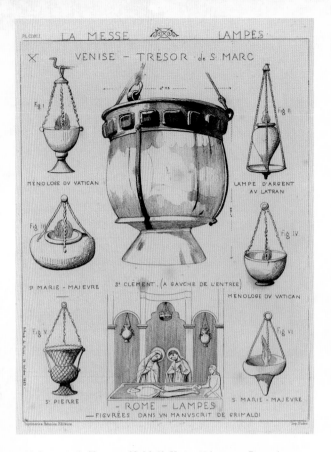

81. Lamps in the Treasury of St Mark's, Venice, 10th century; Roman lamps.

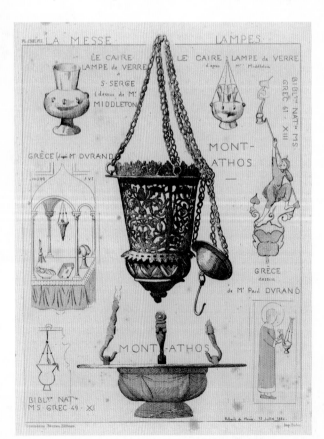

82. Lamps in St Clement's, Rome, 11th century; Gabathae, 12th century.

83. Lamps from Mount Athos; Glass lamp, Cairo.

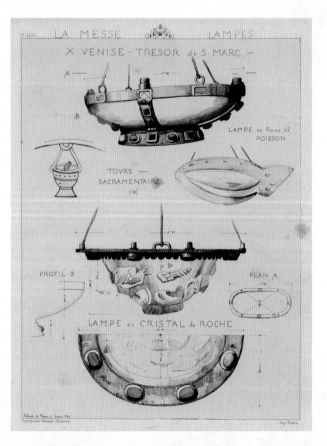

84. Rock crystal lamps from the Treasury of St Mark's, Venice.

Clermont-Ganneau goes on to establish the philological connection between the Latin word *candela* and the Arabic word *qandīl*, also used to designate a glass oil lamp. Rohault de Fleury mentions that according to Eusebius, the church of Jerusalem already had religious illuminations in the year 230.[4] Rohault de Fleury's illustrated work *La Messe* includes illustrations of light fixtures depicted in ancient manuscripts and of surviving examples. Lamps are often mentioned in the works of Saint Paulinus of Nola, a Latin poet who lived c. 354–431 and who became Bishop of Nola.[5] In one *ekphrasis* he describes in great detail the operation of an oil lamp.[6]

It is significant in this context to consider the historical relationship between the advent of Islam and the founding of the great Byzantine basilica of Hagia Sophia in Constantinople. The first church of Hagia Sophia was completed in the year 360; it burned down in 381 and was rebuilt and consecrated in 415, but again it burnt to the ground in 532. Thereafter the emperor Justinian conceived the grand project of rebuilding the Great Church from its foundations. Construction work lasted five years and in 537 the great basilica was consecrated. In the year 558 an earthquake destroyed a great portion of the newly erected church. However, following reconstruction, a second consecration of Hagia Sophia took place on the twenty-fourth of December, 562—eight years before the birth of the Prophet Muhammad.[7] The following year, in 563, a descriptive poem, or *ekphrasis*, was written by Paul the Silentiary[8] vividly portraying the elaborate lighting system in the newly consecrated

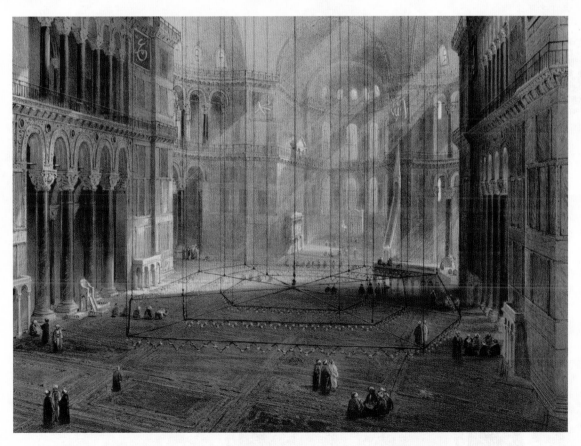

85. Detail from chromolithograph, showing lighting fixtures in Hagia Sophia, predating the mid-19th century restorations.

Hagia Sophia, including huge circular rings suspended from the great dome, supporting hundreds of glass oil lamps.[9] Although none of this complex system of lights and lamps has survived, Maria Fobelli examines this subject in detail and suggests that a clearer picture may be gained by making comparisons with Byzantine lighting devices from archaeological finds, such as treasures found in Syria and Turkey.[10] Fobelli draws attention to details mentioned in the Silentiary's account, such as the big chandelier, consisting of concentric rings suspended from the dome by bronze chains just above the worshippers' heads, and *polycandela* in different shapes—circular, cruciform, and polygonal—some of which were still in use up until 1847, as demonstrated by Gaspare Fossati's chromo-lithography from that time. Fobelli emphasizes the significance that Light had in the contemporary context, referring to Plotinus' philosophy, according to which beauty, which is equated with Light, represents the presence of the divine within creation and to Pseudo-Dionysus the Areopagite, who at the beginning of sixth century was the author of the most complete theory on beauty and the divine light, stating that the approach to God was through symbols.

References in the Early Islamic Traditions

After the migration of the Prophet to Medina, a house was built for him, which was at the same time the first mosque. It is recorded that originally palm-leaves (*sa'af al-nakhl*) were burnt to illuminate the interior of the mosque. However, a merchant named Tamīm al-Dārī brought oil lamps from his native Syria and hung them in the Medina mosque. This act was praised by the Prophet, who gave Tamīm the name *Sirāj* (meaning "lamp") and thus the use of lamps in mosques became established. The incident is described as follows (Arabic below):

Two persons, Tamīm al-Dārī and his servant Abu'l-Barrad, brought from Syria lamps with oil and chains. On Thursday night the lamps were hung in the mosque of Medina and water, oil, and wicks were put in them by Abu'l-Barrad. On Friday when the prophet entered the mosque, he was so astounded by the brilliance of the lamps that he addressed Tamīm and said: "you have illuminated Islam, as Allah enlightened your path."[11]

حمل تميم الداري من الشأم إلى المدينة قناديل وزيتا ومقطا فلما انتهى إلى المدينة وافق ذلك ليلة الجمعة فأمر غلاما يقال له أبو البراد فقام فنشط المقط وعلق القناديل وصب فيها الماء والزيت وجعل فيها الفتيل ؛ فلما غربت الشمس أمر أبا البراد فأسرجها ، وخرج رسول الله - صلى الله عليه وسلم - إلى المسجد ، فإذا هو بها تزهر فقال : من فعل هذا ؟ قالوا : تميم الداري يا رسول الله ؛ فقال : نورت الإسلام نور الله عليك في الدنيا والآخرة

Given that this event took place during the lifetime of the Prophet, it is interesting to consider how it relates to the Verse of Light. As mentioned earlier, Clermont-Ganneau argues that one has the impression that the lamp described in the Verse of Light was inspired by actual lamps that the Prophet may have seen, although others maintain that the revelation of the Verse of Light was not influenced by the use of oil-lamps that were introduced into Islamic places of worship during Muhammad's lifetime.[12] One should, however, bear in mind that there are numerous instances in which verses of the Koran were revealed in direct response to actual events during the lifetime of the Prophet. The incidents or circumstances in relation to which a revelation came to the Prophet (*asbāb al-nuzūl*) were one of the factors taken into account by traditional commentators. One is therefore left to speculate how the incident in the mosque of Medina, involving Tamīm al-Dārī, relates to the revelation of the Verse of Light. It is reported

that the Prophet said: "Whoever lights a lamp in the mosque, the angels and the bearers of the Throne will not cease to pray for forgiveness for him so long as the light of that lamp is shining in the mosque."[13]

Referring to accounts by Al-Azraqī, the *Encyclopaedia of Islam* describes the early history of the lighting of the mosque of Mecca:

> The first to illuminate the Ka'ba was 'Uqba b. al-Azraq, whose house was next to the Mosque, just on the *Maqām*; here he placed a large lamp (*miṣbāḥ*). 'Omar, however, is said previously to have placed lamps upon the wall, which was the height of a man, with which he surrounded the mosque. . . . The first to use oil and lamps (*qanādīl*) in the mosque itself was Mu'āwiya. . . . In the time of 'Abd al-Malik, Khālid b. 'Abd Allāh al-Qasri placed a lamp on a pillar of the Zemzem beside the Black Stone, and the lamp of the Azraq family disappeared. In the reign of al-Ma'mūn in 216 a new lamp-post was put up on the other side of the Ka'ba and a little later two new lanterns were put up around the Ka'ba. Hārūn al-Rashīd (268-271) placed ten large lamps around the Ka'ba and hung two lanterns on each of the walls of the mosque. . . . Khālid al-Qasri had the *mas'ā* also illuminated during the pilgrimage and in 219 the torches called *nafāṭāt* were placed here and 'Omar b. 'Abd al-'Azīz ordered the people, who lived in the streets of Mecca, to put up lamps on the 1st Muḥarram for the convenience of those visiting the Ka'ba. . . .[14]

The Abbasid Caliph al-Ma'mūn Ibn al-Rashīd (r. 813-33) is said to have ordered that all mosques be lit "partly to assist those who wanted to read and partly to prevent crime" and consequently the use of lamps, chandeliers, candelabra, and candlesticks became widespread. Guy Le Strange quotes early accounts by Ibn al-Faqīh and Ibn 'Abd Rabbih (dating from 903 and 913) describing the Haram in Jerusalem and its lighting. These mention that "the Noble Sanctuary . . . is lighted every night by one thousand six hundred lamps" and that "the total number of the lamps that light the *Sakhrah* [Dome of the Rock] is 464, which hang by hooks and chains of copper."[15]

A sixteen-sided silver chandelier with seven hundred glass lamps was donated by the caliph al-Ḥākim (r. 996-1021) to the Amr Mosque in Cairo. It was so large that the entrance gate had to be widened to allow it in. In the *Safarnama*, the account of his travels to Jerusalem in 1047, Nāsir Khusraw reports the widespread use of lamps made of brass and silver in the holy places of Hebron, Bethlehem, and Jerusalem. In the Dome of the Rock in Jerusalem, he saw "a silver lamp suspended by a silver chain from the centre of the Dome, and many other lamps of the same material, each with its weight inscribed on it."[16] It is recorded that the treasure looted by the Crusaders from the Dome of the Rock when they seized Jerusalem in 1099 included twenty-three gold lamps, forty-two silver lamps, and a silver polycandelon weighing seventy-four kilograms.[17] Ibn al-Najjar in 1197 records that the Prophet's tomb in Medina had more than forty silver lamps, two of crystal, and one of gold. Ibn Jubayr in 1185 describes a less important mosque (the mosque of Qasr Sa'd in Sicily) as having forty lamps of brass and crystal. Dimashkī, writing in about the year 1300, describes how in the mosque of Damascus "on the middle night of the month of *Sha'abān* they light in it twelve thousand lamps."[18]

The following chapter provides a description of the historical development of the many different forms of mosque lamp that evolved, grouped according to the material from which they were made.

86. Early Byzantine glass lamp with three applied glass handles,
height 13 cm x width 15.8 cm, Syria, 6th century.

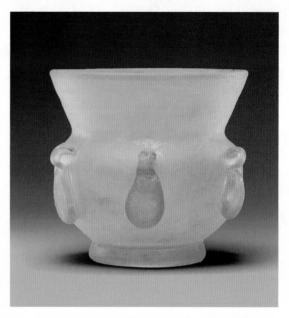

87. Glass lamp, height 10.6 cm x width 11.1 cm,
Iran, 10th-11th century.

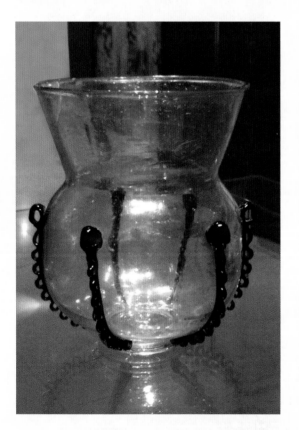

88. Vase-shaped glass lamp with cobalt trailed glass bands,
height 14.7 cm, possibly Iran, 10th-12th century.

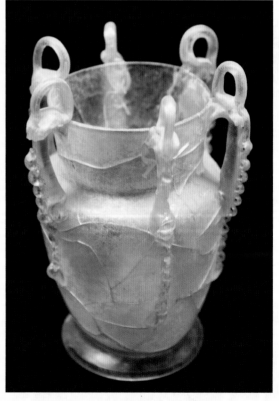

89. Glass mosque lamp, height 16.5 cm x width 12.2 cm,
Gorgan, Iran, 10th-11th century.

Chapter 6
Historical Development of the Mosque Lamp

Development of the Glass Lamp

Early Glass Lamps

The Verse of Light describes a lamp "contained within a glass." It has already been described how glass lamps were brought from Palestine by Tamīm al-Dārī during the time of the Prophet.

The use of glass has a long history:

> [G]lass was one of the earliest artificial materials made by man. . . . Glass appeared for the first time as an independent material in the late third millennium BC. . . . As glassmaking techniques gradually evolved, glassmakers succeeded in fashioning translucent glass into the form of small vessels. . . . [I]t was the revolutionary invention of glassblowing in the mid-first century BC in Syria (Phoenicia) that changed the entire course and scope of glassmaking. This technique made it possible to produce glass vessels in an almost inexhaustible repertoire of shapes at a relatively small cost. Vessels were produced by using both free-blown and mould-blown techniques. Glassblowers also had a new freedom in terms of the size of objects made compared to the artisans using core-forming or casting methods.[1]

Glassblowing had been practiced in Syria since the Roman Period, primarily in Tyre, Sidon, and Antioch. In the fifth and sixth centuries the center of the Roman Empire shifted to Constantinople and here it flourished during the Byzantine period. As already mentioned, the use of glass lamps for the illumination of churches is described by a number of contemporary authors and is occasionally shown in illuminated manuscripts. Although few glass vessels from this period have survived in their entirety, due to the fragile nature of the material, these descriptions have enabled archaeologists such as Rohault de Fleury, Dillon, and Lamm to identify fragments of different types of lamps.[2]

The glass industry continued to develop during the Islamic period when other important centers arose at Raqqa, Aleppo, and Damascus. Initially production of glass continued in the Roman style and consequently it is difficult to distinguish Roman glass from early Islamic glass, which is described as "transitional" or "Proto-Islamic" in style. Although glass production continued in the Roman tradition, the influence of Sasanian craftsmen led to the development of new techniques and a new style. Islamic glasswork began to employ luster-painting, a decorative technique first practiced in seventh- to eighth-century Egypt and in post-ninth-century Persia, using copper and silver oxide pigments to create semi-transparent, iridescent colors, ranging from lemon yellow to deep amber. This led to one of the most important developments in Islamic glasswork, namely the art of polychrome enameling and gilding on glass, which began in the Ayyubid Period and flourished in the Mamluk Period. The majority of glass mosque lamps surviving from before the Mamluk Period originate in Iran. Arman Shishegar describes the development of Islamic glass and the role of Iranian glassmakers:

> Despite the political chaos of the early Islamic centuries, glass-making continued uninterrupted. Although

Sasanian styles of glassmaking persisted, they gradually merged with the Islamic, leading to a mixed heritage of Sasanian, Byzantine, Syrian and Egyptian arts and the forms and patterns popular in the Islamic world. Ancient glassmaking centres carried on their activities and new centres were established in Basra and Kufa. In Syria and Egypt, where Islam had been embraced, glassmaking also continued, still following traditional methods. . . . In the ninth century, in addition to cut decoration, the bodies of vessels such as bowls, beakers and pitchers were decorated by pressing patterned moulds onto the glass when still soft. In addition, the application of glass discs, knobs and star-shaped strings on the vessels' bodies, and plain or crimped strings coiled around their necks, continued the decorative style of the early Islamic centuries. Flasks, vials, bottles, mosque lamp pendants and other items were made of colorless and colored glass with the applied decoration in a different color for added beauty. . . . By the end of the Seljuk period, the manufacture of enamelled and gilded glassware was also flourishing. . . . The finest enamelled and gilded glassware was the common product of migrant Iranian artisans and experienced Syrian glassmakers, centred in Aleppo. . . . After this time, Cairo became the centre of the Muslim world's artists. The most beautiful mosque lamp pendants, enamelled and gilded glassware, and lustre-painted artefacts produced in Iraq, Syria and Egypt are those of the thirteenth and fourteenth centuries. . . . The Mameluke rulers patronised the arts, and migrant Iranian and Iraqi artists were welcomed in Egypt.[3]

Mamluk Glass

Most Mamluk glass lamps were made in Mansurah, Egypt from free-blown glass, with a shape similar to a Greek *kalpe* vase. Because Egypt did not have a supply of pure crystalline glass, the lamps produced were slightly grayish, with bubbles and streaks, but with the development of the arts of gilding and enameling glass, craftsmen were able to overcome this by applying multi-colored decorative motifs to the surface. In the earlier examples this involved applying to the glass lamp body metallic pigments which were permanently fused onto the surface of the glass in a kiln. In the twelfth century, gilding techniques were developed, involving painting the glass lamp body with gold and powdered colored glass, mixed with an oil-based medium, which was driven off when fired in the kiln, leaving the gold and pigments on the surface of the glass. This enabled the craftsmen to make use of a much wider range of colors, comparable to the other decorative arts of the period.[4]

Mamluk mosque lamps are generally decorated with inscriptions from the *āyat al-nūr* on the neck and dedications to the sultan or patron on the upper portion of the body—with blue script on a gold ground for the upper band and gold script on a blue ground for the lower, or vice versa—as well as medallions bearing arabesque motifs or heraldic blazons. These lamps became extremely popular during the reign of Sultan Qalā'ūn (1279-90), and thus became known as *qanādīl qalā'ūnī*. Production of enameled and gilded glass lamps was most prolific during the reign of Sultan Hasan (1347-61) who commissioned great numbers of lamps and glass globes for his famous madrasa in Cairo. Thereafter production declined and the lamps produced in the reign of Shaban II who followed Sultan Hasan are sparsely ornamented. There was a brief revival during the reign of Sultan Barquq who commissioned nearly forty lamps for his mosque in the 1390s. However, in the fifteenth century only few lamps were made.[5]

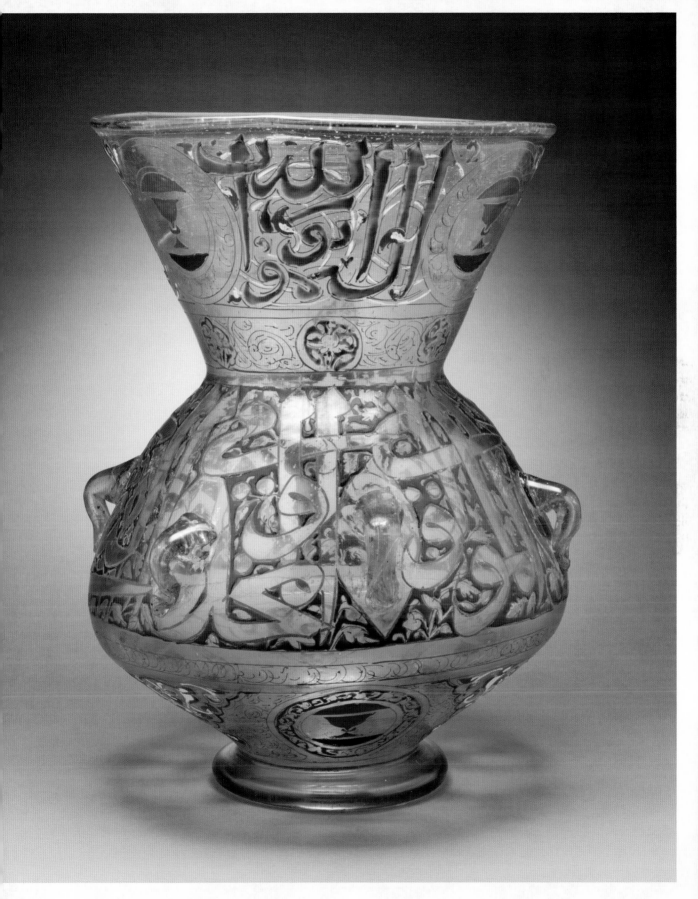

90. Gilded and enamelled glass mosque lamp, height 34.5 cm x width 29.21 cm, Egypt, mid-14th century.

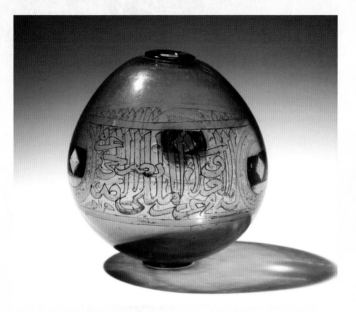

91. Glass globe, gilded and enamelled, for suspension with a mosque lamp,
Mamluk Egypt, late 14th century.

92. Design for a mosque lamp, probably by
Sokollu Mehmet Pasha, Istanbul, 1569.

The subsequent disappearance of the Mamluk art of enameled and gilded glass is usually attributed to the sack of Damascus in 1401 by Timur, who it is thought destroyed the Syrian glass industry and took glassmakers back with him to Samarkand. Shishegar cites evidence of the activity of glassmakers in Samarkand, based on contemporary travel accounts from 1403 to 1406 by Clavijo, who "saw glass globes which were used as lamps, but does not specify their decoration." However, no great glass tradition is known to have existed in Turkestan in the fifteenth century.[6]

In Egypt many of the glass lamps from the Mamluk period have survived, thanks to the fact that the Ottomans respected the Mamluk *waqf* foundations and protected the religious buildings and related objects. Most of the lamps which survived were removed in 1881 by the *Comité de Conservation des Monuments de l'Art Arabe* and deposited in the Museum of Islamic Art in Cairo.

Ottoman Glass

Lamm makes the pertinent comment that "[p]eoples that excel in the ceramic arts are, it seems, seldom as skillful in glass making, and vice versa."[7] As will be discussed in a later chapter, the Ottoman period saw a great flourish in the art of glazed pottery. This was accompanied by a corresponding shift away from the art of glass making. By the fifteenth century, production of all types of fine glass was in steep decline, a sign of which is that the Ottoman Grand Vizier Sokullu Mehmet Pasha ordered a large number of glass lamps from Venice, rather than relying on local production:

When the glassmaking factories of Cairo entered a definitive phase of decline starting from the early 15th century, Venice quickly rose to become the predominant centre, supplying the Mamluks and the Ottomans with mosque lamps on the reverse Silk Route throughout the 16th century

and later. The most conspicuous proof is provided by an order of 900 lamps including ink drawings of the two types of lamps that were demanded, requested by the Ottoman vizier Mehmet Sokullu Pasha in 1569 to the Murano factories[8]

Polycandelon type lighting fixtures, consisting of structures supporting a large number of small glass lamps, became widespread and remained popular in Ottoman architecture, which is characterized by large domed spaces. As the ceilings were very high and there were few wall surfaces or columns to reflect any light cast in an upwards direction, metal frameworks were suspended from the domed ceilings, hanging just a few meters above the floor level, to bring the gentle light from the oil lamps closer to the congregation and also to permit easy filling and cleaning. This lighting system is still in use today in most Ottoman mosques, although the small glass lamps now contain electric light bulbs instead of the original oil lamps.[9]

Rock Crystal Lamps

Historically, it is known that already before the time of the Prophet, rock crystal, a naturally occurring variety of quartz of exceptional transparency, was mined and carved in Mesopotamia and in the Byzantine Empire. Here it was crafted into objects similar in form to those that could have been used as a lamp.[10] Blown glass, the man-made material from which lamps were later made in great number, also existed before the time of the Prophet and was used in the Byzantine period for lamps. Given that the description of the lamp in the Verse of Light places emphasis on the brilliance of the glass—"*this glass is as it were a radiant star*"—it begs the question whether the blown glass of the time would have had the brilliance that we now associate with the material. In the present day, glass can be fabricated with flawless transparency. However, it is doubtful that this

was the case in the time of the Prophet. It was not until much later that techniques of glass blowing developed to such an extent that the man-made glass had a transparency comparable to that of polished rock crystal. It was already described how the glass of the Mamluk period was noted for its cloudiness and one wonders whether the image evoked by the Verse of Light does not correspond more closely to what could have been achieved at the time in rock crystal.[11] The *Encyclopædia Iranica* notes that even in the Sasanian Period "the transparency of rock crystal inspired stone carvers to make lamps or parts of lamps and objects for lighting from it."[12]

In the early Islamic era, rock crystal was much prized and it is recorded that in the first Islamic century a crystal lamp was placed above the Mihrab of Companions of the Prophet in the Great Mosque of Damascus by the Umayyad caliph al-Walīd, who reigned from 705 to 715. Flood describes this legendary crystal lamp, known by the name of *qulayla*, referring to accounts by Ibn ʿAsākir (d. 571H/1176), al-ʿUmarī (d. 749H/1348) and al-ʿIlmāwī (b. 907H/1501) in which it is described as a pearl (*durra*) that shone like a lamp (*sirāj*); to another account cited by al-Ghuzūlī (d. 815H/1412), where it is described as crystal stone (*ḥajar min billawr*), said to be a pearl which shone with its own light even when the other lamps in the mosque were extinguished; and to the account of Ibn Kathīr which describes it as a rock crystal vase or a precious stone referred to as a pearl. He contends that this description suggests a spherical lamp form, similar to what is depicted on fragmentary Koran frontispieces found in the Great Mosque of San'a', which also date from the Umayyad period, mentioning the formal connections between a spherical lamp suspended in a mihrab niche and a pearl within a shell—parallels which are particularly striking, since contemporary mihrabs often had a scalloped form.[13]

This remarkable lamp had a complex destiny: According to al-Ghuzūlī, the ʿAbbāsid

caliph al-Amīn (the son of Hārun al-Rashīd), who reigned 809-13, was a collector of rock-crystal and he had the lamp secretly transported to Baghdad. The next 'Abbāsid caliph, al-Ma'mūn (r. 813–833) subsequently returned it to the Mihrab of the Companions in Damascus. However, it again disappeared and was replaced by a glass lamp; after this broke, the mihrab seems to have remained empty.[14]

The Fāṭimid period is particularly noted for its crystal wares, some of which have survived. The majority of these are ornately carved ewers, however Avinoam Shalem draws attention to a vase now held in the Treasury of Saint Mark's Basilica, Venice, which was made from a tenth-century carved rock-crystal lamp, and he provides a sketch of a suggested reconstruction, showing how the lamp may originally have looked. The great Fāṭimid treasury in which these riches were stored was looted between the years 1067 and 1072; the *Kitāb al-Hadāyā wa'l-Tuḥaf*[15] says that when Imam al-Mustansir was forced to open his treasury in 1068, the looters of the palace brought out of the Treasury of Precious Objects thirty-six thousand pieces of rock crystal.

Rock crystal lamps were used only in major Islamic shrines. Besides the famous *qulayla* in the Umayyad Mosque of Damascus, described above, other crystal lamps are mentioned in historical accounts. For example, in Mecca in the Zamzam Dome, Ibn Jubayr notes the exclusive presence of rock-crystal lamps and Ibn al-Najjar in his history of Medina (dating from 1197) records a variety of lamps in the Prophet's tomb, including more than forty made from silver, two of crystal and one of gold.[16]

It is noteworthy that the word used in the Verse of Light for the lamp glass is *zujājah*, which appears only once in the Koran, whereas the word used in the Koran for crystal is *qawārīr*.[17] However, there are references to glass using the word *qawārīr* in various *aḥadīth*, in which the Prophet gives instructions to transport women gently, referring to them as

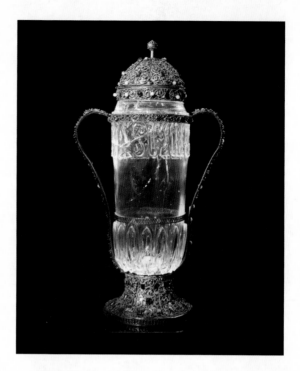

93. Fatimid carved rock crystal lamp, 10th century, Iraq (?), converted to a vase in 13th century Venice.

"glassware" in view of their delicate nature.[18] Although the word *qawārīr* may have been used interchangeably to refer to crystal and to glass, the question is whether the word *zujājah* was also used to refer also to crystal. Avinoam Shalem notes that the term *zujājah* was used by Ibn Jubayr to describe the lamps in the Zamzam Dome and other crystal lamps at Qasr Sa'd in Solanto, Sicily. The term *zujājah* that is used in the Verse of Light is usually translated as "glass," but is also sometimes translated as "crystal": "God is the light of the heavens and the earth. His light may be compared to a niche that enshrines a lamp, the lamp within a crystal of star-like brilliance."[19]

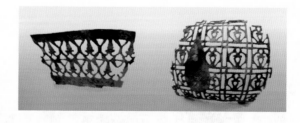

94. Ancient lamp fragments, excavated in Rayy.

Development of the Metalwork Lamp

It seems likely that limitations in the size of early glass lamps and the desire to achieve larger dimensions may have been a primary reason for the development of similarly shaped lamps, made from perforated metal. The historical accounts quoted earlier indicate that early mosque lamps were executed in a variety of materials. Although the use of crystal or glass is mentioned, it appears that the majority were made from metals: bronze, copper, brass, and sometimes precious metals—gold and silver lamps often being donated to important shrines. Sasanian and other existing metalworking traditions flourished in the early Islamic period. While early historical accounts record the materials from which the lamps were made, little is provided in the way of a description of the form and detail of these lamps, and almost none remain—particularly those made from precious metals.[20]

The few examples which have survived are spread over several historical periods and embrace a wide range of diverse forms and styles—much wider compared to what one encounters in mosque lamps in other materials, such as glass and ceramics. It is therefore interesting to trace the development of the metal mosque lamp over the centuries. Notable examples include the following: The earliest are a series of lamp fragments, at one time held by the Art Institute of Chicago, which date from the late ninth to early tenth century.[21] Another slightly later, better-preserved lamp is now kept in the David Collection in Copenhagen.[22] A later, perforated bronze lamp, dated 483H/1090, now kept in the Türk ve Islam Eserleri Müzesi, came from the Umayyad Mosque in Damascus; another, dating from the early eleventh century, came from the Great Mosque at Qayrawan;[23] a late twelfth-century lamp, now in the Louvre, came from the Dome of the Rock in Jerusalem; a bronze lamp now in the Ethnographic Museum at Ankara came from the Eşref Suleyman Camii

at Beyşehir.[24] These lamps and subsequent examples are described in detail below.

Fragments of Earliest Islamic Lamps

The oldest fragments, formerly in the Art Institute in Chicago, were made of bronze, pierced with simple geometric perforations and were from two perforated metal lamps with a shallow globlar body and a flaring neck. These had bands of bold Kufic calligraphy encircling the waist and neck, simple decorative motifs around the rims and honeycomb-like perforations in all other areas. Rice suggests a late ninth- or early tenth-century date and Persia as the likely place of origin, based on a comparison with similar pieces found at Rayy.[25] The fragments excavated at Rayy, to which he refers, include pieces from two fairly well preserved lamps and six lamp bases with a six-pointed star motif on four out of the six of them. The earliest of these specimens have perforated ornament, with motifs "obtained by means of intersecting parallel bands which form squares, in one instance, and lozenges in the other." The later examples, which Rice attributes to the late twelfth century, have what he describes as "lacelike patterns and intersecting circles which recall certain textile designs" as well as some fragments with "interlinked swastika patterns."[26]

Apart from these specimens, a large number of lighting devices was found amongst a ninth- to eleventh-century hoard of about one thousand bronze objects retrieved at Tiberias. Made in a variety of techniques of casting and hammering, with intricate punched and engraved decorations and Arabic inscriptions, most of the objects in the hoard were lighting devices, including dozens of lamp stands, candlesticks, oil lamps, and lamp-fillers, dating from the late Abbasid and Fatimid periods. These include several fragments of eleventh-century perforated copper-alloy lacework mosque lamps.[27]

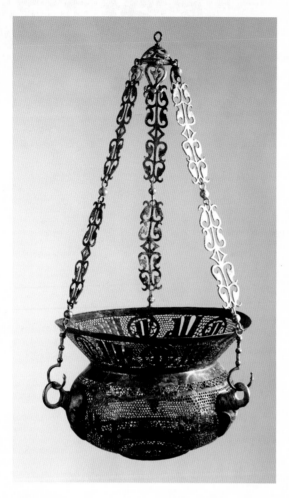

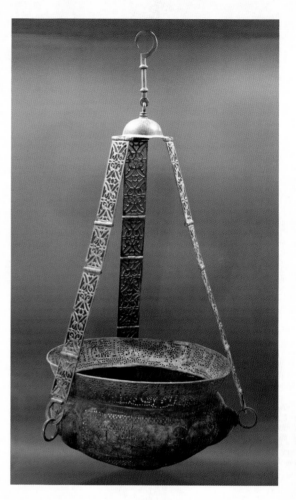

95. Mosque lamp, openwork sheet brass, Iraq or Iran, 10th century.

96. Great lamp of al-Muʿizz, Qayrawan, 1032-51.

Tenth-Century Lamp in David Collection

This early lamp, dating back to tenth-century Iraq or Iran, now kept in the David Collection in Copenhagen, is of openwork sheet brass. On both body and neck of the 40 cm diameter lamp solid areas of Koranic calligraphy in foliated Kufic style are seen in silhouette against the surrounding areas of simple honeycomb-like perforations, consisting of punched circles. Perforated friezes with a simple decorative motif encircle the upper and lower regions of the globular body. The chains, consisting of flat, linked elements with perforated *islīmī* ornament, are from the same period as the lamp, but may not always have belonged to it.

Great Lamp of al-Muʿizz

This lamp from the Great Mosque of Qayrawan in North Africa is larger than any other surviving metal lamp. Now restored, the lamp, which is kept at the Museum of Islamic Art, Raqqada, Tunisia, is 118 cm in height, together with its chains. Made of molded, perforated bronze, the lamp has a short, wide flaring neck rising from a shallow globular body with a flat elliptical profile. The diameter at the top edge of the neck is 51.6 cm and at the widest point of its globular body, 48.5 cm. The suspension details are a prominent element in the design. Three rings project from the body and the lamp is suspended from these by three belts composed of linked rectangular segments, with perforated

foliated scroll-work motifs, which connect to a small hemispherical dome surmounted by a hook. The lamp has no foot detail and the base of the lamp body is perforated with a six-pointed star motif. Like the lamp in the David Collection, the remainder of the body and neck of the lamp has solid areas of calligraphy in foliated Kufic style, which are seen in silhouette against the surrounding areas of rather crude, randomly spaced circular perforations. The inscriptions indicate that this lamp was originally commissioned by Prince al-Muʿizz ibn Badis in 424-443H/1032-51 during the Fatimid-Zirid Dynasty, for the *maqṣūra* of the Great Mosque of Qayrawān.[28]

Lamp from Umayyad Mosque, Damascus

The other eleventh-century lamp, dated 483H/1090, was brought from the Umayyad Mosque in Damascus and is now kept at the Türk ve Islam Eserleri Müzesi in Istanbul. It has the characteristic globular body and flaring neck and a short, undecorated foot. It is 33 cm in height and has a diameter at its upper edge of 29 cm. The lamp is made from sheet brass and is decorated somewhat coarsely with pierced designs and simple geometric patterns, consisting of hexagonal perforations surrounded by pentagons and six-pointed stars on the central part of the globular body, and a simple perforated border at the top. The pattern on the flaring neck consists of roundels containing

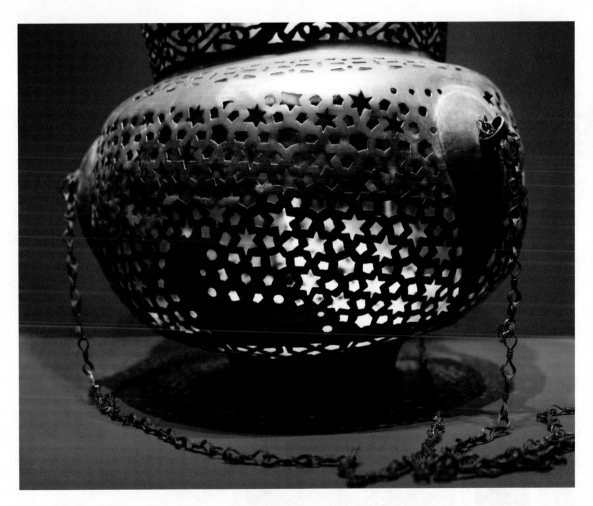

97. Brass mosque lamp from the Umayyad Mosque, Damascus, dated 1090.

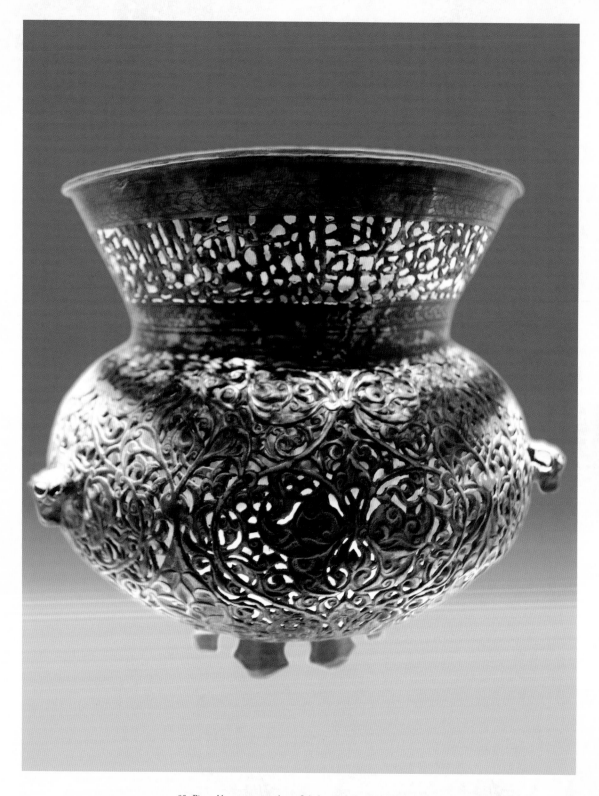

98. Pierced bronze mosque lamp, Seljuk period, dated 699H/1280.

larger six-pointed star motifs, surrounded by borders with simple undulating scroll motifs and areas of foliated "vegetal" ornament in between. Rice writes: "The workmanship of the lamp lacks distinction and in one instance the artisan was so careless as to forget to pierce part of his design. . . . [I]t seems reasonable to assume that it is of local—Damascene—manufacture though not representative of the best work done in that important centre of metal work. It nevertheless deserves attention as one of the rare early Islamic metal lamps and as a rare datable eleventh-century metal object."[29]

Lamp from Konya

Another, somewhat later Seljuk mosque lamp, made for the Eşref Süleyman Camii at Beyşehir and now in the Etnografya Müzesi at Ankara, is remarkable for its use of a sophisticated *repoussé* technique that raises the ornament in high relief. Although the lamp is just 20 cm in height, the work is very fine. Whereas the earlier examples, mentioned above, have simple, mostly geometric ornament and the calligraphy used is angular Kufic, in this lamp the inscription—from the Verse of Light—is in a cursive *naskhī* style and the ornament consists of foliated arabesques, raised in subtly curved three-dimensional relief in which the leaf forms and tendrils appear to overlap. Above and below the band of calligraphy on the neck a braided border is chased into the surface of the lamp, which was originally gilt, as indicated by traces of gilding still visible in places. Three projections in the shape of bulls' heads were used to attach suspension chains to the globular body of the lamp, which terminates at its base in an octagonal crown, with a rosette-shaped knob at its center. This is surrounded by an inscription giving name of the maker, the date, and the place of manufacture as: "Work of 'Alī ibn Muḥammad al-Niṣībīnī, in the city of Konya, in the year 679 [1280-1]."[30]

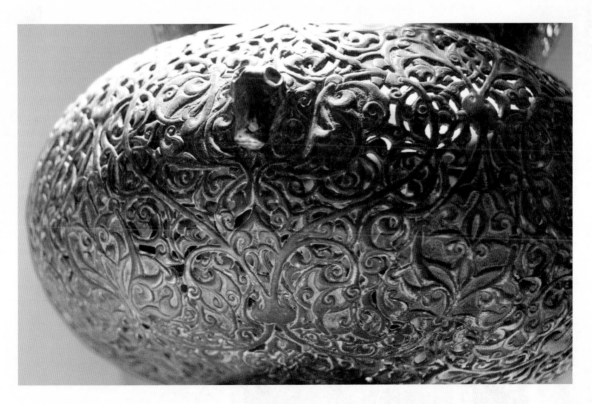

99. Detail of pierced bronze mosque lamp, showing repoussé treatment, Seljuk period, dated 699H/1280.

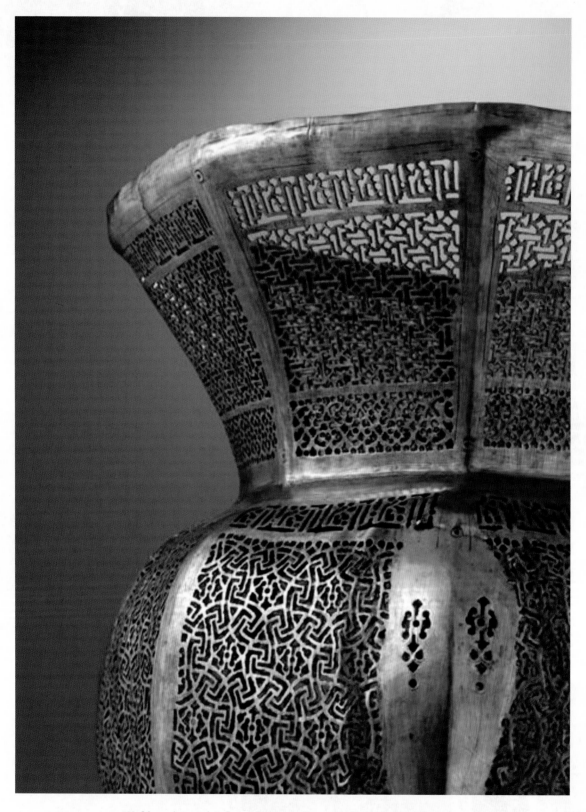

100. Mosque lamp, made in Syria or Palestine for Dome of the Rock, Jerusalem, 12th century.

Lamp from Dome of the Rock

The lamp from the Dome of the Rock in Jerusalem, dating from twelfth-century Syria or Palestine, and now kept in the Louvre,[31] differs in shape from those described up to now, since it is composed of segments, giving it an octagonal plan form. It is made from copper alloy with openwork decoration. The style of the ornament on its globular body and tall neck is geometric, but the motifs are more sophisticated and more complex than the patterns used on the earlier examples: the pattern on the central part of the globular body consists of intersecting circles set out on a hexagonal grid with a swastika motif at each intersection, while the pattern on the neck consists of swastika motifs with diagonal squares at the intersections of their extended arms.[32] Above each of these fields of perforated ornament is a perforated band of Kufic calligraphy and beneath each is an area of perforated ornament with curvilinear motifs.

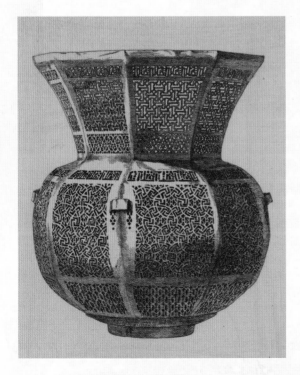

101. Mosque lamp, made in Syria or Palestine for Dome of the Rock, Jerusalem, 12th century.

Mamluk Lamps

The Mamluk era is particularly renowned for its metalwork and one encounters a number of remarkable examples of perforated lamps executed at this time when the art reached its peak.[33] During this period, between 1275 and 1350, an elegant *thuluth* calligraphic style replaced the Kufic and *naskhī* used earlier and inscriptions, offset against a background of perforated geometric and vegetal motifs, became a dominant element in designs. It is notable that on Mamluk metal lamps the Koranic Verse of Light is seldom used—unlike Mamluk glass lamps—and the inscriptions more often include the patron's name or titles, as is usual for Mamluk objects.

One particularly fine Mamluk perforated mosque lamp, commissioned by Sultan Baybars, is well documented, having survived until relatively recently. A detailed lithographic image of this lamp is to be found in the book *L'Art Arabe* by Prisse d'Avennes, published in 1877, accompanied by the comment: "This lamp in gilded bronze decorated the tomb of Sultan Baybars II, and was ordered by his eunuch to honour the memory of his master. It is indeed original and of admirable taste."[34] Rice comments that this attribution is incorrect and that it was in fact made for the mausoleum of al-Malik al-Ẓāhir, Baybars I (d. 1277), at Damascus. This gilded bronze lamp has a globular body and a flaring neck, both composed of segments and thus polygonal in plan.[35] Its height is given as 33 cm. The decoration subdivides the globular body horizontally into three zones, separated by plain bands. The central zone contains epigraphic inscriptions in a cursive style, set on a background of perforated vegetal arabesque scrollwork. The upper and lower zones are filled with a curvilinear motif, consisting of a solid ribbon tracing out an undulating form, with a cusped arch above and a semi-circular curve beneath, which merge above and below with the horizontal bands, in a manner typical of thirteenth-century metalwork. The areas enclosed by this undulating band are filled with

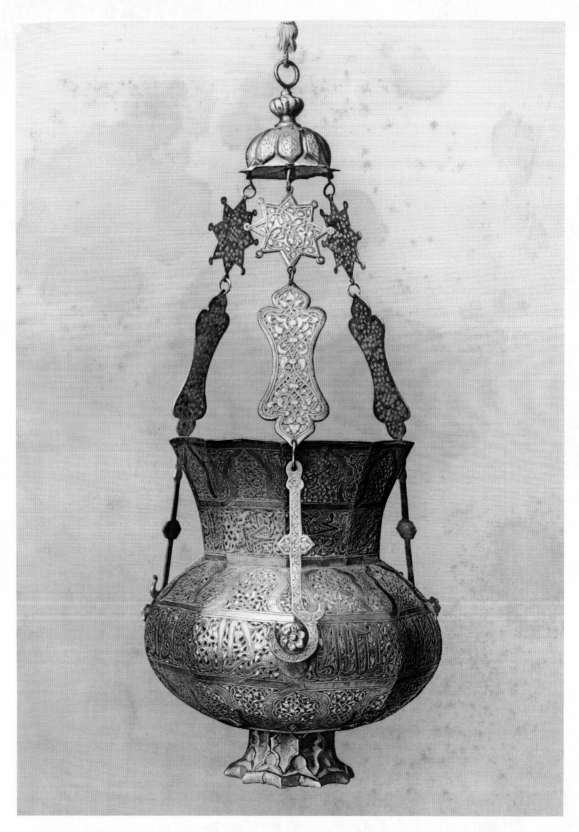

102. Mamluk mosque lamp, made for the mausoleum of Sultan al-Ẓāhir Baybars, ca. 1277.

perforated arabesque scrollwork. The neck of the lamp is subdivided in a similar way into two zones, with epigraphic inscriptions set on a background of perforated arabesque scrollwork in the lower area and the same curvilinear undulating motif above. The top of each segment terminates in a shallow curve, giving the upper edge of the neck a slightly scalloped profile. Beneath the lamp body is a three-dimensionally sculptured foot detail, with a star shaped base, above which a row of tri-lobed arches forms the basis of a kind of *muqarnas* relief on the sides of the foot.

This lamp is a particularly informative example, as it is documented in its entirety, complete with its elaborate suspension details. The top of the lamp has a dome with raised, scalloped segments, the surface of which is decorated with arabesque motifs. The dome is surmounted by a knob with helical segments, shaped like a stylized turban, and above this is a large ring from which the lamp is hung. The base of the dome has a star-shaped rim, with rings to which the suspension elements are attached.

Instead of a chain, these consist of planar elements connected by rings. The uppermost is in the form of an eight-pointed star with round tips protruding from the points and perforated arabesque infill. The intermediate element is an elongated cartouche form, tapering at the waist and terminating top and bottom in tri-lobed arches, also with perforated arabesque infill. The third and lowest element is a flat hook, with a backwards-pointing spur and with scrollwork and trefoil motifs in relief on the surface.[36] Three such hooks connect to three sculptured six-petaled flowers[37] which project from the sides of the lamp body, interrupting the epigraphic inscriptions.

The lamp sadly disappeared a little more than one hundred years ago. However it provided the inspiration for another notable lamp. In 1905, Lord Curzon, then Viceroy of India, wrote to Lord Cromer, British Proconsul in Egypt: "I want to give a beautiful hanging lamp of Saracenic design to be hung [in the Taj Mahal] above the cenotaphs of Shah Jahan and his queen in the upper mausoleum. . . . I

103. Brass lamp in the Taj Mahal, above the cenotaph of Mumtaz Mahal.

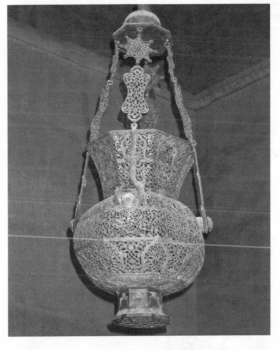

104. Brass lamp in the Taj Mahal, made in imitation of the Sultan Baybars lamp, 1906.

have been trying for years to get the people here to give me a design, but have failed. I turn therefore to Cairo, where my recollection is that some very beautiful lamps still hang in the Arab mosques. If I can get a good design I would propose to have one of these reproduced in silver at Cairo."[38] Subsequently, visiting Cairo on his way to England in November 1905, Lord Curzon commissioned a replica to be made of the Sultan Baybars lamp. The lamp itself had mysteriously disappeared. However, Herz Bey, Director of the Arab Museum at Cairo, was able to provide all of the details of its design and the work was entrusted to one of Egypt's foremost artists, Todros Badir, who fabricated it from bronze with silver and gold inlay. It was presented to the Taj Mahal, where it hangs to this day over the cenotaph of Mumtaz Mahal. The Curzon lamp differs from the Sultan Baybars model in a number of respects: it lacks the epigraphic inscriptions on the neck and the body, instead using perforated vegetal arabesques in all areas; its proportions are altogether more vertical; it has four round suspension details rather than three six-petaled rosettes; these are smaller and connect to the body higher up and in the middle of the face rather than at the corner; the dome and the foot terminate in octagonal surfaces rather than a star-shaped outline, transforming the muqarnas-style detail at the foot into a two-dimensional surface decoration. Unfortunately all attempts to trace the original Mamluk lamp have been unsuccessful.[39]

Another mosque lamp, which was made for the mausoleum of Sultan al-Ẓāhir Baybars in Damascus in 1277, is now kept at the Museum of Islamic Art, Doha, Qatar. Unlike the lamp depicted by Prisse d'Avennes, which is polygonal, this lamp is round in plan. It has a globular body and a tall flaring neck but now lacks a foot detail and also its suspension details. The globular body is not truly spherical but is a somewhat flattened ellipsoid. The ornamentation is subdivided into three horizontal regions by plain borders running horizontally around the lamp. The upper and lower regions contain arabesque roundels— perforated in the upper region and solid in the lower—with areas of perforated arabesque strapwork in between. The roundels are surrounded by circular borders which merge with the horizontal borders above and below. The horizontal borders are interrupted by large, cusped circular borders surrounding three unperforated, undecorated drop-shaped areas on the globular body where the suspension details would have been attached. The middle region of the body and also the neck of the lamp are decorated with epigraphic inscriptions in a cursive style in which the vertical letters are emphasized. The script, outlined by a fine line, is left solid and stands out in silhouette against a background of perforated vegetal arabesques. The central zone containing the epigraphic frieze on the neck of the lamp is bounded above and below by solid bands of vegetal scrollwork. This epigraphic frieze is interrupted by three large roundels, consisting of a perforated geometric motif with interweaving latticework surrounded by a solid band of intricate vegetal scrollwork. This is the only area in which a geometric style of ornament is used on this lamp.

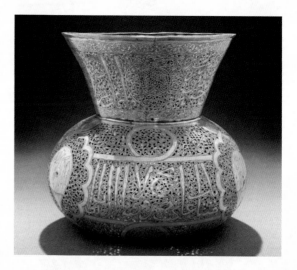

105. Mosque lamp, made for the mausoleum of Sultan al-Ẓāhir Baybars, Damascus, Syria, ca. 1277.

Post-Mamluk Islamic Metalwork

From the middle of the fourteenth century onwards there was a marked decline in the art of Islamic metalwork. There were almost no stylistic developments and few notable works were produced after this date. The decadence of inlaid metalwork at this time was discussed by Maqrizi in his *Topography of Cairo*.[40] Various reasons have been suggested for this decline including "inflation, civil wars, Timur's conquest of Damascus, the plague and the resulting scarcity of workers, as well as a shortage of metal, particularly silver and copper."[41] Nevertheless craft traditions in various parts of the Islamic world have ensured that the perforated metal *qandīl* has never disappeared. One notable example is the type still fabricated in Iran. This has the characteristic globular body and flaring neck, but instead of a foot, it terminates in an inverted ogival dome, which is separate from the main body. Chains, connected to the upper rim of the neck, pass over small pulleys fixed to a circular plate beneath the suspension ring and return through the body of the lamp to connect to the lower domed portion. This enables the two halves to be pulled apart so that the light source inside can be accessed. Made from brass or copper sheet, the lamp is usually perforated with vegetal arabesque motifs with incised relief tooled into the surface. It is not apparent how far back in history lamps of this type go and whether they were traditionally used in mosques. However, in the bazaar in Isfahan one still sees examples in production in sizes ranging from about 25 cm to 1.5 m in height; thus here and elsewhere in the Islamic world the traditional *qandīl* survives up to the present day.

106. Perforated brass lamps for sale in the bazaar in Isfahan.

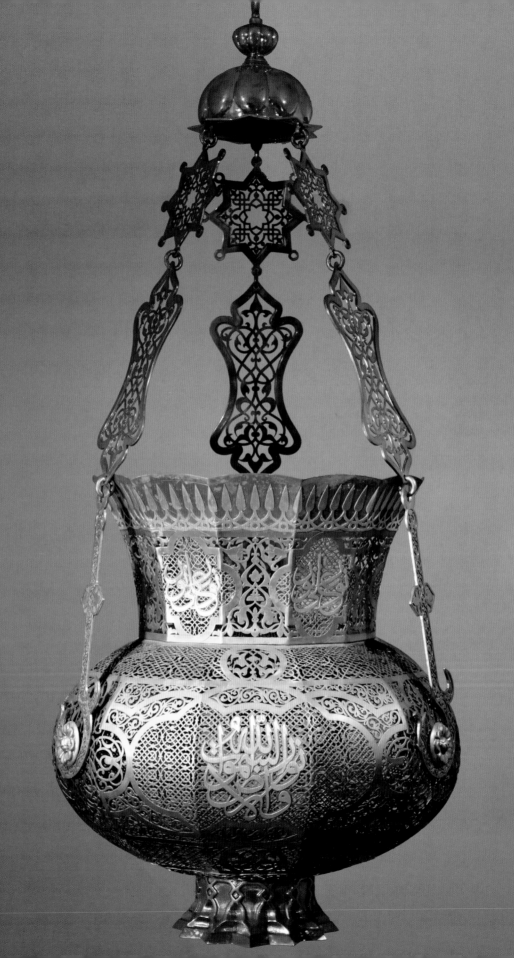

A Contemporary Design based on Traditional Examples

When the present author and his wife were faced with the task of designing of a mosque lamp for a contemporary project, it was the lamps and Islamic metalwork of the Mamluk period that provided the main source of inspiration. The perforated mosque lamp of Sultan Baybars was taken as the basis for the overall form: of the globular body, the flaring neck, the foot detail, the dome, suspension ring, the planar suspension elements and hooks, and the sculptured flowers projecting from the sides of the lamp body. This lamp, 70 cm wide and 160 cm high, was fabricated from perforated brass, using a combination of different techniques, partly by hand and partly with contemporary manufacturing methods. Although the Mamluk examples were mostly inlaid with silver, in this case pewter was used to inlay areas of calligraphy and ornament, including arabesque friezes with stylized lancet leaves running around the upper edge of the neck and surrounding the foot detail. For the epigraphic inscriptions, the first line of the Verse of Light (*God is the light of the heavens and the earth*) was used on the globular body, and on the flaring neck, the key phrase appearing later in the verse: *Light upon light*. Thus even in the contemporary context inspiration can be drawn from these fine examples from the past.

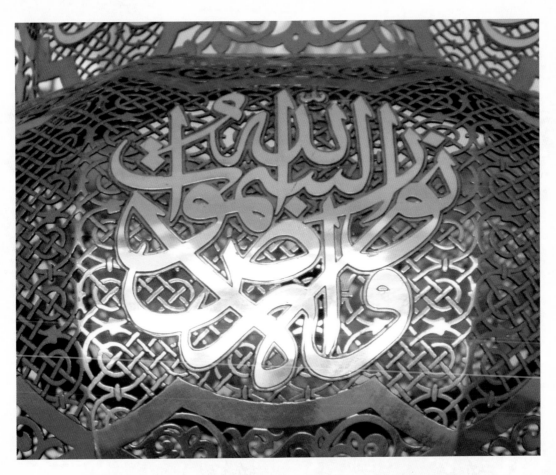

108. Calligraphic inscriptions from *Āyat al-Nūr* on perforated brass mosque lamp, designed 2003.

Opposite: 107. Perforated brass mosque lamp, designed 2003.

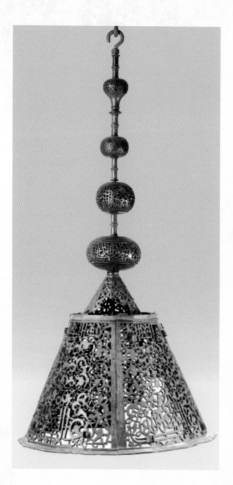

109. Lamp from Mosque of the Alhambra, Granada, Spain,
Nasrid period, 1305.

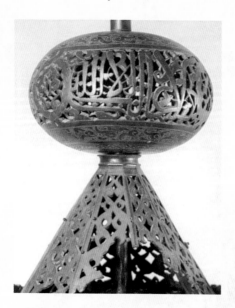

110. Detail of lamp from Mosque of the Alhambra,
Granada, Spain, Nasrid period, 1305.

Larger, More Complex Types of Chandelier

The desire to create lamps of a larger size, containing more than one single wick to emit more light, led to a departure from the globular mosque lamp form and to the development of more complex types of chandelier.

Lamp from Mosque of the Alhambra

A fine lamp, commissioned by Muhammad III of Granada, was made by royal workshops of the Nasrid court in Spain in 705H/1305 for the Mosque of the Alhambra. It is now kept at the National Archaeological Museum in Madrid.[42] The lamp is considerably larger than the examples described above. It is composed of six elements arranged vertically above one another on a central shaft; below a support hook at the top are arranged four ellipsoidal elements of progressively increasing size; the main body, below these, consists of a truncated cone, 54 cm high and 79 cm wide, surmounted by an eight-sided pyramidal cover, bringing the lamp to a total height of 230 cm.[43] All parts are perforated with foliated vegetal arabesque motifs. The main body and ellipsoidal elements have several *naskhī*-style inscriptions, including the Nasrid dynasty's motto: *Wa lā ghāliba illā-llāh* ("There is no Conqueror but God") and the name of the Emir. The lip of the lower rim has the inscription: "May the Almighty favour those beneath, whom my light illuminates with its splendor."

Diverse Lamp Types

The suspended polycandelon of Byzantine origin, consisting of a metal frame, disk or tray holding small glass containers, remained popular for centuries in Egypt, North Africa, and Spain, where it was finally transformed into larger and more complex types of chandelier. Of the types derived from the polycandelon, the simplest is the *thurayyā* (pl. *thurwān*), which has a perforated dome-shaped

111. Polycandelon, Byzantine, 6th-8th century.

cover, suspended a small distance above the perforated round tray that holds the lamp glasses. A particularly fine example of this type is the lantern of Sultan Ahmad, dated 1342, which is kept in the Museum of Islamic Art, Cairo (museum no. 1482). Another variant is the pyramidal type, in which the polycandelon tray with the lamp glasses is surmounted by a tall tapering perforated polygonal body, often with a hinged door on one side, and a domed top. In both cases the glass receptacles containing the oil and the wicks are fitted into openings in the tray and thus hang below the lamp, as in the classic polycandelon type, but usually with short perforated sleeves projecting below the openings. In the case of the domed *thurayyā* there are usually six in a circular arrangement and a seventh in the center. In the case of the "pyramidal lamps" the number of glass receptacles depends on the form of the polygon.

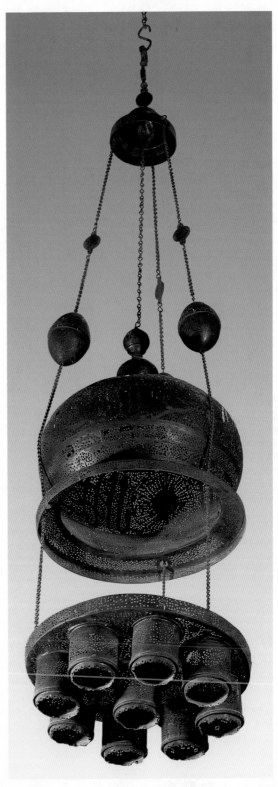

112. Perforated *thurayya* type lantern of Sultan Ahmad, 1342.

113. Brass "pyramidal" lamp inlaid with silver, Egypt, 14th century.

114. "Pyramidal lamp" from the Mosque of 'Asal Bay, Cairo, 1495.

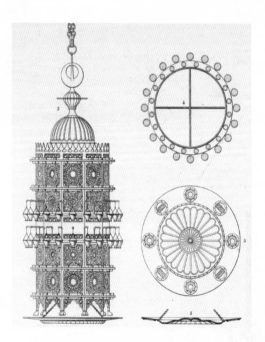

115. "Section and Details of the Lamp of the Sanctuary of the Mosque of Hassan."

There also exists the multi-tiered type known as the *tannūr* (pl. *tanānīr*) in which several polygonal trays are arranged above each other, separated by perforated panels usually with geometric and epigraphic bands, which form the sides of the body. The whole cast bronze structure is covered by a large dome with *repoussé* surface decoration, surmounted by a crescent finial; it often has crenellations at the base of the dome, and terminates in foot details, which enable the lamp to be lowered to the ground. In addition to those held in the trays, glass lamps may project from the body of the lamp on brackets. The largest Mamluk *tannūr*, that of Sultan al-Ghūrī, is 303 cm high and 96 cm in diameter; it is sixteen-sided and has six tiers.[44]

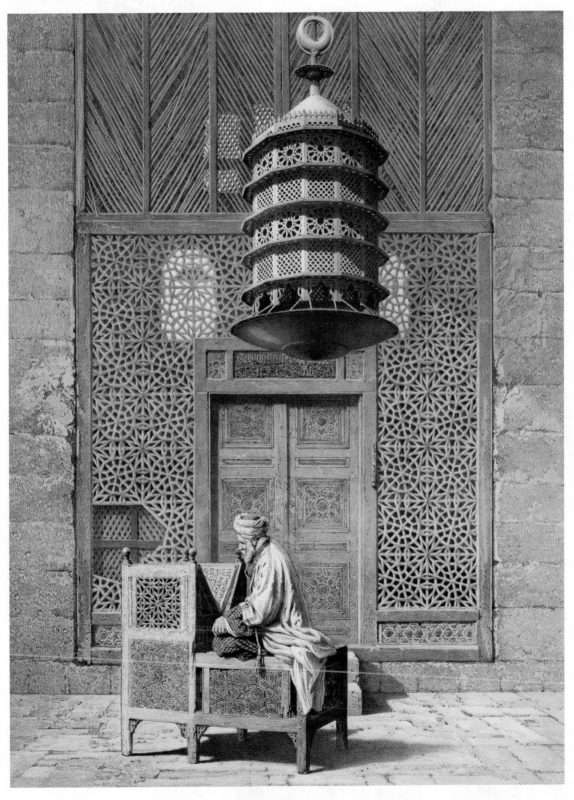
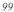

116. *Tannūr*-type bronze lantern in Mausoleum of Sultan Barquq, Cairo.

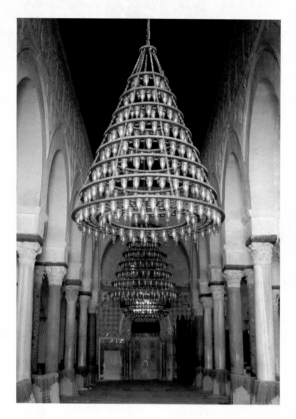

117. Large, multi-tier polycandelon-type lamps, Great Mosque of Qayrawan, Tunisia.

Regional Variations

Ibn Jubayr in 1185 describes a large polycandelon in Mecca, which he calls a *thurayyā*, with branches like a tree carrying *qandīl* and *miṣbāḥ* type lamps, as well as candles and torches.[45] In the Great Mosque of Qayrawan, Tunisia, one sees large, conical, eight-tiered polycandela, with decoratively perforated wheels of diminishing size, holding an outer and an inner ring of glass lamps.

In Morocco, the equivalent of the *tannūr* was called the *thurayyā*. These were typically large devices, the example in the Qarawiyyin Mosque in Fez, dated 600H/1204, having a diameter of 225 cm and supporting as many as five hundred and twenty *qandīl* lamps bracketed off the stepped conical exterior. It has inscriptions from the *āyat al-nūr* and from beneath a dome rises with interlacing ribs forming a star. In the Maghreb another type of lamp is found in which a church bell was used as a core to support rings or ribs with projecting brackets to carry the oil containers. There are numerous examples at the Qarawiyyin mosque at Fez, which at one time had one hundred and thirty such lamps, made from bells taken from churches during Muslim victories over the Christians in Spain.

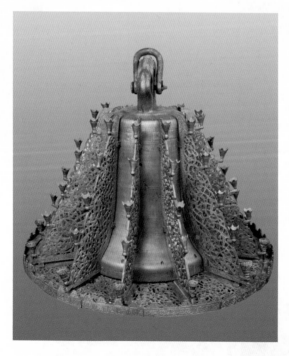

118. Side view of *tannūr*-type bell lamp, Qarawiyyin Mosque, Fez.

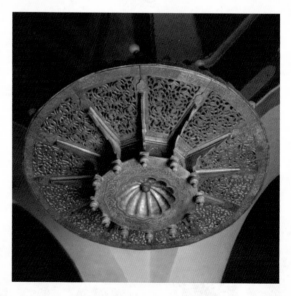

119. View from below of *tannūr*-type bell lamp, Qarawiyyin Mosque, Fez.

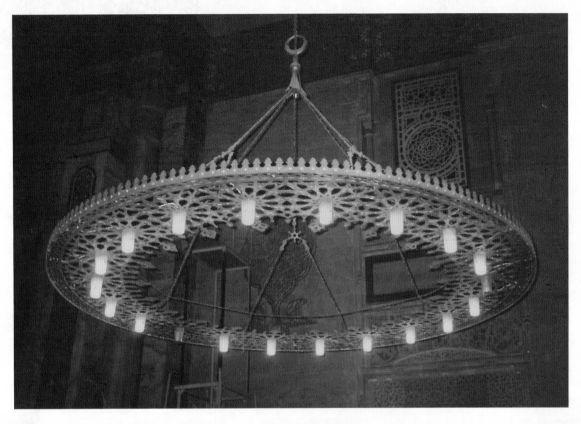

120. Large, single-tier polycandelon-type lamp, Al-Rifa'i Mosque, Cairo, early 20th century.

Later Lamp Types

After the Mamluk period, the Ottoman period heralded a radically different style of mosque architecture. Emulating the phenomenal technical achievements of Justinian's Hagia Sophia, built some nine hundred years before, mosques were built with tall, wide-spanning domes. In the Ottoman mosques even larger polycandelon-type devices were used. Giant metal frameworks, supporting a myriad of glass receptacles, were suspended from the domes, just a short distance above head height. Unlike their Byzantine predecessors, these metal structures found in the Ottoman mosques are seldom given a monumental ornamental treatment and, despite their huge size, their slender metal profiles and the many chains which support them form a filigree web which remains remarkably unobtrusive in the space beneath the domes.

There are later examples of large polycandelon-type lamps made from brass, which do receive a monumental ornamental treatment, such as those in the Mosque of al-Rifa'i in Cairo, built in a Mamluk revival style in the early twentieth century. These take the form of large wheels—approximately four meters in diameter—with geometric style open-work surfaces surrounding the glass lamp containers and a frieze of trefoil elements standing up in a rim around the outer edge. Similar designs are found in the mosques of the architect Abdel Wahed El-Wakil, built in Arabia in the late twentieth century.

This trend towards larger lighting devices led the development of the mosque lamp ever further away from the *qandīl* type form described in the Verse of Light. However, the symbolic significance of the *qandīl* form was such that it remained in use, although, as we shall see, less and less as a functional lighting device.

121. Engraved brass mosque lamp, 11th century.

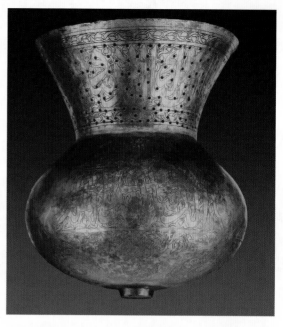

122. Gilt copper mosque lamp, with incised decoration, height 30.2 cm x width: 25.4 cm, Ottoman, early 16th century.

123. Mamluk brass lamp inlaid with silver and gold, late 14th century.

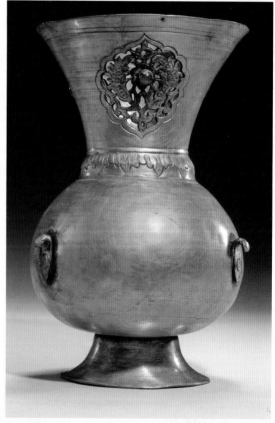

124. One of a near-pair of Ottoman tombak lamps, height 19.6 cm, Turkey, 17th century.

Opaque "Lamps"

The majority of lamps made from metals overcame the opacity of the material by perforating the lamp body, in order to allow light to pass. However, rather surprisingly, in the development of the *qandīl* type lamp there took place a notable trend towards greater thickness of the metal used and less transparency. This is described by Rice as follows:

> The earliest Islamic metal lamps were decorated with pierced overall patterns (Chicago, Qayrawan, Rayy, TIE Museum, Louvre). In the 13th century a marked reduction of the pierced surfaces took place (Konya, Baybars lamp). Finally, after the middle of the 14th century, there appeared specimens without any perforation whatever. . . . The metal lamps of the 13th and 14th centuries were fashioned out of thicker sheets of metal; the pierced areas were drastically reduced or completely eliminated.[46]

Lamps, made from unperforated metal, such as the silver and gold inlaid Mamluk example in the Museum of Islamic Art in Cairo (museum no. 15123)[47] would have been opaque and therefore could not have functioned efficiently as light fixtures. Other examples of opaque metal lamps made in the Ottoman period include a silver mosque lamp, dated 1618-22, originally from the shrine of Eyüp (now kept in the Türk ve Islam Eserleri Müzesi, Istanbul. – inv. no. 177) and a tombak gilded lamp (now kept in the Türk İnşaat ve Sanat Eserleri Müzesi Müdürlüğü, Istanbul). Light emitted from such opaque lamps could only have been cast upwards and, in cases where the space in which they hung had high ceilings, one cannot imagine that any noticeable amount of light would have been reflected downwards. It is evident that in such cases, the "lamp" could not have been intended to act as an actual lighting device;

instead its association with the Koranic Verse of Light made its function primarily symbolic. In fact representations of mosque lamps in the architectural decoration of mosques are also used in a similar way, as will be discussed in a later chapter.

Development of the Ceramic Lamp

It is maybe surprising that the glass *qandīl*, so widespread during the Mamluk era, became superseded in Ottoman Turkey by lamps made from pottery. It has already been described how the Mamluk tradition of enameled and gilded glass came to an abrupt end. In the sixteenth century the Ottomans conquered the Islamic world and during the period of their rule the vast majority of *qandīl*-type mosque lamps were made from ceramics rather than glass.

The tradition of ceramic mosque lamps goes back at least to the thirteenth century, as demonstrated by examples from Raqqa, Syria. However, in Ottoman Turkey pottery attained a technical and aesthetic excellence and

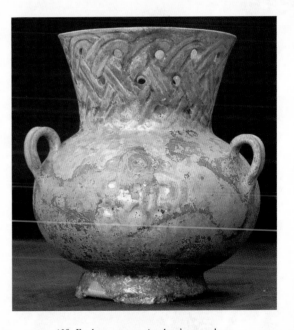

125. Earthenware turquoise glazed mosque lamp, height 17.1 cm, Raqqa, Syria, 12th century.

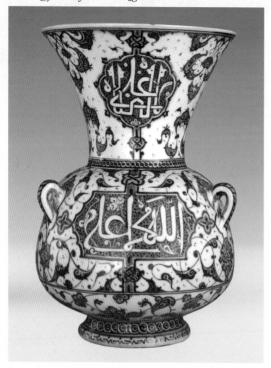

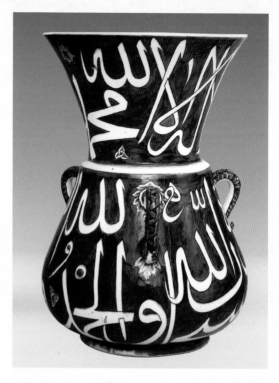

126. Iznik Mosque lamp, height 27.6 cm, ca. 1510.

127. Iznik Mosque lamp, height 43.4 cm, ca. 1570-1575.

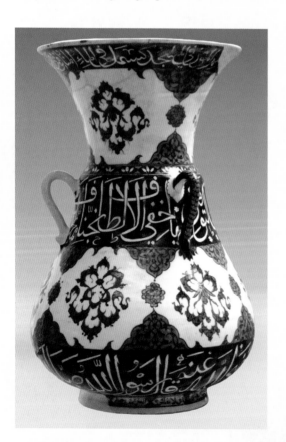

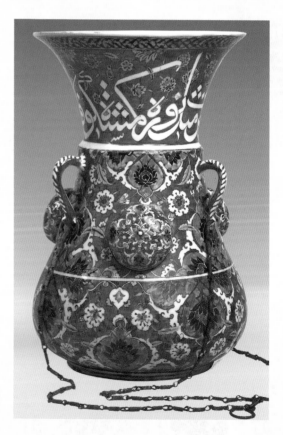

128. Iznik mosque lamp, height 38.5 cm, signed by Musli, 1549, probably made for Dome of the Rock, Jerusalem.

129. Mosque lamp from Süleymaniye Mosque, height 48 cm, Istanbul, ca. 1557.

130 A-E. Lamp from Süleymaniye Mosque, Istanbul, ca. 1557, with calligraphy from Verse of Light around neck of lamp.

outstanding mosque lamps were made in the sixteenth century in the imperial workshops in Iznik. Notable examples include the blue-and-white lamps made for the Mausoleum of Sultan Beyazid II (1510) and the famous polychrome lamp donated to the Dome of the Rock in Jerusalem by Süleyman the Magnificent in 1549. Almost none were made after the death of Sultan Murad III in 1595.[48]

Although these are almost without exception referred to as "lamps," the fact that the ceramic material is opaque means that they could not in fact have served effectively as lighting devices. Nevertheless, their presence within the mosque served as a reminder of the lamp in the Verse of Light, not just due to their form, which resembled Mamluk glass lamps, but also through the epigraphic inscriptions on them; and calligraphy was an art that flourished in the Ottoman period. One particularly fine example is the lamp made for the Süleymaniye Mosque complex in Istanbul, now kept at the Victoria and Albert Museum in London (museum number: 131-1885).

Hanging Ornaments

Since these "lamps" could not have functioned effectively as lighting devices, they are more accurately described as hanging ornaments in the form of mosque lamps. There exists a tradition of hanging ornaments in both Christian and Muslim sanctuaries and places of worship in the Middle East, where it remains common practice to hang spherical ornaments of glass, metal, or ceramic, independently or along with mosque lamps. It is recorded that decorated ostrich eggs and reflective mirrored balls hung alongside the many glass lamps suspended on multi-tiered iron rings from the dome of the Süleymaniye mosque in Istanbul and also the Selimiye mosque at Edirne.[49] Various explanations have been suggested for the functional reasons underlying this tradition of hanging spherical or ovoid ornaments above the lamps:

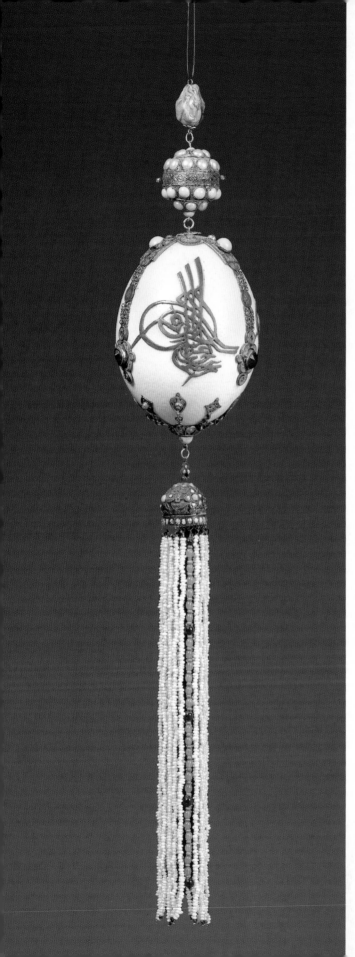

An old legend has it that the reason for threading such ornaments through the suspension chains of oil lamps was that their curved, glazed and, therefore, slippery surface would stop mice climbing down the chains to drink the oil in the lamps. . . . It has also been suggested that both the lamps and the hanging ornaments associated with them acted as ingenious acoustic devices. In mosques and tombs they were hung in groups near the place where prayers were read and would have helped dampen the echo by allowing the voice of the reader to bounce off them.[50]

It is possible that these globes may have been intended to prevent the lamp's chains from getting entangled when the lamp was lowered for filling, lighting, or cleaning. There is also a connection with the tradition of hanging ostrich eggs in shrines:

> These [hanging ornaments] are usually referred to as mosque balls, or ceramic eggs, a designation which is not inappropriate given that we often find ostrich eggs used in the same context. Ostriches were indigenous to the Arabian desert and pilgrims returning from the Hajj would often bring such eggs back from Mecca as mementos of their pilgrimage. [51]

Bock remarks: "[A]t least in the Coptic Church, the custom of hanging ostrich eggs or their imitations in religious buildings can be traced back to the thirteenth century. This was apparently also a widespread practice among Armenian, Greek-Orthodox, Latin and Nestorian Christians, from Egypt to Palestine, to Eastern Europe, and . . . probably also Western Europe. By the early thirteenth century at the latest, it was, moreover, common also in Islam."[52]

131. Ottoman ostrich egg hanging ornament with tughra of Sultan Abd al-Hamid II, Turkey, late 19th-early 20th century.

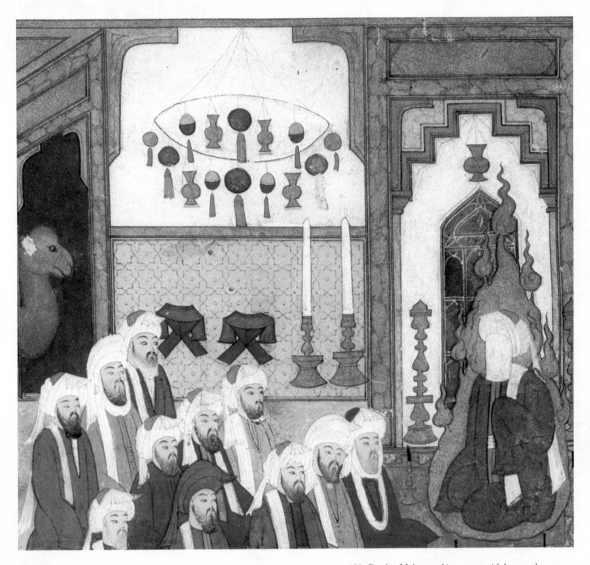

132. Prophet Muhammad in mosque with lamp and
hanging ornaments, from *Siyer-i Nebi*, ca. 1595.

Graphic representations of hanging ornaments are to be seen in illuminated manuscripts, such as the illustration of "The Prophet Muhammad and 'Ali in a mosque, decorated with mosque lamps and hanging ornaments" in *Siyer-i Nebi*, from circa 1595[53] and the illustration of "A King being chased out of the Tomb of Imam 'Ali at Najaf" in the *Falnama* from circa 1550-55.[54]

Flood notes that the Fatimid treasury contained gilded ostrich eggs and he comments on the connection between ostrich eggs and the luminous symbolism of the pearl, and its associations with the lamp in the Light Verse described as a pearly star (*kawkab durrī*).[55]

The Form of Iznik Mosque Lamps

In the ceramic lamps made in Iznik a change in shape can be seen over the course of the sixteenth century. With time the form tends towards a taller, more slender S-shaped profile and in so doing the central sphere progressively becomes lost.[56] It may thus be seen how the process of refinement can eventually lead to decadence. At the end of its historical development, the form of the *qandīl* has departed from its classical form and is no longer identifiable with the *kawkab durrī* described in the Verse of Light.

133. Frontispiece of an early 8th-century parchment Koran, found in the Great Mosque in Sana'a, Yemen, probably produced in the Umayyad court of Damascus.

Chapter 7

How Would Early Mosque Lamps Have Looked?

Many examples of historical mosque lamps are to be found in museums. However, although they are appreciated as beautiful art objects, it is not always apparent how they would have functioned as lamps and what light they would have produced. It is noteworthy that, although it is only a matter of decades since the traditional oil lamp has been replaced by electric lighting in many parts of the Islamic world,[1] there are no examples that the author has been able to identify, in museums or in their original context, in which the oil lamp is seen in working order, complete with all its functional accessories. This makes it difficult to gain an accurate impression of how the traditional oil lamp would have functioned and the overall impression it would have created.[2]

Historical accounts often record the materials, from which early lamps were made, but they rarely give a description of their form and there are only few surviving examples to which one can refer. One further source of evidence is to refer to historical manuscripts in which lamps are represented. In these one rarely finds the lamp depicted in realistic detail. However, there do exist examples which provide interesting insights. The earliest and most noteworthy example consists of fragments from an early eighth-century illuminated parchment Koran, probably produced in the Umayyad court of Damascus, which was discovered in 1972 during restoration works in the Great Mosque in Ṣanʿāʾ, Yemen.[3] This manuscript is of particular interest since its illuminated frontispieces contain one of the earliest surviving depictions of mosque lamps. These are shown in the context of pictorial representations of two mosques, composed of rows of arches on columns: in one case, a lamp hangs from each arch, in the other lamps hang in every other row of arches. In the former the composition is surmounted by a larger arch, containing a larger somewhat more elaborate lamp. The images in this manuscript, known as the "Great Umayyad Koran" (Catalogue number Codex Ṣanʿāʾ DAM 20-33.1), are described in detail by Hans-Caspar Graf von Bothmer, the director of the German team responsible for the restoration and cataloguing of all the manuscripts found.[4] He explains how at first sight they appear to represent multi-storied, arcaded façades, but in fact give a plan view of the architecture, onto which the arcades are projected. The arched form at the top of the first of these images thus represents the plan of the mihrab niche, in which the lamp is emphasized.

The lamps depicted in the manuscript are all round in form and, although a conical neck projects at the upper end, this is relatively small in comparison to what one sees in later mosque lamps.[5] The wick in the interior is visible, indicating that the material from which the lamp is made is transparent—presumably glass or crystal. The wick extends out of a receptacle contained within the lamp body, probably intended to hold the lamp oil. The base of the wick is located half-way up the lamp, at the center point of its spherical form, and the flame appears to rise as high as the rim of the neck.

This manuscript provides particularly valuable insights into the form of the earliest mosque lamps, due to the fact that it originates from the first Islamic century and is thus historically close to the revelation of the Verse of Light. Lamps are also represented in later miniature paintings. Many of the miniatures

134. "The Bier of Iskandar," detail from the Demotte *Shahnameh* of Firdawsī, Tabriz, 1330-36.

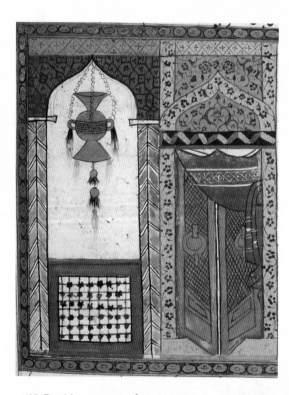

135. Detail from manuscript *Āthār al-bāqiya ʿan al-qurūn al-khāliya*, by Muḥammad ibn Aḥmad Abū al-Rayḥān al-Bīrūnī.

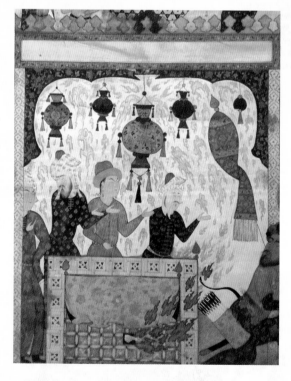

136. "A King Being Chased out of the Tomb of Imam ʿAli at Najaf," from illuminated *Falnama* (Book of Divination), Iran, ca. 1550.

in al-Ḥarīrī's *Maqāmāt*, dating from 1240, depict scenes in which the architectural settings contain hanging lamps. The so-called Demotte *Shah-nameh* of Firdawsī, dating from 1330-36, shows lamps hanging above and beside the bier of Iskandar; flame can be seen emerging from the top of the central lamp.[6] A Persian miniature from the *Mi'raj-nameh* of Mirheydar, dating from 1435-36, shows a lamp hanging from an arch in a scene where the Prophet Muhammad leads Jesus, Abraham, and other prophets in the prayer. Likewise a miniature from the *Siyer-i Nebi*, dating from c. 1595, shows the Prophet in a mosque, with lamps and hanging ornaments above his companions, and a lamp hanging in the mihrab in front of which he sits. A miniature painting from the *Falnama*, c. 1550-55, showing a king being chased out of the tomb of Imam 'Ali at Najaf, also has representations of lamps and hanging ornaments—with colorful tassels and ornamentation in a distinctly Chinese style. Although there is a tendency in miniature painting for graphic representations to be stylistic in character, these examples are

of interest precisely because they show how the mosque lamp was conceptualized in its essential form. In almost every case the form of the lamp is represented with a round or elliptical body, a flaring, funnel-shaped neck and base, as well as suspension chains—as is also the case with representations of mosque lamps in architectural decoration, which will be dealt with in a later chapter.

In addition to studying miniature paintings, further insights may be gained by referring to depictions in orientalist paintings. In contrast to the stylized character of miniature paintings, these are typically naturalistic and

137. "The Lighter of the Lamp" (*l'allumeur de lampe*), oil painting by Costa Antonio Fabres (1854–1936).

138. Detail from "The Lamp Lighter," 1900, by Ludwig Deutsch (1855–1935).

139. Detail from "Prayer in the Mosque [of 'Amr in Cairo]," depicting mosque lamps and a prayer rug with lamp motif, by Jean-Léon Gérôme, 1871.

are characterized by meticulous attention to detail, although one must take into account the possibility that the scenes depicted may include an element of fantasy. They are of course much more recent (mostly from the late nineteenth century) and therefore do not depict examples from the early Islamic period, however many of these paintings are a valuable source since they were painted in a period when oil lamps were still in use in mosques and in Islamic architecture. Some examples, such as *The Lighter of the Lamp*, painted by Costa Antonio Fabres (1854-1936) and *The Lamp Lighter*, by Ludwig Deutsch, (1855-1935) show how the oil lamps were lit. The painting *Prayer in the Mosque* by Jean-Léon Gérôme (1824-1904) shows a great variety of different lamp types. Paintings and lithographs such as these— and also early photographs of mosques that occasionally show details of the lighting—are all of interest, inasmuch as they show lamps in use in the context of their original architectural settings, rather than as lifeless museum exhibits.

To return to the key question of how the lamp described in the Koranic Verse of Light and mosque lamps in the earliest Islamic period would have looked, let us examine some of the conclusions we have been able to draw in the preceding chapters: The lamp in the Verse of Light is, of course, allegorical. However, presumably it would have been comparable to a

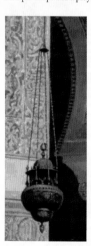

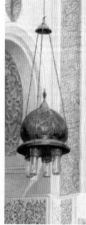

140 A-F. Details from "The Harem Dance," by Giulio Rosati (1857–1917).

141. 19th century photograph, showing interior of Muhammad Ali Mosque, Cairo.

142. Detail of an early 20th century photograph showing glass lamps, filled with oil and water, Al-Aqsa Mosque, Jerusalem.

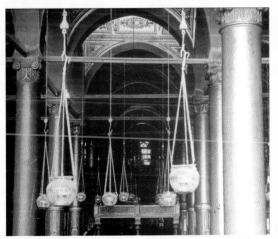

143. Photograph showing glass lamps from Prophet's Mosque in Medina, 1908.

144. Detail from 19th century photograph of minbar of Muhammad Ali Mosque, Cairo.

contemporary form of lamp, conceivable at the time. Various interpretations suggest that the word *mishkāh* may refer to a perforated metal outer lamp body, which would have housed a separate glass container to hold the oil and the wick. Many of the earliest surviving examples are indeed from perforated metal, and lamps of gold, silver, and brass are recorded in early accounts (e.g., by Nāsir Khusro, Ibn al-Najjar, and Ibn Jubayr). Nevertheless, the description in the Verse of Light and al-Samhūdī's account of Tamīm al-Dārī bringing lamps from Syria in the time of the Prophet Muhammad, both refer to glass lamps.[7] It is debatable whether it is more likely to be a lamp of blown glass or of rock crystal that is described. Lamps from blown glass existed in the pre-Islamic Byzantine period. However, the description in the Verse of Light is of a glass of exceptional clarity, comparable to a shining star, and one wonders whether the blown glass of that period could have achieved a comparable quality. It is recorded that lamps of crystal existed in the early Islamic period, such as the famed *qulayla*, which used to hang in the mihrab of the great Umayyad Mosque of Damascus, and those in the Zamzam dome in the Haram in Mecca. It seems likely that the lamp described in the Verse of Light most closely corresponds to such a lamp, although it is probable that the lamps brought by Tamīm al-Dārī from Syria would, on the contrary, have been from blown glass. It is a matter of conjecture whether there is a direct connection between the event involving Tamīm al-Dārī and the revelation of the Light

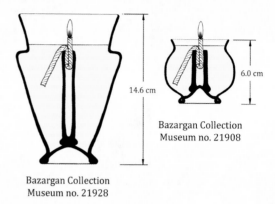

14.6 cm

Bazargan Collection
Museum no. 21928

6.0 cm

Bazargan Collection
Museum no. 21908

145. Suggested reconstruction of arrangement of wick in lamps with tubular wick holders.

Verse and the lamp described in it. Despite the apparent coincidence, there is no conclusive justification for linking the two. Although no *qandīl* type rock-crystal mosque lamps seem to have survived,[8] it is likely that they would have resembled blown glass lamps, fragments of which have been found in excavations. It is to be noted that, although the glass mosque lamps produced in the Mamluk period were typically about 30 cm tall, the size of earlier glass lamps was much smaller. Some of these earlier examples have glass tubes rising from their base and it has been suggested that these may have acted as candle holders.[9] However, considering the size of these lamps and the fact that the tube sometimes rises almost to the upper rim,[10] it seems more likely that these would have acted as wick holders for oil lamps.[11]

Glass lamps would have been partly filled with water—as indicated in the account of

146. Cylindrical rock crystal lamp, 10th century, seen here without its 13th century Venetian vase mount.

147. Traditional lace maker's lamp uses water lenses to magnify the light of a single candle.

Tamīm al-Dārī—to support the floating wick and to protect against fire.[12] Once the oil was consumed, the wick would automatically have been extinguished in the water and by adjusting the amount of oil filled, one could presumably have controlled the length of time one wanted the lamp to burn. The water would also have enhanced the optical performance, acting as a lens, which would have magnified the flame in a striking way when seen from below through the water.[13]

A simulation by the author of a spherical glass lamp, with a wick floating on oil and water, demonstrated the non-uniform distribution of light to be expected from such an arrangement: Light is radiated in an upwards direction uninterrupted; below the "horizon" there is a dark zone created by total internal reflection from the oil and water; beneath this level the water acts as a lens, concentrating the light below and magnifying the flame when seen from certain angles. One could thus imagine that such a lamp, suspended in a mihrab, would not just have illuminated the canopy of the niche above, but would also have cast an intense pool of light on the space below, where the imam stands when leading the prayer.

148, 149, 150. Simulation of spherical glass hanging lamp with wick floating on oil and water.

Chapter 8
The Mosque Lamp in the Contemporary Context

In the light of the above, what practical conclusions can be drawn with regard to the lighting of buildings—particularly mosques and places of worship—in the contemporary context? The last century has seen the advent of electrical lighting and its ubiquitous use has meant that the traditional mosque lamp has been almost entirely replaced by industrially produced light fixtures and the lamp, "kindled by the oil of a blessed tree," has disappeared from use.[1]

In the time of the Prophet the lamp described in the Verse of Light represented the most intense light source that could be achieved with the technical means of the day. Olive oil—hitherto uncommon in Arabia—burnt more brightly than the sesame oil used in lamps or than the palm fronds customarily burnt as torches. The glass, together with the water would have acted as an optical lens, magnifying the flame and transmitting the light to the eye of the beholder in the clearest way possible. If enclosed in a niche, this would have concentrated and focused the light—particularly the component cast upwards—onto the immediate surroundings. Therefore the overall effect must have been of a bright light shining in the comparative darkness of an otherwise dimly lit interior. The description in the Verse of Light gives the impression of a single niche, acting as a bright focal point, rather than a multiplicity of niches distributed throughout the space in order to raise the lighting level of the whole ambience.

Contemporary electric lighting gives one the technical means of achieving much higher lighting levels, distributed uniformly throughout a space. The design brief for present-day mosque projects often calls for lighting levels sufficient to be able to read the Koran at any point within the prayer hall. An attempt is often made to avoid glare—that is to say, points of higher intensity in relation to others—and to achieve a uniform distribution throughout the space. This is frequently achieved by using concealed lighting fixtures, which cast their light onto surfaces in their vicinity, which in turn reflect the light in a diffused manner. The fact that it is possible to control light through scientific means and thus to achieve high lighting levels, evenly distributed, may no doubt be looked upon as a technical achievement of the modern age. However, consideration should be given to consequences of such a form of lighting.

Paradoxically, one might argue, this is the type of lighting that makes one least conscious of light as such. In the same way that the fish is unaware of the water in which it swims, ambient lighting is easily just taken for granted. It may be said on the contrary that it is the contrast between light and darkness that makes one most conscious of light. The attraction of the traditional type of light fixture with a perforated lamp body is precisely that the pattern of light and shadows cast on the surrounding surfaces draws attention to the light. The lamp likewise has two aspects, both equally attractive: when it

Opposite: 151. Light and shadow projected by perforated brass lamp.

152A & B. Two aspects of the perforated brass lamp.

is not lit the lamp itself is seen with its intricate surface decoration and when it is lit one sees the patterns of light and shade it projects on the surrounding surfaces. In this connection Behrens-Abouseif quotes Ibn al-Haytham, author of the famous work on optics:

> Darkness causes beauty to appear. For the stars are visible only in darkness. And, similarly, the beauty of lamps, candles and fires only appears in the darkness of night or in darkened places. . . .[2]

Thus to be conscious of Light, which the Koran describes as a symbol of the Divine, it may be better not to illuminate architectural spaces in a uniform manner. In practical terms it may be called into question whether it is in fact necessary to be able to read the Koran at every point within the mosque. Although reading the Koran is one activity that takes place within a mosque, only a small proportion of the mosque users will typically want to do this at any one time. The whole space within a mosque is generally occupied only when the users congregate for the performance of the canonical prayers, and is commonly filled to capacity only for the Friday prayers and *'Eid* prayers. Hence it should be sufficient if there are certain areas in which lighting levels are higher where those who wish to read can sit.[3]

Lighting is a key element in determining the ambience in any architectural setting. It has been demonstrated that it can affect one's productivity in a work space and one's capacity to learn in an educational environment. It also has a strong impact on one's emotions—for example the intimate ambience created in the context of a candlelit dinner.[4] It is a particularly important element in sacred architecture. Titus Burckhardt gives us the following exposition on the importance of Light in architecture in his chapter "The Alchemy of Light":[5]

> The artist who wishes to express the idea of the "unity of existence" or

153. Interior of Mihrimah Sultan Camii, Istanbul, showing Koran stands in window arches. See note 3 on page 163.

the "unity of the real" (*waḥdat al-wujūd*), has actually three means at his disposal: geometry, which translates unity into the spatial order, rhythm, which reveals it in the temporal order and also indirectly in space, and light which is to visible forms what Being is to limited existences. Light is, in fact, itself indivisible; its nature is not altered by its refraction into colors nor diminished by its gradation into clarity and darkness. And in the same way as nothingness does not itself exist except by its illusory opposition to Being, so also darkness is visible only by contrast with light, to the extent that light makes shadows appear.

"God is the light of the heavens and the earth," says the Koran (24:35). It is the divine light which brings things out from the darkness of nothing. In the symbolical order in question, to be visible signifies to exist; now, just as shadow adds nothing to the light, things are real only to the extent that they share in the light of Being.

There is no more perfect symbol of the Divine Unity than light. For this reason, the Muslim artist seeks to transform the very stuff he is fashioning into a vibration of light. It is to this end that he covers the interior surfaces of a mosque or palace—and occasionally the outer ones—with mosaics in ceramic tiles. This lining is often confined to the lower part of the walls, as if to dispel their heaviness. It is for the same purpose that the artist transforms other surfaces into perforated reliefs to filter the light. *Muqarnas* also serve to trap light and diffuse it with the most subtle gradations.

Colors reveal the interior richness of light. Light viewed directly is blinding; it is through the harmony of colors that we divine its true nature, which bears every visual phenomenon within itself. . . .

We have compared this art to alchemy,[6] the well-known theme of which is the transmutation of lead into gold; lead is the base metallic substance, shapeless and opaque, whereas gold, the solar metal, is in some way light made corporeal. In the spiritual order, alchemy is none other than the art of transmuting bodily consciousness into spirit: "body must be made spirit," say the alchemists, "for spirit to become body." By analogy, one can say of Muslim architecture that it transforms stone into light which, in its turn, is transformed into crystals.

154. Muqarnas vault over entrance to Masjid Imam, Isfahan.

155. Prayer carpet with lamp motif, Cairo, late 16th century.

Chapter 9
The Mosque Lamp Motif in Islamic Art and Architecture

The Light Verse is one of the few cases where the Koran makes direct reference to a quasi-architectural element as a symbol and Islamic architecture has for this reason grasped the inherent potential for visual expression. It may be said that this lies at the root of the development of the art of the mosque lamp, as described in the preceding chapters. However, the lamp in a niche, or the lamp motif alone, is such an evocative symbol that one also finds this image recurring time and again in the decorative motifs in Islamic art throughout the world.[1]

The mosque lamp motif features frequently in the design of carpets, particularly prayer-rugs.[2] The motif even appears on coinage from the Mamluk period, as demonstrated by a copper *fals* coin in the David Collection, Copenhagen, on which one sees a mosque lamp hanging in an arch on two columns.[3] However, more than anywhere else, the motif is encountered in Islamic architecture and tomb markers.

156. Mosque lamp detail with inscription from *Āyat al-Nūr* on *sitarah* made for the Prophet's Mosque in Medina by the Ottoman Sultan Selim III, Egypt, 1791-92.

157. Mamluk *fals* coin with lamp motif, Hama, western Syria, 709-741H/1310-1341.

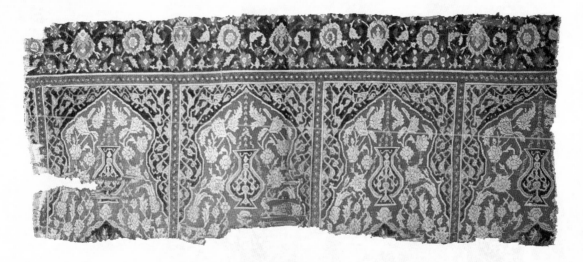

158. *Şaf* carpet from Selimiye Mosque, Edirne, late 16th or early 17th century.

159, 160 & 161. Mosque lamps, painted on the interior of tomb tower at Kharraqan, Iran, 1067-68.

One of the first known examples is in a remarkable series of frescoes from the Seljuk period, painted on the interior of one of two tomb towers, dated 1067-68, at Kharraqan in Iran. In each of seven panels a keel-shaped arch, outlined in blue, surrounded a representation of a mosque lamp. The lamp has a round body, from which extend a funnel-shaped neck and foot. Three chains, consisting of elongated hexagonal forms alternating with squares, with hooks at each end, attach to rings on the sides of the lamp body and to a chain hanging down from the apex of the arch. At the mid-point of the body is a Kufic inscription invoking blessings.[4]

An example which may predate those at Kharraqan is a so-called "mihrab-like panel," now kept in the Museum of Ghazni, Afghanistan. This rectangular marble panel, dated 450H/1058, has decoration carved in low relief consisting of a hanging lamp with globular body, suspended by three chains from the top of an arch, which is framed on three sides by an epigraphic band in cursive script. This panel has no elements suggesting a funerary context, however the same motif is found on tombstones in Ghazni from the twelfth century onwards.[5]

Motifs related to the hanging lamp are found in Islamic architecture even earlier than this. In his description of the mosaic mural decorations in the courtyard of the Umayyad Mosque in Damascus, Finbarr Barry Flood notes the use of "the motif of pearls or pearl-like ovoids suspended on golden chains":

> The nature of these pendant objects is somewhat ambiguous, and this has given rise to a range of identifications in previous studies. Jean Lassus . . . refers not to hanging pearls, but to "the lamps which hang throughout the mosaics, in the windows, in the doors and between the columns." Creswell suggested that the motif of a pearl suspended from a chain was "probably imitating a lamp hanging in a doorway." . . .[6]

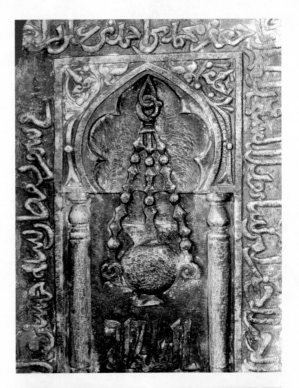

Top: 162: "Mihrab-like" marble panel, dated 450H/1058.

Bottom: 163. Detail of mosaics in the Umayyad Mosque, Damascus, showing "pearl-like ovoids suspended on golden chains."

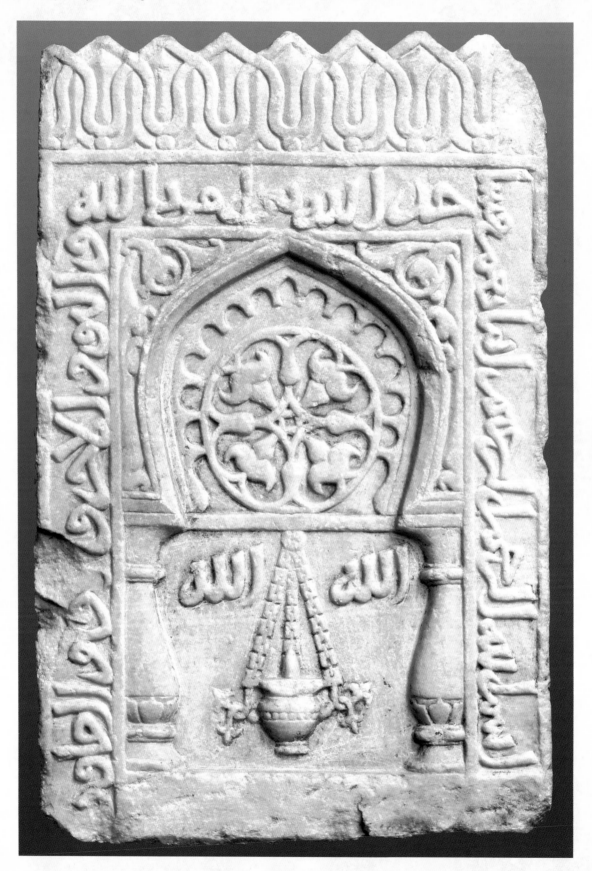

164. Mihrab tile, carved marble, Afghanistan, Ghaznavid dynasty, c. 1100.

Flood describes the luminescent qualities of the pearl, the equivalence between the pearl and the lamp and, citing rabbinic and Christian traditions, "the belief that jewels in general, and the pearl in particular, functioned as a source of light":

> Medieval descriptions of a mysterious lamp which hung in the eastern mihrab of the Damascus mosque and which was referred to as a pearl (*durra*) support the idea that the visual ambiguities inherent in the treatment of the pearl motif in the mosaics of the mosque could serve to suggest an association between the pearl and the lamp.[7]

Flood notes the correlation between the pearl in the oyster shell and the lamp in the niche, highlighting the way this is connected to the proliferation of the scalloped shell form in Umayyad mihrabs.[8] Burckhardt writes in this connection:

> Many of the oldest prayer-niches are adorned with a canopy in the form of a seashell. This motif is found already in Hellenistic art, but it would not have been incorporated into the art of Islam unless it had a spiritual significance. The shell is associated with the pearl, which is one of the Islamic symbols of the Divine Word; according to a saying of the Prophet, the world was created from a white pearl. The sea-shell enclosing the pearl is like the "ear" of the heart receiving the Divine Utterance; it is, in fact, in the *miḥrāb* that this utterance is made. It may seem surprising that a form such as the *miḥrāb* which is, after all, simply an accessory to the liturgy, should be the focus of a particularly rich and profound symbolism. But this is implicit proof of the link between

165. Marble mihrab from Al-Manṣūr Mosque, Baghdad, 766, found in Jāmiʿ al-Khāṣṣaki.

sacred art and esoterism, the "science of the inward" (*ʿilm al-bāṭin*).[9]

Despite such cases of possibly "ambiguous" motifs, many of the representations of mosque lamps encountered are clearly identifiable and quite naturalistic. In the mosque of al-Aqmar in Cairo (519H/1125), besides epigraphic inscriptions from the *sūrat al-nūr* mentioned in an earlier chapter, one also finds a rectangular panel on the upper left corner of the external façade of the mosque with a visual representation of the Lamp in the Niche. Creswell describes this as

> "a really charming composition composed of two little spirally fluted pilasters which support a pointed

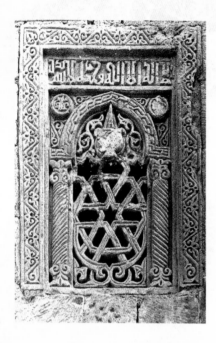

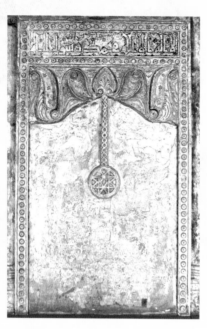

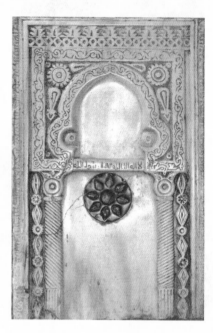

166. Mosque lamp motif in tympanum of arch on external façade, Al Aqmar Mosque, Cairo.

167. Flat mihrab, Mosque of Ibn Ṭūlūn, Cairo, Fatimid period, 9th century.

168. Mihrab in the cave of the Dome of the Rock, Jerusalem.

arch, the whole framing a simple interlacing star design of six points. A lamp hangs from the apex of the arch, the earliest example I have ever seen of this motif."[10]

Due to associations with the Lamp in the Niche described in the Verse of Light, the mosque lamp motif was frequently used on mihrabs. In her discussion of this motif on the façade of the mosque of al-Aqmar, Caroline Williams mentions a very early flat mihrab in the mosque of Ibn Ṭūlūn in Cairo:

This panel [in the mosque of al-Aqmar] is similar to one of the flat mihrabs in the mosque of Ibn Ṭūlūn, dated to the ninth century foundation of the mosque. Unfortunately, much of the design of this flat mihrab has been lost, but still very visible is the mosque lamp in the shape of an eight-pointed star that hangs down from its center.[11]

If this indeed dates from the ninth century, this would mean that it predates all the other architectural examples mentioned above.[12] However, in this flat mihrab the "lamp" is stylized and consists only of a circular disc, containing a geometric motif resembling an eight-pointed star, although the chain connecting it to the arch above is depicted quite naturalistically. The circular disc with the eight-pointed star bears a notable similarity to the black stone disc within an arched form at the center of the flat mihrab in the Cave of the Dome of the Rock in Jerusalem. Here also the circular disc has decorative carving in the form of an eight-pointed, star-shaped rosette.[13] Seen in isolation, neither of these discs would be considered to resemble a lamp, however the chain in the example in the mosque of Ibn Ṭūlūn, and the juxtaposition with the arched surround in both cases, lead one to recognize a connection with the Verse of Light, which moreover compares the lamp to a radiant star (*kawkab durrī*).

169 & 170. Carved stone mosque lamps in portal to Mashhad al-Husayn, Aleppo, Ayyubid period, 1195-96.

Another early architectural example is to be found in the monumental portal of Mashhad al-Husayn in Aleppo, constructed in 569H/1173-74 and restored in 596H/1200, and considered to be the most elaborate vault of its kind in Ayyubid architecture. It demonstrates particularly rich relief carving, with a row of lamps, like those actually hung in portals and prayer halls, carved in realistic detail in three-dimensional relief around three sides of the muqarnas vault above the entrance.[14]

Other examples of mosque lamp motifs used in mihrabs include the thirteenth-century single-block marble mihrab from 'Alawi (Ulvi) Sultan Masjid, Konya; those in the Mausoleum of Zainab at Sinjar built between 1239-59; the Shrine of Shaikh Binyaman, at Bidakhavid, southwest of Yazd, Iran, dated 1379; and Masjid-i Jami' of Mir Chaqmaq, Yazd, dated 840H/1436-37. Two very similar flat mihrabs are to be found in two mausolea in Mosul, Iraq: the mausoleum of Yaḥyā b. Qāsim and that of Imam 'Awn al-Dīn, both built during the

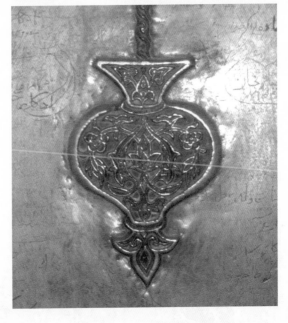

Top: 171. Carved stone mosque lamp, mihrab of Masjid-i Jami' of Mir Chaqmaq, Yazd, Iran, dated 840H/1436-37.

Bottom: 172. Mosque lamp motif in mihrab, Yazd, Iran..

Top left: 173. Mosque lamp motif on mihrab column, Sultan Barquq Mosque Complex, Cairo.
Bottom left: 174. Mosque lamp motif on minbar, Sultan Barquq Mosque Complex, Cairo, 1399-1412.
Right: 175. Single block marble mihrab with mosque lamp motifs, Alawi (Ulvi) Sultan Masjid, Konya, 13th century.

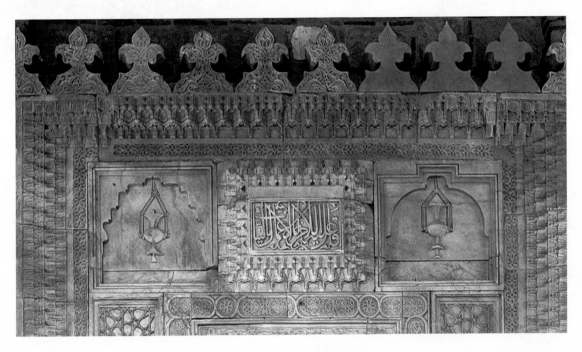

176. Mosque lamp motifs above mihrab of Ilyas Bey Camii, Milet, Turkey, Seljuk period, 1403.

thirteenth century. These are unusual as in both cases the qibla direction faces into the corner of the space and the mihrab consists of two flat panels wrapping around the corner, with a mosque-lamp within a pointed arch on columns spanning across the two panels.[15] The mihrab in the khanqah, mosque, and madrasa complex of Sultan Barquq in the Qarafa, Cairo (1399-1412) has a mosque lamp motif on one of its columns. There is also a lamp motif on the panel at the top of the mosque's marble minbar. In Turkey an example of mosque lamp motifs used above a mihrab is to be found in Ilyas Bey Camii, Milet, built in 1403 during the Seljuk period. Also in Turkey, the mosque lamp motif is seen within an arched form, flanked by candlesticks, on a tiled mihrab in the Yeşil Türbe, Bursa, built in 1421 in the Ottoman period.[16]

Numerous examples of mihrabs bearing a mosque lamp motif are to be found in northern India, many occurring in the Sultanate architecture of Delhi. In some examples the lamp motif is quite naturalistically represented (as in the Qala-i-Kuhna Masjid, Delhi), in others it is

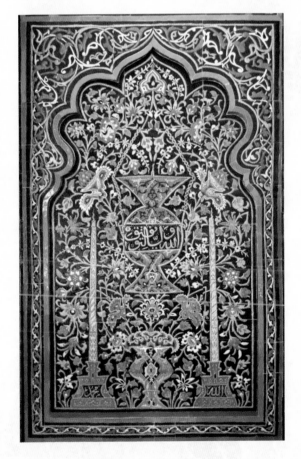

177. Detail of tiled mihrab, Yeşil Türbe, Bursa.

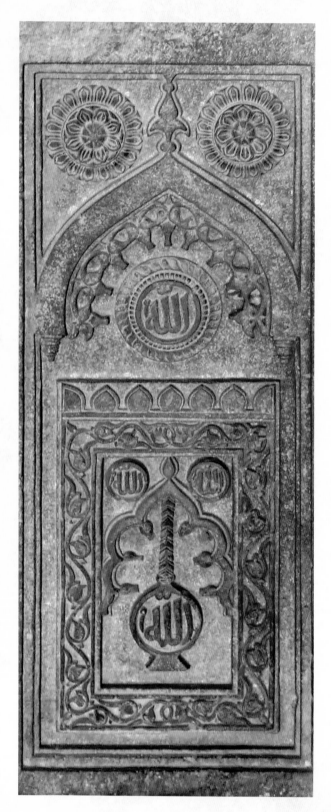

178. Detail of secondary mihrab, Jamali Kamali Masjid, 1528-29, Mehrauli Archaeological Park, Delhi.

stylized or reduced to a disc containing a sacred inscription conveying the divine presence (as in the Jamali Kamali Masjid and the Sultan Garhi Tomb, both in Delhi, and the Masjid of Isa Khan Niazi, Ghayaspur).

One of the foremost examples, in which the Lamp in the Niche motif is encountered, is the Adina Mosque of Pandua in the eastern province of Bengal, built by Sikandar Shah in 776H/1375 and seen as one of the greatest Islamic monuments in all of South Asia. Naseem Banerji describes its use as follows:

An unusual feature of the architectural decoration of the Adina Mosque is the ubiquity of the motif of the lamp within a niche that is represented on its *mihrabs,* tympanums, as well as on each offset and recess of its exterior walls. The interior of its main *mihrab* has four rows with twenty-eight rectangular panels in relief with lamps suspended from chains within each panel. . . . The subsidiary *mihrab* to its right has a large lamp hanging down its central panel in addition to four rows with a total of twenty-eight lamps in the background. . . . All but one of its thirty-five other *mihrabs* have single lamps suspended within their concave arches, and placed on terracotta background designs on twenty-six of its tympanums are additional lamps. Moreover, the outer walls of this gigantic mosque, which measures approximately 524 x 322 ft., once had a total of one hundred and twenty-seven arches with lamps.[17]

It is notable that the examples of the mosque lamp motif in mihrabs in Bengal and northern India mostly date from the same historical period. There are demonstrable connections between the emergence of this practice and influences from contemporary Islamic teachings. Banerji examines these influences and refers to evidence suggesting links between

Sultan Sikandar Shah and Illuminationist Sufis who had established *khanqahs* (monasteries) in the region of Pandua and Gaur, two medieval capitals of Bengal.[18]

> In Bengal, and more specifically in Pandua, the shrine of Jalal al-Din Tabrizi, which began as a *khanaqah* for a small number of dedicated disciples, was probably responsible of the diffusion of the Ishraqi doctrines of Illumination. . . . [T]he widespread use of the motif of the "lamp within a niche," as part of the architectural decoration of mosques and tombs in all parts of Bengal, as well as the fact that these monuments range in date from at least as early as the early 14th century to the late 17th century would suggest that Illuminationist Sufi ideas had been widely disseminated in Bengal long before the reign of Sultan Sikandar Shah and persisted . . . long after his demise.[19]

Banerji lists many examples demonstrating the widespread use of the lamp motif in Bengal,[20] but speaks of a degeneration of the motif in later examples "almost as if the original configuration and symbolism had been lost."[21] In the decoration of almost all types of monuments in the Sultanate architecture in this region one encounters a wide variety of pendant forms and, apart from motifs which obviously represent the mosque lamp, the forms are often not clearly identifiable.

Among these pendant forms one also finds the so-called "bell-and-chain" motif or *ghanta-mala*, described as "an ornamental motif of bells suspended from a garland of pearls," often encountered in Hindu temple architecture, as for example in the eponymous Ghantai Temple at Khajuraho. In a paper dealing specifically with this subject, Khoundkar Alamgir describes the widespread use of this motif in the Islamic architecture of Bengal (present-day Bangladesh and West Bengal, India) and how from 1300 onwards various forms of this motif

179. Main mihrab with mosque lamp motifs, Adina Masjid, Pandua, Bengal, 1375.

180. Mosque lamp motifs in mihrab niche, Adina Masjid, Pandua, Bengal, 1375.

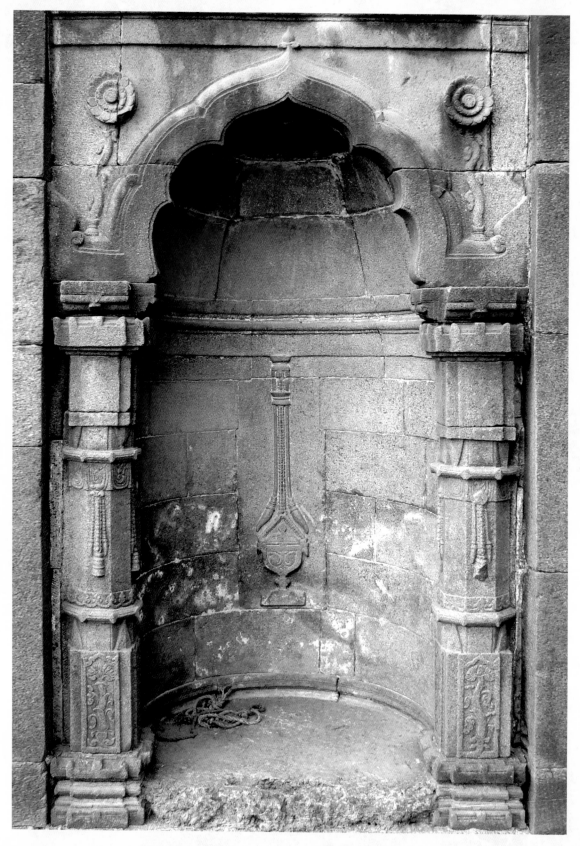

181. Hanging lamp motif in mihrab niche, Baro Sona Masjid, Malda, West Bengal, 1526.

were extensively used.[22] Alamgir comments on the wide variety of pendant forms and while mentioning disagreement among scholars about how the various forms are identified, he concludes that these hanging motifs, such as lamps, *shika* pendant rope trays, earrings, and vegetal or geometric designs representing diverse elements from the folk arts of traditional Bengal, are all derivations of the bell-and-chain motif. It is interesting how this motif of Hindu origin became incorporated into Islamic architecture, as at the Mausoleum of Shams al-Dīn Iltutmish, built in 1235, in the northwest corner of the Qutb Mosque, near Delhi, where one finds Hindu motifs, including the bell-and-chain, tassel, lotus, and diamond emblems in the sandstone carvings. Friezes composed of the bell-and-chain motif are also in evidence on the Qutb Minar itself. The practice of using stones from earlier Hindu temples in the construction of mosques was commonplace in Bengal. However, the suggestion that all pendant forms encountered are derivations of the bell-and-chain motif seems questionable from a number of points of view.

Firstly, it should be noted that in general the bell does not have positive connotations in Islam, as indicated by various traditions of the Prophet, although the process by which pre-Islamic forms were integrated into the Islamic context should be taken into account.[23] There is undoubtedly a positive symbolism attaching to the bell-and-chain motif. In the context of Hinduism and Buddhism, the bell would have been associated with prayer and it is very likely that in Bengal there was a perpetuation of pre-Islamic sensitivities towards this form, which would explain how architectural elements from temples, on which the bell-and-chain motif appears, could have been re-used in mosques. However, there does not seem to exist sufficient pretext from an Islamic standpoint to explain how variations of the Hindu *ghantamala* motif could have become so extensively adopted in the Islamic architecture of Bengal.

Secondly, unlike the bell-and-chain motif found in Hindu temple architecture, where the form of a bell is clearly identifiable, in the majority of the motifs decorating the mosque architecture of Bengal, the elements are highly stylized and it begs the question whether these motifs are accurately described as representing a bell and chain. In some such cases where abstract decorative motifs have been described as such, this attribution seems quite arbitrary. Likewise, there seems to be even less reason to identify other pendant forms of the Sultanate period as representing the *shika*, the traditional basket suspended from ropes found in Bengal—particularly since these motifs bear a very strong resemblance to others that are identified as lamps.[24]

182. Hindu bell-and-chain motif, on temple columns in Qutb Complex, Delhi, India.

183. Pendant motifs within arches dominate façade of Choto Bagha Mosque, Rajshahi, Bangladesh.

These forms, described as the Islamic equivalent of the bell-and-chain motif, have one significant difference from their Hindu predecessors: they are almost invariably enclosed within an arched form and the resulting combination bears a strong similarity to the motif of the lamp within the niche. Sometimes the motifs in question entirely dominate the ornamentation of certain mosques—such as the early fourteenth-century Goaldi Mosque in Sonargaon and the Choto Bagha mosque in Rajshahi, covering the external façades. It would therefore seem much more plausible to see these as variants of the lamp-in-the-niche motif, and the connection with the Koranic Verse of Light would consequently explain their ubiquitous use in the mosque architecture of Bengal.

It is notable that the hanging lamp motifs that dominate the architecture in the Adina Mosque, described above, are quite diverse in form. While some display recognizable details, in others a high degree of stylization is observable—particularly in some of the motifs executed in terracotta in the tympanum of the arches on the qibla wall inside the mosque and in the arched panels on the exterior façades. Nevertheless in every case, in the given context one does not hesitate to identify them as lamps, despite the fact that viewed in isolation, some of these would bear no greater resemblance to a lamp than to a bell. Similar observations apply to other hanging motifs found in the Sultanate architecture of Bengal. In many cases, where the motif is reduced to

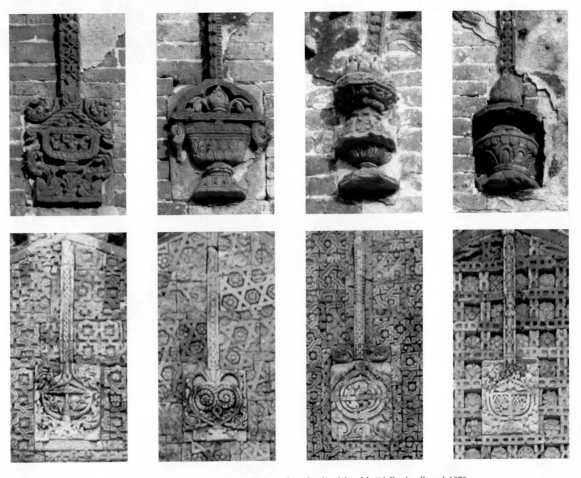

184A-D & 185A-D. Terracotta pendant motifs on façades, Adina Masjid, Pandua, Bengal, 1375.

a rectangular form containing an ornamental pattern (as at the Lattan mosque and Darasbari mosque, Gaur) or to a seemingly non-representational *islīmī* decoration (as at the Goaldi mosque, Sonargaon; the Choto Sona mosque, Shibganj; the Choto Bagha mosque, Rajshahi; the Kusumba mosque, Rajshahi; the Majlis Awlia mosque, Faridpur; the Tantipara mosque, Gaur; and the Qadam Rasul mosque, Malda) the degree of stylization precludes a definitive identification. There is a noticeable tendency towards ever greater stylization and it might be claimed that in the latter examples the motifs are purely ornamental, without reference to any specific symbol. However, the juxtaposition of these pendant forms with their arched surrounds suggests

that one may be justified in recognizing them as variants of the lamp-in-the-niche motif. The same may be said of later examples that one finds painted on mihrabs in Turkey during the Ottoman period, where one likewise sees the form of the lamp modified to resemble an arabesque ornament, which if viewed in isolation would hardly be recognizable as a lamp. Undoubtedly these examples represent a decadence of the form, but one is nevertheless still able to recognize in them a reference to the Verse of Light. This is quite evident in the case of mihrabs, but the argument can apply equally to the decorative panels adorning the façades of the mosques in Bengal and elsewhere.

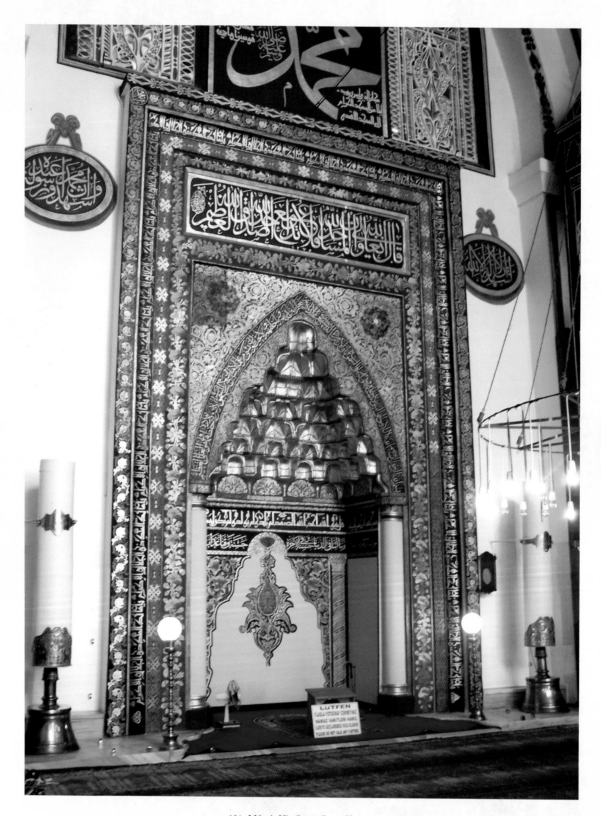

186. Mihrab, Ulu Camii, Bursa, Turkey.

Eva Baer writes in this connection:

> Another set of decorative motifs that may have invoked blessings are panels and arcades. . . . [T]hese frames and panels were part and parcel of the Islamic decorative repertoire throughout the centuries. However, because of the formal resemblance to the *mihrab*, these panels were occasionally charged with religious symbolism. This was certainly the case with decorative panels which carried one or more attributes that marked them as *mihrab*: an inscription such as the *shahada* or the sura of the light; a hanging lamp or a pair of candlesticks Arched panels and arcades which framed either a geometric or a plant design are a relatively common feature in Islamic art, which generally had a purely decorative function. However, some of the arched panels with vegetal motifs may nevertheless have been read as a *mihrab*.[25]

In the work "The Mihrab Image,"[26] Nuha Khoury discusses the use of the mosque lamp motif in mihrabs, both those with a concave niche, which indicate the qibla direction in mosques, and also two-dimensional mihrabs, which may serve other functions.[27] Khoury maintains that the symbolism is not the same in niche mihrabs as in two-dimensional mihrab types, which she calls "mihrab images" and describes as follows:

> These mihrabs frequently incorporate depictions of lamps, often flanked by candlesticks, and suspended beneath an arch. The composition is usually framed by inscriptions. . . . Variations of this composition occur in many parts of the Islamic world, including Egypt, Iraq, Iran, Turkey, and Yemen, and are known from the late eleventh century onward. . . . A close examination of the flat mihrab compositions, and especially of the lamps and inscriptions that appear on them, indicates that they are one of a number of distinct types of mihrabs, and are not related to mosque niche mihrabs. The contexts in which these particular flat mihrabs most often appear—in mausolea and on tombstones, cenotaphs, and a variety of shrine-related objects—suggest an interpretation that is connected with death and eschatology.[28]

Whereas, in niche mihrabs, the lamp motif makes reference to the Koranic Verse of Light, Khoury claims that this is not the case with two-dimensional mihrabs, generally used in connection with mausolea and shrines, and in such cases the symbolism of the lamp motif is instead related to the *āyat al-kursī* (the Throne Verse, *Sūrat al-Baqarah* [2]:255), which expresses the idea of the intercession (*shafāʿa*) of the Prophet, his descendants (*awliyāʿ*), and specific martyrs (*shuhadāʿ*) on Judgment Day.[29]

Hadith accounts assert that these ideas are expressed in verse 3:169, which was revealed following the battle of Uhud and which the Prophet was asked to explain.[30] His response is recorded in several versions of hadith. Abu Dawud's version states, When your brothers were killed in the battle of Uhud, God deposited their souls inside green birds that drink of the rivers of paradise and eat of its fruit, then take shelter in gold lamps (*qanādīl*) that hang in the shadow of [God's] Throne.[31]

The *qanādīl* of the hadith are special objects, vessels of light or reliquaries with a specific terminology and specific functions. As containers or images of souls, they derive their

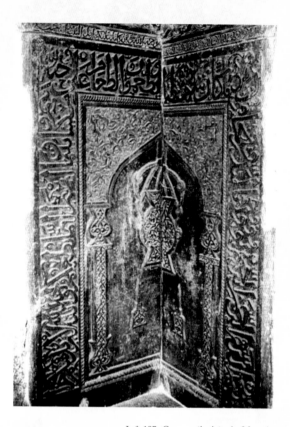
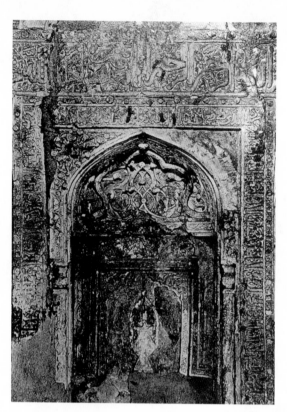

Left: 187. Corner mihrab in the Mausoleum of Imam Yaḥyā b. Qāsim, Mosul, 13th century.
Right: 188. Mihrab, Sitt Zaynab, Sinjar. 1239-59.

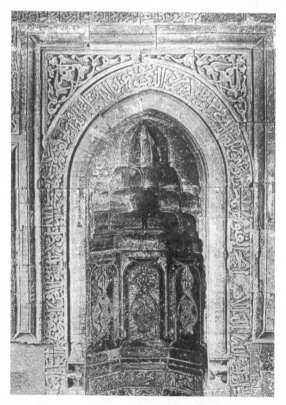
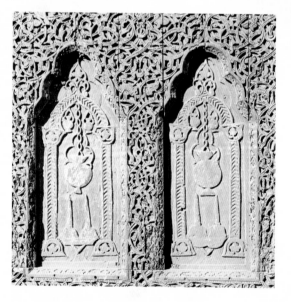

Above: 189. Side panel of Cenotaph of Fada,
Shrine of Khalid Ibn al-Walid, Hims, Syria.

Left: 190. Mihrab, Panja 'Ali, Mosul, 1287-88.

191. Glazed fritware panel with mosque lamp motif and representation of the Prophet's sandals, Darwish Pasha Mosque, Damascus.

luminosity from their contents. . . . Their associations with mystical light, a reflection of the baraka of a saint, makes the *qanādīl* fundamental motifs for representing miraculous phenomena that occur in tombs and shrines. . . . Read from the perspective of this tradition, mihrab images become representations of the soul in the *barzakh*. . . . The idea of light as a cardinal companion in the tomb and beyond is expressed by the formula, *qaddasa Allāhu rūḥahu wa nawwara ḍarīḥahu* ("May God sanctify his soul

and illumine his grave") which appears both in literature and in shrines.[32]

Many "mihrab images" originated in Iran and Iraq, such as the mihrab of the *maqām* of Sitt Zaynab at Sinjar (1239-59) where a single lamp in a niche is framed by the Throne Verse, and thirteenth-century mihrabs from Mashhad, Qum and Nejef. Several were connected to specific relics, such as the mihrab of Panja 'Ali at Mosul, which relates to the handprint of Imam 'Ali,[33] and ceramic panels on which the Lamp in the Niche motif is combined with a depiction of the Prophet's sandals at the Darwish Pasha

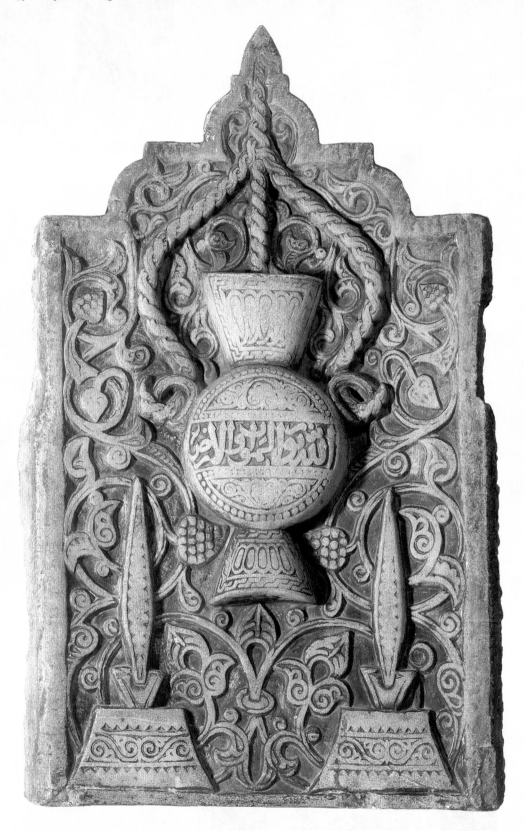

192. Stele with lamp motif with inscription from Verse of Light, Budayriyya Madrasa, Cairo, 1357.

Mosque in Damascus. However, most mihrab images belonged to shrines and mausolea and examples can be found on tombstones in many locations, including Yemen, Turkey, Iran, Afghanistan, Syria, and Egypt. Perceived ambiguities have sometimes led to a debate as to whether certain pieces should be classified as tombstones or mihrabs. Géza Fehérvári discusses this question in his article "Tombstone or Mihrab? A Speculation":

> [A] great number of flat mihrabs have survived from the first few centuries of the Hijra. . . . Tombstones with *mihrāb* designs from early Islamic times are not infrequent either. . . . Accordingly, these stone, marble, stucco, or faïence plaques can be taken either as *mihrābs* or as tombstones. It is, indeed, difficult to distinguish them, unless an inscription clarifies their purpose beyond any doubt.[33]

It is interesting how the Uhud hadith appears to establish a secondary symbolism for lamps, as luminous containers for blessed souls after death. However, given that the lamp motif is represented in the same way on both mihrabs and tombstones, and it is sometimes even difficult to distinguish between the two, it is hard to imagine that the lamp was understood to have two distinct and mutually exclusive meanings, depending on the context. It seems more plausible that there existed a multi-faceted symbolism, according to which the lamp was simultaneously understood in different ways. Apparently demonstrating a multi-layering of this type is a funerary stele from the Budayriyya Madrasa, Cairo, dated 1357 (now kept at the Museum of Islamic Art, Cairo) which has a hanging lamp and two candlesticks; despite its funerary function, its lamp motif has an epigraphic inscription from the Verse of Light running across its globular body.

Other examples in which the mosque lamp motif is encountered in a funerary context include the Cenotaph of Fada (or Fuḍḍah) at the Shrine of Khālid Ibn al-Walīd, Ḥomṣ, Syria, which has a row of arches containing hanging lamps and candlesticks,[35] as well as numerous gravestones in Turkey, including examples from the Seljuk period in the Ahlat region, those found in the graveyard of Eyüpsultan Camii in Istanbul, and also those now kept in the Iznik Museum.[36]

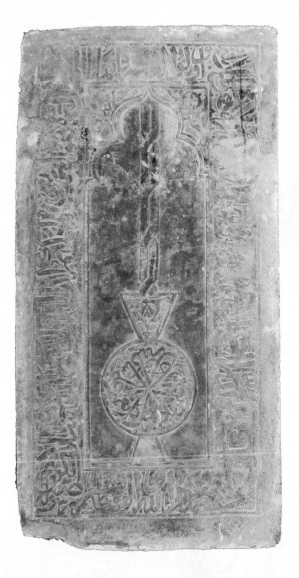

193. Mosque lamp motif on grave marker.

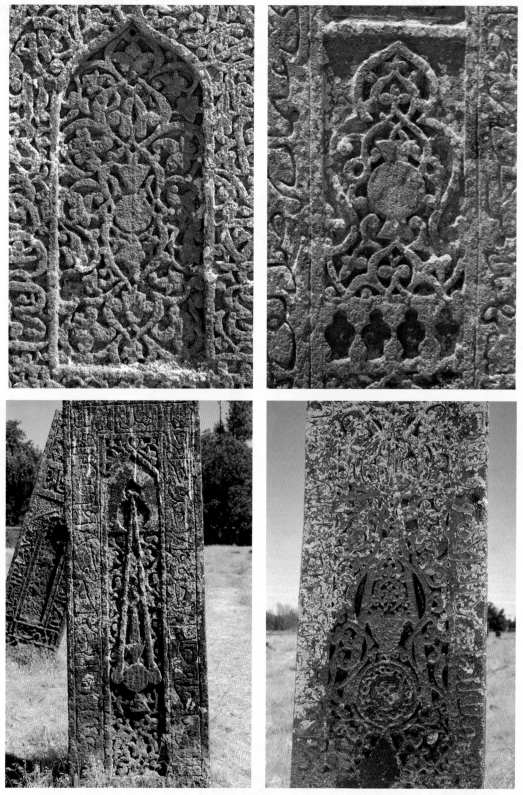

194, 195, 196 & 197. Mosque lamp motifs on grave markers dating from the Seljuk period in Ahlat, Eastern Anatolia, Turkey.

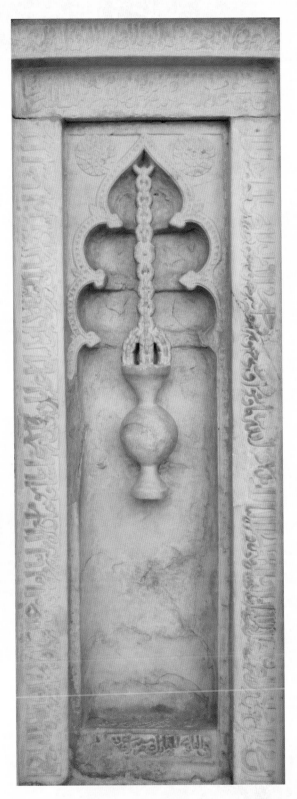

198. Lar Mihrab, carved from marble in Cambay, Gujarat,
early 14th century.

There are also many examples of Islamic tomb markers from Gujarat, India, with the lamp-in-the-niche motif. Elizabeth Lambourn provides a detailed description of the production of tombstones, mihrabs and marble carvings at the port of Khambhāt (Cambay) and their export to patrons around the Indian Ocean, from East Africa to Java:

> While there is a considerable variety of headstone design during the 1280s and 1290s, some key features emerge quite clearly. Inscriptions constitute the main type of decoration, but most examples also carry a lamp motif, something of a fashion on grave memorials throughout the Islamic world at the time. . . . [T]he majority render the lamp motif in a rich, rounded relief, placing it at the center of an arched niche and flanking it with split plantains. . . . Khambhāt mihrabs such as that from Lār and the mihrab niche commissioned by al-Kāzarūnī's freed-slave Khāliṣ in 726H/1326 are sculpted from single blocks of marble, with no joins or additions. The niche of Khāliṣ' mihrab is carved to a depth of more than fourteen centimeters, with the lamp "hanging" at its center almost in the round, attached to the back of the niche by only three thin bridges of marble.[37]

Lambourn describes how the carving aimed to achieve a *trompe l'oeil* effect with the life-size lamps hanging from meticulously worked chains precisely imitating contemporaneous glass lamps, for which they might have been mistaken, particularly if painted in color. In two further articles, Lambourn describes other notable examples where carved lamp motifs are again employed,

including the mihrab niche of the Fakhr al-Dīn mosque in Mogadishu and a two-part marble panel from the Cemetery of the Sultans at Kilwa in Tanzania, both produced at the port of Khambhāt around the late thirteenth to early fourteenth century. The Kilwa panel, the two sides of the tomb of 'Umar al-Kāzarūnī in the Jami Masjid, Khambhāt and also grave markers exported to Samudra Pasai, Sumatra, and Gresik, Java all feature a row of carved hanging lamps within arches.[38]

The same arrangement is seen on the sides of grave markers in Ahmadabad, Gurajat at the Rani Ka Hajira, the tombs of the queens of Shah Ahmad I, built c. 1445. However, in these, the form of the lamp is modified from the classic *qandīl* form in the earlier examples; while it retains the hemispherical body with the conventional foot, the top is transformed into a conical, multi-tiered shape from which two forms, presumably representing smoke or flames, emerge on either side. It is suspended

199. Tomb of 'Umar bin Ahmad Al Kazaruni, Cambay, Gujarat.

200. Cenotaph of Sultanah Nahrasiyah, Samudra Pasai, Aceh, Sumatra.

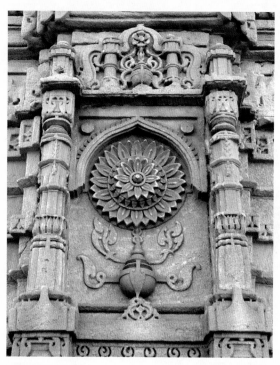

201. Sahar ki Masjid (Bohrani), Champaner, Gujarat.

202. Tomb of Mughali Bibi, Rani Ka Hajira (Tombs of the Queens), Ahmadabad.

by one, three, or five parallel chains and in most cases is surmounted by a dominant rosette or *shamsah* motif, filling the tympanum of the arch above. This form is encountered extensively in the architecture of Champaner, Gujarat, such as the fifteenth-century Jami Masjid, Kevada Masjid, Sahar ki Masjid and the mosque of Rani Sipri, in the mihrabs and on the façades.[39] A similar composition is found on the sides of the tomb of Ghiyasuddin Azam Shah (d. 1411) in Sonargaon in present-day Bangladesh. Here the form of the lamp resembles the lamp motifs in the Adina mosque mihrabs, again indicating that there were regional variations in the way the lamp was represented.

203. Tomb of Ghiyasuddin Azam Shah (d. 1411), Sonargaon, Bangladesh.

The lamp motif is also used in epigraphic compositions on Khambhāt gravestones, inserted in the voids between the verticals of Kufic script, as for example on the headstones of three monumental cenotaphs at the shrine of Malik Ibrahim (d. 822H/1419) at Gresik in eastern Java.[40] A similar use of the mosque lamp motif is found in an earlier faience inscription from the Seljuk period in Turkey, at the Ulu Cami of Eski Malatya, built in 1247, where, between the elongated shafts of the Kufic letters, one finds a hanging lamp within an arched form, flanked by two candlesticks and three stars.[41]

Many fine examples of mihrab panels, on which the mosque lamp motif is used, were earlier produced during the Seljuk and Ilkhanid periods in the workshops in Kashan, Iran, where the art of luster-ware pottery flourished. Luster mihrabs, made during the Ilkhanid period for shrines, include examples at Najaf in Iraq; Natanz in central Iran; Qum (1264); Jami' Zir Dalan, Nejef (late thirteenth century); Imamzadeh Yahya, Veramin (1265), now kept at the Doris Duke Foundation for Islamic Art, Honolulu; and four mihrabs in the collections of the Walters Art Gallery, Baltimore, the Metropolitan Museum of Art, New York, the Louvre, Paris, and the Victoria and Albert Museum, London.[42] Larger panels were made in several pieces, such as the example made for the tomb of 'Abd al-Ṣamad in Natanz, measuring 123.2 by 59.7 cm, which consisted of a set of three molded luster tiles. Many were, however, made in a single piece and are among the largest objects created by the luster potters of Kashan.[43] Although many of these panels are described as mihrabs, it is generally supposed that they were used in a funerary context, rather than as the qibla marker in a mosque. This supposition is supported by the fact that several such luster "mihrabs" are found in pairs and it has therefore been suggested that they might have been set on either side, or at either end of a cenotaph. A notable example is the so-called "Salting Mihrab,"[44] kept at the Victoria and Albert Museum, together with a second, almost identical piece, with very similar dimensions and decoration, which differs significantly only in the choice of Koranic verse used.

Discussing a late twelfth-century piece with a series of recessed arches, the smallest of which holds a lamp, Blair and Bloom write:

> In a typically Islamic layering of symbolism, the possible function of a grave marker takes the form of a mihrab, itself not only a literal niche, but also figurative gateway into Paradise and to the presence of God, symbolized here by a hanging lamp.[45]

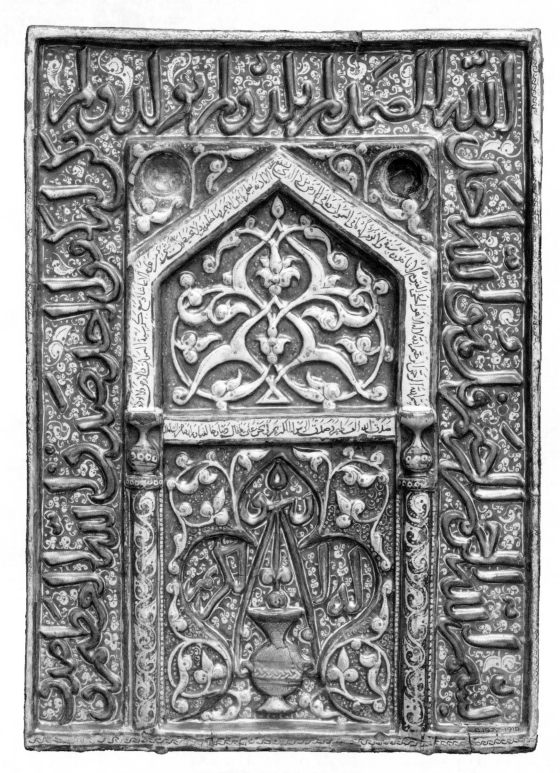

204. "Salting" mihrab, Kashan, Iran, ca. 1300.

This reference to a "typically Islamic layering of symbolism" prompts us to repeat the statement by René Guénon, quoted at the outset, about what he calls "the harmonious multiplicity of meanings which are included in all symbolism":

> We have often said, and we cannot repeat it too often: every real symbol bears its multiple meanings within it-self. . . ."[46]

One finds the motif of the lamp within the niche taking on a variety of forms consisting of a hanging ornament within an arch. In some cases the lamp is depicted naturalistically, with details, such as the suspension chains, meticulously imitating the form of actual lamps—sometimes even in three-dimensional relief, as in the Mashhad al-Husayn sanctuary in Aleppo and in the marble carvings produced at Khambhāt in Gujarat. In other cases one finds a more stylized representation of a lamp. In numerous examples, such as in many mihrabs in Delhi, the hanging ornament takes the form of a circular disk containing an epigraphic inscription reinforcing the divine presence conveyed by the lamp form. In yet other cases, the hanging ornament, if viewed in isolation, would hardly be recognizable as a lamp: sometimes it takes the form of an arabesque motif, as in the case of motifs painted on Ottoman mihrabs and those woven into many carpet designs. Likewise with various forms encountered in the Islamic architecture of Bengal, it may not be clearly identifiable as a lamp as such. However, in each case, no matter how naturalistic or abstract, the juxtaposition of the pendant form with the surrounding arch makes it recognizable as a symbolic representation of the lamp within the niche, and it acts as a reminder of the Verse of Light.

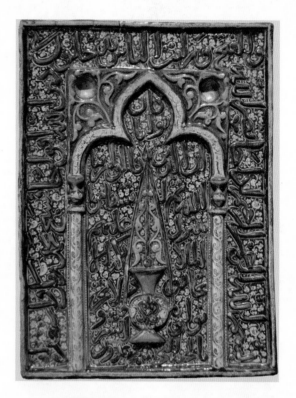

205. Oljaitu ceramic panel, late 13th-early 14th century.

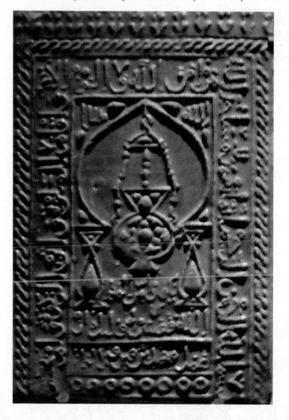

206. Glazed mihrab tile, probably Kashan.

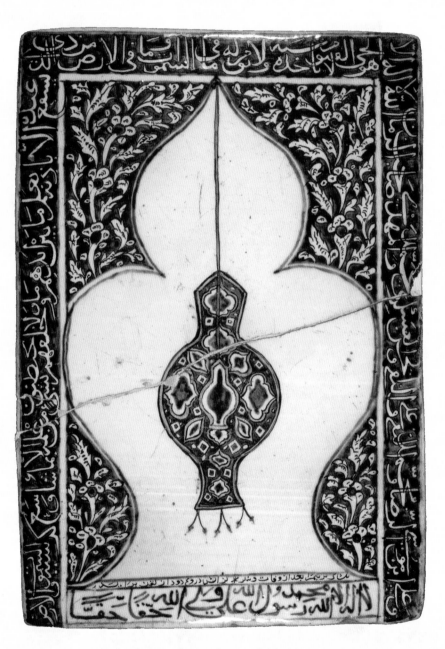

207. Tile with mihrab arch and stylized mosque lamp, height 69 cm x width: 41 cm, Iran, 17th-18th century.

Chapter 10
Conclusions

This study essentially covers two areas: first the symbolism of Light and of the lamp in Islam and other sacred traditions, with particular reference to the Koranic *āyat al-nūr*, then second the Mosque Lamp in all of its various manifestations. The symbol of the lamp in the niche, described in the Verse of Light, is such a unique formulation in the Koran and has such significance in Islamic culture, that whenever one encounters the mosque lamp, particularly the *qandīl* type, consisting of a single hanging lamp, it is associated with the verse. Unlike Judaism and Christianity, in which the Sanctuary Lamp or Altar Lamp are essential liturgical elements, and other traditions in which a lighted flame is used in conjunction with the rites of prayer, Islam assigns to the lamp no such liturgical role. Nevertheless, the widespread usage of actual lamps and also the lamp in the niche as a motif in architectural decoration and on prayer rugs meant that in Islamic culture one was surrounded by frequent reminders, symbolic in nature.

It is characteristic of Islamic art and architecture that the practical is combined with the spiritual. The Prophet praised Tamīm al-Dārī for bringing lamps to provide illumination in the mosque, but this was not just the fulfillment of a practical requirement. The lamp was evocative of illumination of a different order, as indicated by the words of the Prophet to Tamīm: *"you have illuminated Islam, may Allah enlighten your path."* So, as is characteristic of every symbol, the outer form expresses an inner reality which simultaneously reverberates on different levels. In the case of the mosque lamp it is possible to say that the symbolic dimension predominated over the functional. Although more complex types of

mosque lamp continued to be developed to provide higher levels of lighting in the mosque, the single *qandīl* lamp always remained in use, since its form acted as a reminder of the Verse of Light. Even though the amount of light actually emitted would have been compromised, glass mosque lamps were richly decorated with gilding and enameling, displaying epigraphic inscriptions. Furthermore it is particularly evident in the case of the "lamps" created in the Ottoman period, as well as other opaque examples, that these must have served almost exclusively as symbolic reminders, since they were virtually non-functional as lighting devices. Therefore one concludes that the chief function of mosque lamps was to act as reminders, referring to the symbolism in Verse of Light. In certain contexts the lamp may also have been understood as a representation of the luminous container of a blessed soul or as a reflection of the *barakah* or spiritual radiation of a saintly person. However, in every case mosque lamps, or representations of lamps in architectural decoration, symbolized a spiritual or divine presence, due to the universally understood symbolism of Light.

The mosque lamp has never ceased to act as an evocative reminder of the Verse of Light, but in this modern age few will be conscious of the depths of meaning that the verse conveys. It is therefore hoped that this study may have provided an opportunity for the reader to dwell on aspects of the profound message it contains. Al-Ghazālī's *Mishkāt al-Anwār*, which is relatively well-known, provides an inspiring commentary, describing the light that is manifested at different levels of reality, expounding the science of symbolism, and giving an interpretation of the meaning of the

niche, the lamp, the glass, the tree, the oil, and the flame in relation to the human soul and its faculties. However, in accordance with "the harmonious multiplicity of meanings which are included in all symbolism," there are innumerable alternative ways in which the verse may be interpreted.

The mosque lamp demonstrates how a symbol has the power to communicate higher truths; echoing the symbolism in the Verse of Light, it recalls how on the macrocosmic plane the divine Intellect illuminates every level of the transcendent and manifested orders, while on the microcosmic plane it illuminates the heart, as God leads man on the path of enlightenment.

> God guideth to His Light whom
> He will
> And God citeth symbols for men,
> And God is the Knower of all things.

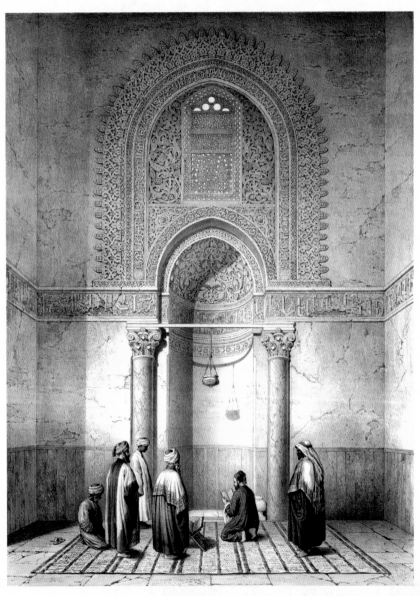

208. Lamp hanging in mihrab of Muḥammad ibn Qalā'ūn Mosque, Cairo.

Notes

Notes to Chapter 1

1. *Sūrat al-A'rāf* [7]:180. See also *Sūrat Ṭā-Hā* [20]:8; *Sūrat al-Ḥashr* [59]:24; and *Sūrat al-Isrā'* [17]:110.

2. See *Sūrat al-Nisā'* [4:]174; *Sūrat al-Mā'idah* [5]:15; *Sūrat al-An'ām* [6]:1; *Sūrat al-Tawbah* [9]:32; *Sūrat al-Nūr* [24]:40; *Sūrat al-Qaṣaṣ* [28]:71; *Sūrat al-Aḥzāb* [33]:43; *Sūrat al-Zumar* [39]:69; and *Sūrat al-Ṣaff* [61]:8.

3. Quoted in HRH Prince Ghazi bin Muhammad bin Talal, "Editor's Introduction," in Jalāl al-Dīn al-Maḥallī and Jalāl al-Dīn al-Suyūṭī, *Tafsīr al-Jalālayn: Great Commentaries on the Holy Qur'an*, trans. Feras Hamza (Louisville, KY: Fons Vitae, 2008), p. v.

4. See *Tafsīr al-Jalālayn*, p. v, which describes how, according to Ibn 'Abbās (the Prophet's cousin and student), *Sūrat al-Ra'd* [13]:17 can be interpreted symbolically.

5. Schuon, *Understanding Islam: A New Translation with Selected Letters* (Bloomington, IN: World Wisdom, 2011), chapter "The Koran and the Sunnah," p. 50.

6. Likewise *Sūrat al-Isrā* [17]:89.

Notes to Chapter 2

1. Guénon, *Fundamental Symbols: The Universal Language of Sacred Science* (Cambridge, UK: Quinta Essentia, 1995), chapter "The Holy Grail," p. 29.

2. Frithjof Schuon speaks of "the incommensurable disproportion between the Spirit on the one hand and the limited resources of human language on the other" (*Understanding Islam: A New Translation with Selected Letters* [Bloomington, IN: World Wisdom, 2011], chapter "The Koran and the Sunnah," p. 34).

3. Guénon, *Fundamental Symbols*, chapter "Word and Symbol," pp. 13-14.

4. The speed of light is considered to be a constant value (*c*), as expressed in the famous equation of mass-energy equivalence $E = mc^2$, and the Theory of Relativity considers it to be a key factor in the interrelationship of space and time.

5. 'Abdullah Yusuf 'Ali, *The Meaning of the Holy Qur'ān* (Beltsville, MD: Amana Publications, 2004), p. 876.

6. Rom Landau, *The Philosophy of Ibn 'Arabī*, (London: George Allen & Unwin Ltd, 1959), p. 37.

7. Mullā Ṣadrā Shīrāzī, *On the Hermeneutics of the Light Verse of the Qur'an*, trans. Latimah-Parvin Peerwani (London: Saqi Books, 2004), pp. 35-36.

8. René Guénon, *Fundamental Symbols*, chapter "Spirit and Intellect," p. 9 n.

9. Schuon, *Songs Without Names: Volumes VII-XII* (Bloomington, IN: World Wisdom, 2006), CXXII, p. 144.

10. Unpublished writings, courtesy of World Wisdom.

11. Schuon, *The Eye of the Heart* (Bloomington, IN: World Wisdom Books, 1997), p. 4.

12. In addition to the metaphorical use of the term, the testimony of numerous individuals returning from near-death experiences describes the quasi-visual perception of an intense light. The turning point for Saul, later to become Saint Paul, was heralded by an apparition of light: "At midday, O king, I saw in the way a light from heaven, above the brightness of the sun, shining round about me and them which journeyed with me" (Acts 26:13). Ironically the term Enlightenment has been claimed by the secularizing movement in the West, which heralded the end of the spiritual traditions in the Middle Ages.

13. Reynold A. Nicholson, trans., *The Mathnawī of Jalālu'ddīn Rūmī*, vol. 1 (London: Luzac & Co., 1925), p. 1125.

14. Ibid., p. 1130.

15. Ibid., p. 1080.

16. Edward Henry Whinfield, trans. and ed., *Masnavi i Ma'navi: Teachings of Rumi, The Spiritual Couplets of Maulana Jalalu-'d-Din Muhammad i Rumi* (1898; repr., Ames, IA: Omphaloskepsis, 2001), Book II, Story 5, verses 115-116, p. 78.

17. Quoted in Michael Oren Fitzgerald and Judith Fitzgerald, *The Sermon of All Creation: Christians on Nature* (Bloomington, IN: World Wisdom, 2005).

18. From a letter written in the fourteenth century by Saint Catherine of Siena to one of her disciples, quoted in Titus Burckhardt, *Siena: City of the Virgin* (Bloomington, IN: World Wisdom, 2008), pp. 54-55.

19. Seyyed Hossein Nasr, *Islamic Art and Spirituality* (Ipswich: Golgonooza Press, 1987), pp. 50-51.

20. *Inna'llāha ta'ālā khalaqa khalqahu fī ẓulmatin thumma alqa 'alaihim min nūrihi yauma'idhin, fa man aṣāba min nūrihi yauma'idhin ihtadā wa man akhṭa'a ḍalla.* Recorded by Imam Ahmad from 'Abdullah bin 'Amr.

21. Schuon, *Dimensions of Islam* (London: George Allen & Unwin, 1970), pp. 102-20.

22. It is noteworthy that in Islamic calligraphy the diacritical point, corresponding to the breadth of the nib of the *calamus* reed pen, in fact acts as the module for the proportioning of all the letters in the alphabet.

23. Schuon, *Dimensions of Islam*, pp. 108-09.

24. Ibid., p. 112.

25. Schimmel, *Deciphering the Signs of God: A Phenomenological Approach to Islam* (Albany, NY: State University of New York Press, 1994), pp. 12-13.

26. See Éric Geoffroy, *Introduction to Sufism: The Inner Path of Islam* (Bloomington, IN: World Wisdom, 2010), chapter "The Prophet as Primordial Light," pp. 44-45.

27. Quoted in Christiane J. Gruber, "Between Logos (Kalima) and Light (Nūr): Representations of the Prophet Muhammad in Islamic Painting," in *Muqarnas* 26 (2009), p. 259 n. 61. A similar hadith states: It is related that Jābir ibn 'Abd Allāh said to the Prophet: "O Messenger of Allāh . . . tell me of the first thing Allāh created before all things." He said: "O Jābir, the first thing Allāh created was the light of your Prophet from His light, and that light remained in the midst of His Power for as long as He wished, and there was not, at that time, a Tablet or a Pen or a paradise or hell fire, or an angel or a heaven or an earth, or a sun or a moon, or jinn or man. And when Allāh wished to create creation, he divided that Light into four parts and from the first made the Pen, from the second the Tablet, from the third the Throne, then he divided the fourth into four parts [and from them created everything else]."

28. See Annemarie Schimmel, *Mystical Dimensions of Islam* (Chapel Hill, NC: The University of North Carolina Press, 1975), p. 224

29. Quoted in Gruber, "Between Logos," p. 250.

30. William Henry Temple Gairdner, trans., *Al-Ghazali's Mishkat al-Anwar ("The Niche for Lights")* (London: Royal Asiatic Society, 1924), p. 88. Gairdner notes that some versions of the hadith read "seven hundred veils" and others "seventy thousand." See Muslim 263 (343) and Ibn Mājah 191.

31. Hadith narrated by Abu Dharr, Muslim 261.

32. William C. Chittick, *Sufism: A Beginner's Guide* (Oxford: Oneworld Publications, 2007), chapter "The Paradox of the Veil," p. 181.

33. Schuon, *Esoterism as Principle and as Way* (London: Perennial Books, 1990), chapter "The Mystery of the Veil," pp. 47-64.

34. Unpublished writings. This echoes the words of Saint Catherine of Siena when, in a prayer, she says: "It is only through shadows that one comes to know the light" (*Ben confesso che chi cognosce la tenebre cognosce la luce*), from Orazione XVIII, a prayer by Catherine of Siena, in the year 1379, addressed to Christ on the cross. See Giuliana Cavallini, ed., *Le Orazioni di S. Caterina da Siena* (Rome: Edizioni Cateriniane, 1978); and, based on the Cavallini edition, Suzanne Noffke, trans. and ed., *The Prayers of Catherine of Siena* (New York: Paulist Press, 1983).

35. It is noteworthy that, according to Genesis 1:1-19, Light, Day, and Night were created on the first day, the firmament of Heaven on the second day, but the sun, the moon and the stars were only created on the fourth day. God's Light can therefore not be equated with the light of the sun and the other "lights in the firmament of the heaven."

36. This account also appears in the Koran, *Sūrat al-Qaṣaṣ* [28]:30.

37. Nicholson, *Mathnawī*, p. 2880.

38. Schuon, *Adastra & Stella Maris: Poems by Frithjof Schuon* (Bloomington, IN: World Wisdom, 2003), "Das Sein," pp. 44-45. See also the chapter "Ontology of the Burning Bush" in René Guénon's *The Symbolism of the Cross*, trans. Angus Macnab (Hillsdale, NY: Sophia Perennis, 2001), in particular his comment that: "In certain schools of Islamic esoterism, the 'Burning Bush,' a support of the divine manifestation, is taken as a symbol of the individual appearance persisting after the being has attained to the 'Supreme Identity' . . . ; it is the heart resplendent with the light of the *Shekinah*, by the effectively realized presence of the 'Supreme Self' at the center of the human individuality" (p. 93 n. 5).

39. Schuon, *Understanding Islam: A New Translation with Selected Letters* (Bloomington, IN: World Wisdom, 2011), chapter "The Koran and the Sunnah," p. 48 n. 31.

40. Schuon, *Gnosis: Divine Wisdom* (Bloomington, IN: World Wisdom, 2006), chapter "Gnosis: Lan-

guage of the Self," p. 66.

41. Frithjof Schuon, *Form and Substance*, chapter "The Five Divine Presence," p. 63 n. 10.

42. Koran, *Sūrat al-Qaṣaṣ* [28]:32. See also *Sūrat Ṭa-Ha* [20]:22-23 and *Sūrat al-Naml* [27]:12, as well as Exodus 4:6-7.

43. Unpublished writings.

44. See James W. Boyd and Firoze M. Kotwal, "Worship in a Zoroastrian Fire Temple: The H. B. Wadia Ātaš Bahrām," in *Indo-Iranian Journal* 26 (1983).

45. Sunil Kristi Krishnadas, trans., *Bhagavad Gita: The Spiritual Song* (Bloomington, IN: Trafford Publishing, 2010), chapter 15, verse 12, p. 196.

46. Swami Sivananda, trans., *Ten Upanishads: With Notes and Commentary* (Rishikesh, India: Divine Life Society, 1973), p. 148.

47. From the Yoga Sutra of Patanjali, second century B.C.E, quoted in Lama Surya Das, *Awakening to the Sacred: Creating a Personal Spiritual Life* (New York: Broadway Books, 1999), p. 14.

48. Tiruvacagam 22.8.9, quoted in Ratna-Ma Chelliah Navaratnam, *Testament of Truth: A Study of the Life and Teachings of Yogaswami* (Jaffna, Sri Lanka: K. Navaratnam, 1972), p. 251.

49. Chandogya Upanishad 3:13:7, quoted in Phyllis Zagano, ed., *Mysticism and the Spiritual Quest: A Cross-cultural Anthology* (Mahwah, NJ: Paulist Press, 2013).

50. The Prophet had adopted the practice of making retreats in the cave of Hira (*Ġhār Ḥirāʾ*) on the side of a mountain close to Mecca. As narrated by ʿĀʾishah: "He used to go in seclusion in the cave of Hira where he used to worship continuously for many days . . ." (Ṣaḥīḥ Al Bukhārī, Volume 1, 1.3). It is noteworthy that the name of this mountain is *Jabal al-Nūr*, meaning the Mountain of Light.

51. Referred to in Exodus 19:11, 18, 20 as Mount Sinai and likewise in the Koran as *Ṭūr Sīnāʾ* or *Ṭūr Sīnīn*, but in Exodus 3:1 and Deuteronomy 1:6; 4:10, 15; 5:2; 9:8; 18:16; 29:1, etc., as Mount Horeb, as also in 1 Kings 19:8 when God appeared to the prophet Elijah (called Elias in the New Testament) when he returned to the same cave several centuries later. At the summit of Mount Sinai is a small cave, where Moses is said to have spent forty days and received the Ten Commandments, referred to in Exodus 33:22 as a "cleft in the rock."

52. These parallels in the revelation of all three Semitic monotheistic religions are particularly striking.

It should be noted that in Christianity, God's message was manifested in the person of Jesus, while in Islam, the message was manifested as a scripture (as in Judaism). Further parallels are also to be seen, as Muhammad's truthfulness and integrity and his being "unlettered" (*al-nabī al-ummī*) made him an uncontaminated vessel, fit for the Divine Message, in the same way that the Virgin Mary was a pure receptacle for the "word made flesh." In this connection Schuon writes: "[I]t is the Koran that in all strictness corresponds to the Christ-Eucharist, and that represents the great Paracletic manifestation, a 'descent' (*tanzīl*) effectuated by the Holy Spirit (*Ar-Rūḥ*, called *Jibrīl*—Gabriel—in its function as Revealer). It follows that the function of the Prophet is from this point of view analogous and symbolically even identical to that of the Virgin Mary, who was likewise the 'ground' for the reception of the Word. . . . [The Virgin and the Prophet] are identified—in their receptive function . . . with the passive aspect of universal Existence . . . and it is for this reason that the Virgin is 'immaculate' and, from the merely physical standpoint 'virgin,' while the Prophet, like the Apostles, is 'illiterate' (*ummī*), that is to say, pure from the taint of human knowledge or knowledge humanly acquired. This purity is the first condition for the reception of the Paracletic Gift, just as in the spiritual order chastity, poverty, humility, and other forms of simplicity or unity are indispensable for the reception of the Divine Light. . . . To return to the purity of the Prophet, we also find in his case the exact equivalent of the 'Immaculate Conception'" (Schuon, *The Transcendent Unity of Religions*, trans. Peter Townsend [Wheaton, IL: Quest Books, 1993], chapter "Christianity and Islam," pp. 120-22).

53. For example, Saint Anthony (c. 983-1073) established the famous Monastery of the Caves in Kiev. In the thirteenth century, Saint Francis spent time in prayer and contemplation in the *Eremo delle Carceri*, a small hermitage on Monte Subasio, above Assisi in Umbria; subsequently a sizeable complex grew up around Saint Francis' cave and the original oratory, which today is still inhabited by Franciscan monks.

54. Koran, *Sūrat al-Kahf* [18]:7-26.

55. Lings, *Symbol & Archetype: A Study of the Meaning of Existence* (Louisville, KY: Fons Vitae, 2006), chapter "The Symbolism of the Mosque and the Cathedral," p. 131-32. The author's notes are given with updated citations.

56. Titus Burckhardt, *Sacred Art in East and West,* (Louisville, KY: Fons Vitae, 2001), pp. 104-05.

57. Burckhardt, *Chartres and the Birth of the Cathedral: Revised* (Bloomington, IN: World Wisdom, 2010), p. 29.

58. Burckhardt, *Sacred Art,* p. 105.

59. *Fundamental Symbols,* chapter "The Cave and the Labyrinth," p. 141.

60. Ibid., chapter "The Heart and the Cave," p. 145.

61. Titus Burckhardt, *Art of Islam: Language and Meaning* (Bloomington, IN: World Wisdom, 2009), pp. 90, 93.

62. Burckhardt, "The Universality of Sacred Art," in Ranjit Fernando, ed., *The Unanimous Tradition: Essays on the Essential Unity of All Religions* (Columbo: Sri Lanka Institute of Traditional Studies, 1991) p. 108.

63. Burckhardt notes that according to this tradition, Zacharias took Mary as a child into the Holy of Holies because he recognized that she was herself the holy tabernacle.

64. Burckhardt, *Art of Islam,* pp. 90, 93.

65. Frithjof Schuon, *In the Face of the Absolute: A New Translation with Selected Letters* (Bloomington, IN: World Wisdom, 2014), chapter "The Mystery of the Prophetic Substance," p. 127.

66. Schuon adds in a note: "Within the framework of this particular symbolism the words 'neither of the East nor of the West' seem to indicate that the Virgin, in that she personifies both the universal *Shakti* and the *Sophia Perennis*, belongs exclusively neither to Christianity nor to Islam, but to both religions at the same time, or that she constitutes the link between the two."

67. Schuon, *Form and Substance in the Religions* (Bloomington, IN: World Wisdom, 2002), chapter "The Virginal Doctrine," pp. 115-16.

68. Unpublished writings. In this context the Arabic term *faqr* denotes "spiritual poverty" (in the sense conveyed by Matthew 5:3: "Blessed are the poor in spirit, for theirs is the kingdom of heaven") and *rizq,* "divine sustenance."

69. See "nūr" in Hans Wehr, *Dictionary of Modern Written Arabic,* ed. J. Milton Cowan (Ithaca, NY: Cornell University Press, 1976).

70. See Afnan H. Fatani, "Mishkat," in Oliver Leaman, ed., *The Qur'an: An Encyclopedia* (London: Routledge, 2006).

71. The symbolic significance of this alternative interpretation will later be elaborated upon in the context of the commentaries on the Verse of Light given by Shaykh Maḥmūd Shabistarī and Ṣafī ʿAlī Shāh Niʿmatullāhī and also the observations made by Mahmud Bina-Motlagh.

72. Charles Simon Clermont-Ganneau, "La lampe et l'olivier dans le Coran," in *Revue de l'Histoire des Religions* 81 (1920), p. 218. This and all subsequent passages quoted from this work are translated from the French by the present author.

73. See Erica C. Dodd, "Light I: The Lamp in the Niche," in Helene E. Roberts, ed., *Encyclopedia of Comparative Iconography: Themes Depicted in Works of Art,* vol. 1 (Chicago: Fitzroy Dearborn, 1998), pp. 499-504.

74. *al qulūbu arba'atun: qalbun ajradu fīhi mithlu-s sirāji yuzhiru, wa qalbun aghlafu marbūṭun ʿalā ghilāfihi, wa qalbun mankūsun, wa qalbun muṣfaḥ. Fa amma-l qalbu-l ajradu: fa qalbu-l mu'mini sirājuhu fīhi nūruh.* Recorded by Imam Ahmad from Abu Sa`id Al-Khudri. Its chain of transmission is good (*jayyid*) although it was not recorded by Al-Bukhārī and Muslim.

75. *Sūrat al-Furqān* [25]:61; *Sūrat Nūḥ* [71]:15-16; and *Sūrat al-Naba'* [78]:12-13.

76. "[V]erily thou wilt come upon an alcove and thou shalt see a Lamp suspended above the alcove" (Edward William Lane and Stanley Lane-Poole, trans., *Stories from the Thousand and One Nights,* vol. 16 [New York: P. F. Collier and Son, 1909]).

77. Assadullah Souren Melikian-Chirvani, "The Lights of Sufi Shrines," in *Islamic Art* 2 (1987), quoted in Naseem Ahmed Banerji, *The Architecture of the Adina Mosque in Pandua, India: Medieval Tradition and Innovation* (Lewiston, NY: Edwin Mellen Press, 2002), p. 148 n. 313.

78. In this account, the holy lamp still had to be lit but there was only enough oil remaining for one day and it would take several days for new oil to be prepared. Despite the amount of oil that remained, the lamp burned for eight days—enough time for new oil to be prepared. See "Candlestick," in *The Jewish Encyclopedia: A Descriptive Record of the History, Religion, Literature, and Customs of the Jewish People from the Earliest Times to the Present Day,* vol. 3 (New York: Funk & Wagnalls, 1903), pp. 531-33.

79. See also Exodus 27:20. It should be noted that whereas the King James 2000 Bible uses the terms "lamp" and "lampstand", the original King James Version of the Bible uses the terms "candle" and

"candlestick". However, this is in fact a misnomer, since the seven branches of the menorah supported oil lamps not candles. We have thus used the King James Translation, but replaced "candle" with "lamp" and "candlestick" with "lampstand."

80. See "Candle," in Jean C. Cooper, *An Illustrated Encyclopaedia of Traditional Symbols* (London: Thames & Hudson, 1978), p. 28.

81. See Augustin J. Schulte, "Altar-Lamp," in *The Catholic Encyclopedia: An International Work of Reference on the Constitution, Doctrine, Discipline, and History of the Catholic Church*, vol. 1 (New York: Robert Appleton, 1907), p. 354.

82. Charles Rohault de Fleury, "Lampes," in *La Messe: études archéologiques sur ses monuments*, vol. 6 (Paris: Librairie des Imprimeries réunies, 1888), p. 19. This and all subsequent passages quoted from this work are translated from the French by the present author.

83. Ibid., p. 1.

84. See, for example, illustrations 81-84 on page 72.

85. Ibid., pp. 25-28. Rohault de Fleury mentions examples of "crowns of light" at the cathedrals of Paris, Metz, Poitiers, Reims, Saint Lambert in Liège, Aix-la-Chapelle, Troyes, and Hildesheim as well as at churches in Bayeux, Saint Viton in Verdun, Saint-Maurice and Saint Peter in Angers, Cluny, Holy Cross in Orleans, Saint John in Lyon, Saint-Rémy in Reims, Saint Pantaléon in Cologne, Weissembourg in Alsace, and the ancient abbey of Combourg.

86. "Why is Ghee Lamp Preferred to Oil Lamp During Puja Ritual?" last modified November 5, 2015, http://www.hindujagruti.org/hinduism/knowledge/article/why-is-ghee-lamp-preferred-to-oil-lamp-during-puja-ritual.html

87. Swamini Vimalananda and Radhika Krishnakumar, *In Indian Culture: Why do we....?* (Mumbai: Central Chinmaya Mission Trust, 2008), chapter "Why Do We Light a Lamp?," p. 4.

88. See "Dīpa," in *The Soka Gakkai Dictionary of Buddhism* (Tokyo: Soka Gakkai, 2002).

89. Tenzin Gyatso (the Fourteenth Dalai Lama), *Illuminating The Path to Enlightenment: A Commentary on Atisha Dipamkara Shrijnana's* A Lamp For The Path To Enlightenment *and Lama Je Tsong Khapa's* Lines Of Experience, trans. Geshe Thupten Jinpa, eds. Rebecca Mcclen Novick, Thupten Jinpa, and Nicholas Ribush (Long Beach, CA: Thubten Dhargye Ling, 2002), pp. 14-15.

90. A.G.S. Kariyawasam, *Buddhist Ceremonies and Rituals of Sri Lanka* (Kandy, Sri Lanka: Buddhist Publication Society, 1995), p. 6.

91. See in particular the chapter "The Five Divine Presences" in Schuon, *Form and Substance in the Religions* (Bloomington, IN: World Wisdom, 2002), pp. 51-68.

92. Stoddart, *Outline of Buddhism* (Oakton, VA: Foundation for Traditional Studies, 1998), pp. 38-39.

93. Stoddart, *Remembering in a World of Forgetting* (Bloomington, IN: World Wisdom, 2008), pp. 48-49, 61-62.

94. This characteristic of the material is borne out in the Koranic account (in *Sūrat al-Naml* [27]:44) of how Bilqis, the Queen of Sheba, mistook the floor of King Solomon's palace "paved smooth with slabs of glass" for an expanse of water, although it is worth noting that the term used here is *qawārīr*, denoting crystal, whereas the word used in the *āyat al-nūr* is *zujājah*.

95. This question will be examined in further detail in a later chapter entitled "How Would Early Mosque Lamps Have Looked?"

96. *kulū mina-z zaiti waddahanū bihi fa innahu shajaratun mubārakah*. Hadith transmitted by al-Tirmidhī, Ibn Mājah and Dārimī. (Al-Tirmidhī Hadith 4221, Narrated by Abu Usayd al-Anṣārī)

97. "The Prophet ordered them to treat pleurisy with sea costus and olive oil" (Tirmidhī 4535) and likewise: "The Prophet used to recommend olive oil and *wars* for pleurisy" (Tirmidhī 4536), both narrated by Zayd ibn Arqām. *Wars* is a yellow-colored plant, like sesame, found in the Yemen.

98. See Guy Le Strange, *Palestine Under the Moslems: A Description of Syria and the Holy Land from A.D. 650 to 1500* (London: Alexander P. Watt, 1890), p. 73: "'Ṭūr Sīnā,' writes Mukaddasi, 'is the place where Moses and the children of Israel encamped. . . . The Christians have a monastery (*Dair*) in Mount Sinai, and round it are some well cultivated fields, and there grow here olive-trees, said to be those mentioned by Allah in the Ḳurān (chap. xxiv., ver. 35), where it is written concerning that "blessed tree, an olive neither of the east nor of the west." And the olives from these trees are sent as presents to kings.' (Muk., 179.)"

99. In 527 the Byzantine Emperor Justinian ordered the construction of the protective walls and many of the buildings which still survive today; however, as early as 378 a Greek monk named Silvanos settled

on the site and thereafter it became home to a community of monks.

100. Mark 6:13; likewise, in James 5:14.

101. Charles Simon Clermont-Ganneau, "La lampe et l'olivier dans le Coran," in *Revue de l'Histoire des Religions* 81 (1920), p. 216.

102. Le Strange, *Palestine Under the Moslems*, p. 353.

103. Clermont-Ganneau, "La lampe et l'olivier," pp. 249ff.

104. Le Strange, *Palestine Under the Moslems*, p. 147.

105. Clermont-Ganneau, "La lampe et l'olivier," pp. 225-29.

106. Frithjof Schuon, *Logic and Transcendence: A New Translation with Selected Letters* (Bloomington, IN: World Wisdom, 2009), chapter "Understanding and Believing," pp. 176-77.

107. Unpublished writings.

108. Lings, *A Sufi Saint of the Twentieth Century: Shaikh Ahmad Al-'Alawi, His Spiritual Heritage and Legacy* (Cambridge, UK: The Islamic Texts Society, 1993), p. 174 n. 2.

109. Schuon, *Esoterism as Principle and as Way* (London: Perennial Books, 1990), chapter "The Primordial Tree," p. 79.

110. Guénon, *Fundamental Symbols*, chapter "The World Tree," pp. 220-23.

111. Ibid., p. 223.

112. Almquist, "The Sun in the Tree," in *Religion of the Heart* (Washington, DC: Foundation for Traditional Studies, 1991), pp. 10-11.

113. Unpublished writings.

Notes to Chapter 3

1. Significant commentators on the *āyat al-nūr* include: al-Ṭabarī (d. 310H/923); Ka'ab al-Aḥbār (d. 32H/652 or 34H/654); Ibn 'Abbās (d. 68H/687); Muqātil (d. 150H/767); Junayd (d. 297H/910); Abū Sa'īd al-Kharrāz (d. 277H/891); Sahl al-Tustarī (d. 283H/896); Ibn 'Aṭā' (d. 309H/92); Manṣūr al-Ḥallāj (d. 309H/922); Abu 'Alī al-Jūzajānī (Fourth Century H/Tenth century); Abū 'Abd al-Raḥmān al-Sulamī (d. 412H/1021); Abū'l-Qāsim al-Qushayrī (d. 465H/1072); Shams al-Dīn al-Daylamī (d. shortly after 593H/1197); Avicenna (Abū 'Alī al-Ḥusayn ibn 'Abd Allāh ibn Sīnā), 980-1037; al-Ghazālī [Abū Hāmid Muḥammad ibn Muḥammad al-Ghazālī] (1058-1111); Rūzbihān Baqlī [Abū Muḥammad Shaykh Rūzbihān Baqlī] (1128-1209); Fakhr al-Dīn al-Rāzī (1149-1209); Ibn 'Arabī [Muḥyiddīn ibn al-'Arabī] (1165-1240); Rūmī [Jalāl al-Dīn Muḥammad Rūmī] (1207-1273); Mulla Ṣadra [Ṣadr al-Dīn Muḥammad Shīrāzī] (c. 1571-1641); Dārā Shikūh [Sultan Muḥammad Dārā Shikūh] (1615-1659); and Safi 'Alī Shah Ni'matullāhī (d. 1898).

2. René Guénon, *Fundamental Symbols: The Universal Language of Sacred Science* (Cambridge: Quinta Essentia, 1995), chapter "The Sacred Heart and the Legend of the Holy Grail," p. 24.

3. See Gerhard Böwering, "The Light Verse: Qur'ānic Text and Sūfī Interpretation," in *Oriens* 36 (2001), pp. 113-144.

4. See Kristin Zahra Sands, *Sūfī Commentaries on the Qur'ān in Classical Islam* (London: Routledge, 2006), pp. 8-12.

5. Ibid, pp. 114ff. See also Gerhard Böwering, "The Light Verse."

6. Regarding the spelling of his name, see Frank Griffel, "Al-Ghazālī or Al-Ghazzālī? On A Lively Debate Among Ayyūbid And Mamlūk Historians In Damascus," in *Islamic Thought in the Middle Ages: Studies in Text, Transmission and Translation, in Honour of Hans Daiber*, eds. Anna Akasoy and Wim Raven (Boston: Brill, 2008), pp. 101-112.

7. Sands provides a table, giving a comparison of interpretations of the various elements of the lamp and the niche in classical *tafsīr* of the Light Verse. See Sands, *Sūfī Commentaries*, p. 129, table 9.1.

8. See Mullā Ṣadrā Shīrāzī, *On the Hermeneutics of the Light Verse of the Qur'an*, trans. and ed. Latimah-Parvin Peerwani (London: Saqi Books, 2004), pp. 31-32.

9. Ibid., p. 41.

10. Roger Lipsey, ed., *Coomaraswamy: Selected Papers I, Traditional Art and Symbolism*, (Princeton, NJ: Princeton University Press, 1977), chapter "Philosophy of Persian Art," p. 263.

11. A better translation of the expression "the Self of the Truth" would be "the Truth Itself."

12. Dārā Shikūh, *Majma'-ul-Baḥrain: Or The Mingling of the Two Oceans*, ed. and trans. Muhammad Mahfuz-ul-Haq (Calcutta: Asiatic Society, 1926), chapter "Discourse On Light (*Nūr*)," pp. 48-50. In his translation of this passage, M. Mahfuz-ul-Haq translates *rūḥ* as "soul." However, the term corresponds more closely to "spirit" and the translation has been amended accordingly.

13. Edward Henry Whinfield, trans., *Gulshan i Raz: The Mystic Rose Garden of Sa'd ud din Mahmud Shabistari* (London: Trübner & Co., 1880).

14. The stars have been described in an analogous manner as perforations in the dome of the heavens, but with an inverse symbolism, since in this case the light of the Spirit comes from outside the perforated envelope.

15. Abū Bakr Sirāj ad-Dīn, *The Book of Certainty: The Sufi Doctrine of Faith, Vision and Gnosis* (Cambridge, UK: Islamic Text Society, 1992), pp. 88-89.

16. Unpublished writings.

17. Frithjof Schuon, *Sufism: Veil and Quintessence, A New Translation with Selected Letters* (Bloomington, IN: World Wisdom, 2007), chapter "The Quintessential Esoterism of Islam," p. 111-13.

18. Unpublished writings.

19. Schuon refers to formulations by Abū Ṭālib Al-Makkī, Ibn ʿArabī, Jurjānī, Ghazālī, and Jīlī.

20. Frithjof Schuon, *Form and Substance in the Religions* (Bloomington, IN: World Wisdom, 2002), chapter "The Five Divine Presences," pp. 51-55, 55 n. 4. While it may seem unexpected that in this description of the microcosmic, human "way of seeing" the Principle (rather than the gross, material state) is situated in the center—and vice versa for the macrocosmic, divine "way of seeing"—Schuon explains in the same note: "This is necessarily one of the meanings of the Yin-Yang: the black part, containing a white dot, represents the night of the microcosm with the luminous divine center, whereas the white part, with the black dot, symbolize the Infinite insofar as It 'contains' the finite". Schuon's description of the doctrine of the five realms of 1) *hāhūt*, 2) *lāhūt*, 3) *jabarūt*, 4) *malakūt*, and 5) *nāsūt*, has been represented by William Stoddart in the form of a diagram. See Stoddart, *Remembering in a World of Forgetting* (Bloomington, IN: World Wisdom, 2008), p. 49; see also our version of this diagram on page 38 supra.

21. Mahmud Bina-Motlagh, Professor Emeritus of Mathematics and Philosophy of Science, Isfahan University of Technology, Iran.

22. *inna'llāha khalaqa mulkahu ʿalā mithāli malakūtihi, wa assasa malakūtahu ʿalā mithāli jabarūtih.* Hasan Hasanzadeh Amoli, *Resale Nur ala Nur dar Zekr va Zaker va Mazkur* (Qom, Iran: Tashayo Press, 1993), p. 30.

23. The three stages of the soul on the spiritual path are traditionally described as: initially *nafs al-ammārah* (the "commanding" soul, i.e. the passionate soul which incites to evil), then *nafs al-lawwāmah* (the self-reproaching soul), and finally *nafs al-muṭma'innah* (the soul at peace).

24. *Sūrat al-Fajr* [89]:27-30 "O thou soul which art at peace. Return unto thy Lord with gladness that is thine in Him and His in thee. Enter thou among My slaves! Enter thou My Paradise!" Translation by Martin Lings, *What is Sufism?* (Berkeley, CA: University of California Press, 1977), p. 42.

Notes to Chapter 4

1. Frithjof Schuon, *Understanding Islam: A New Translation with Selected Letters* (Bloomington, IN: World Wisdom, 1994), chapter "The Koran and the Sunnah," p. 51.

2. Titus Burckhardt, *Art of Islam: Language and Meaning* (Bloomington, IN: World Wisdom, 2009), p. 50.

3. Jean-Louis Michon, *Introduction to Traditional Islam: Illustrated* (Bloomington, IN: World Wisdom, 2008), p. 72.

4. The inscription continues up to the phrase "a blessed tree, neither of the east nor of the west."

5. See Gülru Necipoğlu-Kafadar, "The Süleymaniye Complex in Istanbul: An Interpretation," in *Muqarnas* 3 (1985), p. 100.

6. See Sheila Blair, "The Monumental Inscriptions from Early Islamic Iran and Transoxiana," in *Muqarnas Supplements* 5 (1991), pp. 191-92. Here Blair mentions the possible connections between the Arabic terms *nūr* (light) and *manāra* (minaret, or place of light). See also Assadullah Souren Melikian-Chirvani, "The Light of Heaven and Earth: From the *Chahār-ṭāq* to the *Miḥrāb*," in *Bulletin of the Asia Institute* 4 (1990), pp. 109-112.

7. See Janine Sourdel-Thomine and Donald N. Wilber, "Inscriptions seljoukides et salles à coupoles de Qazvin en Iran," in *Revue des Etudes Islamiques* 42 (1974), pp. 3-43.

8. Safavid period mihrab, height 290 cm, width 245 cm, Cleveland Museum of Art, 1962.23.

9. Here they follow on from the *Surat al-Nūr* [24]:11. See Caroline Williams, "The Cult of ʿAlid Saints in the Fatimid Monuments of Cairo, Part I: The Mosque of al-Aqmar," in *Muqarnas* 1 (1983), pp. 37-52.

10. Based on the false premise that the Verse of Light is used in the epigraphic inscription above the monumental entrance of the Sultan Hasan madrasah, Dodd develops an elaborate argument linking the doorway of the mosque to its *miḥrāb*, due

to the supposed reference to the lamp in a niche. However, the inscription is not from the Verse of Light but from the verses immediately following it, containing no reference to the lamp, which invalidates her theory. See Erica C. Dodd, "The Image of the Word: Notes on the Religious Iconography of Islam," in *Berytus* 18 (1969), pp. 35-62. A second work, in which the same idea is expressed is Dodd, "Light I: The Lamp in the Niche," in Helene E. Roberts, ed., *Encyclopedia of Comparative Iconography: Themes Depicted in Works of Art*, vol. 1 (Chicago: Fitzroy Dearborn, 1998), p. 499.

Notes to Chapter 5

1. Charles Simon Clermont-Ganneau, "La lampe et l'olivier dans le Coran," in *Revue de l'Histoire des Religions* 81 (1920), p. 217.

2. See Clermont-Ganneau, "La lampe et l'olivier," p. 237. The author mentions references by Paulinus of Nola, who speaks of chandeliers with glass pendants forming mobile "*girandoles.*"

3. Ibid., pp. 237-38.

4. Charles Rohault de Fleury, *La Messe: études archéologiques sur ses monuments*, vol. 6 (Paris: Librairie des Imprimeries réunies, 1888), p. 3.

5. His dying words were: "I have prepared a lamp for my anointed" (Psalms 132:17).

6. Quoted in part in Rohault de Fleury, *La Messe*, p. 5 and in full in Alexandre Burnier, "Faire voir la Parole: la *phantasia* dans le 7e *Natalicium* de Paulin de Nole," in *Incon i triestini di filologia classica* 4 (2004-05), pp. 257-72. This text provides interesting details concerning the three metal hooks at the end of the cable by which the lamp glass was suspended; the glass vase filled with water with the oil floating on top, the oil yellow in color and the water white; the little leaden tripod, which held the wick on the surface of the oil; and the way the wick was prepared from linen.

7. The Prophet was born in the year 570 in Mecca, five years after the death of Justinian. His migration to Medina was in the year 622, and he died in the year 632.

8. Silentiaries were respected court officials, who ranked with the senators, were employed in all kinds of service and often became the historians of the emperor.

9. See William R. Lethaby and Harold Swainson, *The Church of Sancta Sophia, Constantinople: A Study of Byzantine Building* (New York: Macmillan & Co., 1894), pp. 49-50.

10. See Fobelli, "Light and lighting in Justinian's Hagia Sophia in Constantinople," a paper presented at the Twenty-First International Congress of Byzantine Studies, London 2006. Important liturgical treasures were found in Syria and Turkey, among them the Kaper Karaon Treasure, found in 1908 at Stuma, and the Sion Treasure, found in 1963 at Kumluca, Lycia.

11. This incident is described by 'Alī ibn Aḥmad al-Samhūdī (d.1505), in his history of the city of Medina, *Wafā' al-Wafā bi-Akhbār Dār al-Muṣṭafā* ([Beirut: Dar Al-Kotob Al-Ilmiyah, 2006], vol. 2, p. 149) and also in the *tafsīr* on *Sūrat al-Nūr* [24]:36 by al-Qurṭubī (1214-1273) in *al-Jāmi' li al-aḥkām al-Qur'ān* ([Cairo: Maṭba'ah Dar al-Kutub al-Maṣriyyah, 1935], vol. 22, p. 274). The translation quoted here is from Avinoam Shalem, "Fountains of Light: The Meaning of Medieval Islamic Rock Crystal Lamps," in *Muqarnas* 11 (1994), p. 9 n. 35 which is based on the version in Clermont-Ganneau, "La lampe et l'olivier," p. 259. A more literal translation of the Prophet's words to Tamīm would be: "You have illuminated Islam; may the light of God be upon you in this world and the hereafter."

12. In support of this, Gerhard Böwering points out that in the account of Tamīm al-Dārī the oil lamp is described by the term *qandīl*, which does not occur in the Koran. Furthermore he cites the opinion of a few scholars (notably Richard Bell, *A Commentary on the Qur'an*, vol. 1 [Manchester: University of Manchester, 1991], pp. 601-03 and Régis Blachère, *Le Coran* [Paris: Maisonneuve & Larose, 1966], pp. 380-82), who maintain that the underlying rhyme patterns in the Koranic text indicate that the Verse of Light originated in the earlier Meccan period before the *Hijra*, whereas Tamīm al-Dārī's advice came years after this in Medina. See Gerhard Böwering, "The Light Verse: Qur'ānic Text and Sūfī Interpretation," in *Oriens* 36 (2001), pp. 117-18. It should be noted that this is a view not upheld by most Muslim clerics and it is generally accepted that the sura was revealed in the fifth or sixth year after the *Hijra*.

13. *Al-Fataawa al-Kubra*, 5/88-93.

14. Johannes Pedersen, "Masdjid," in Martijn Theodoor Houtsma et al., eds., *E. J. Brill's First Encyclopaedia of Islam, 1913-1938*, vol. 5 (New York: E. J. Brill, 1993), sub-section "Lighting," pp. 343-44

15. Guy Le Strange, *Palestine Under the Moslems:*

A Description of Syria and the Holy Land from A.D. 650 to 1500 (London: Alexander P. Watt, 1890), pp. 160-63.

16. Wheeler M. Thackston, trans. and ed., *Nāser-e Khusraw's Book of Travels (Safarnāma)* (Albany, NY: Bibliotheca Persica, 1986), pp. 55-58.

17. Mujīr al-Dīn, *Histoire de Jérusalem et d'Hébron, depuis Abraham jusqu'à la fin du XVe siècle de J.-C.*, trans. Henry Sauvaire, (Paris: Ernest Leroux, 1876), p. 71. A somewhat different account is given in Doris Behrens-Abouseif, *Mamluk & Post Mamluk Metal Lamps*, Cairo, Institut Français d'Archeologie Orientale, 1995, p. 9, which cites Mujīr al-Dīn's *al-Uns al-jalīl bi-tārikh al-Quds wa-'l-Khalīl* ([Amman: Maktabat al-Muhtasib, 1973], vol. 1, p. 308), stating that the treasure included "thirty gold lamps, two thousand four hundred silver lamps and a silver polycandelon."

18. Le Strange, *Palestine Under the Moslems*, p. 265.

Notes to Chapter 6

1. Arman Shishegar, "Glass," in Naṣr Allāh Pūrjavādī, ed., *The Splendour of Iran*, vol. 1 (London: Booth-Clibborn Editions, 2001), p. 448.

2. Glass lamps were recovered from an eleventh-century shipwreck excavated at Serçe Liman, Turkey. The lamps were part of a cargo of broken glass being shipped to a glass factory for reuse. Three types of lamps were found on board: suspended lamps (ninety-eight examples), standing lamps (one hundred and thirty-six examples), and one mosque lamp. None of the catalogued pieces had a complete profile, but their distinctive shapes make them readily identifiable. See Margaret E. Morden, "The Glass Lamps from the 11th-Century Shipwreck at Serçe Liman, Turkey" (Master's Thesis: Texas A&M University, 1982).

3. Shishegar, "Glassware," *Splendour of Iran*, pp. 202-03.

4. See Stefano Carboni and Qamar Adamjee, "Enameled and Gilded Glass from Islamic Lands," in *Heilbrunn Timeline of Art History* (New York: The Metropolitan Museum of Art, 2000); also Tim Stanley, Mariam Rosser-Owen, and Stephen Vernoit, *Palace and Mosque: Islamic Art from the Middle East* (London: V&A Publications, 2004).

5. See Esin Atil, *Renaissance of Islam: The Art of the Mamlûks* (Washington DC: Smithsonian Institution Press, 1981), pp. 118-22.

6. See Shishegar, "Glassware," p. 203. See also Carl Johan Lamm, "Glass and Hard Stone Vessels," in *A Survey of Persian Art from Prehistoric Times to the Present*, vol. 3, eds. Arthur Upham Pope and Phyllis Ackerman (London: Oxford University Press, 1939), pp. 2592-2600, and plates in vol. 6; and Guy Le Strange, trans. and ed., *Clavejo: Embassy to Tamerlane 1403-1406* (London: Routledge, 1928), p. 288.

7. Lamm, "Glass and Hard Stone Vessels," p. 2593.

8. Stefano Carboni, "Islamic Glass East and West: A Journey along the Silk Route from China to Venice," in *Arts of Asia* 37, no. 2 (2007), pp. 84-97. See also Stefano Carboni, ed., *Venice and the Islamic world: 828-1797* (New York: The Metropolitan Museum of Art, 2007), pp. 269-70. Likewise, in the second half of the nineteenth century there was a revival of enameled glass in Venice and Murano when glassmakers such as Antonio Salviati (and also Philippe-Joseph Brocard in France) made imitations of mosque lamps and other items of enameled Islamic glass. While these were generally produced for sale in the West as collectible decorative items, in 1867 Ismail Pasha, Khedive of Egypt, ordered from Salviati fifty mosque lamps modeled on Syrian originals from the fourteenth century.

9. See Godfrey Goodwin, *A History of Ottoman Architecture* (London: Thames & Hudson, 1987), pp. 232-33. See also descriptions from travel accounts in Emine Fetvaci, "Music, Light and Flowers: Aesthetics of 17c Ottoman Mosque Architecture," in *Journal of Turkish Studies/Türklük Bilgisi Araştirmalari* 32, no. 1 (2008).

10. See Avinoam Shalem, "Fountains of Light: The Meaning of Medieval Islamic Rock Crystal Lamps," in *Muqarnas* 11 (1994), pp. 1-11.

11. In "Fountains of Light" Shalem writes: "It is no wonder that rock crystal was used in connection with light, notably as lamps. The natural merit of rock crystal, namely its pellucidity, was considered by medieval Islamic physicists, such as Ibn al-Haytham (b. 965) to have reached the third degree of translucence below the most transparent substance, the celestial body, the first and the second degrees being attributed to air and water respectively" (p. 3).

12. Jens Kröger, "Crystal, Rock," in Ehsan Yarshater, ed., *Encyclopædia Iranica*, vol. 6 (Costa Mesa, CA: Mazda, 1993), p. 437.

13. See Finbarr Barry Flood, *The Great Mosque of Damascus: Studies on the Makings of an Umayyad*

Visual Culture (Boston: Brill, 2000), pp. 47-56.

14. See Flood, *Great Mosque of Damascus*, p. 48. A slightly different version of the events is recounted by Avinoam Shalem: "the lamp was brought by stealth to Baghdad during the reign of al-Amin . . . and a glass lamp was sent to Damascus as a replacement" ("Fountains of Light," p. 2).

15. See Ghādah Ḥijjāwī Qaddūmī, trans. and ed., *Book of Gifts and Rarities (Kitāb al-Hadāyā wa'l-Tuḥaf): Selections Compiled in the Fifteenth Century from an Eleventh-Century Manuscript on Gifts and Treasures* (Cambridge, MA: Harvard University Press, 1996).

16. See Le Strange, *Clavejo*, p. 252.

17. See e.g., *Sūrat al-Naml* [27]:44 and *Sūrat al-Insān* [76]:15-16. Another Arabic term, *ballūr* (pl. *billawr*), is used for rock-crystal, the finest, purest and most translucent type of natural glass. See Julius Ruska, "Billawr," in Martijn Theodoor Houtsma et al., eds., *E. J. Brill's First Encyclopaedia of Islam, 1913-1938*, vol. 2 (New York: E. J. Brill, 1993), p. 720. The term *ballūr* was used by Ibn Jubayr to describe the lamp in the Umayyad Mosque of Damascus. See Abu'l-Husayn Muhammad ibn Jubayr, *The Travels of Ibn Jubayr*, trans. Ronald J. C. Broadhurst (London: Jonathan Cape, 1952).

18. The hadith mentioned is as follows (narrated Anas): "The Prophet was on a journey and a slave named Anjasha was chanting (singing) for the camels to let them go fast (while driving). The Prophet said, 'O Anjasha, drive slowly (the camels) with the glass vessels!' Abu Qilaba said, 'By the "glass vessels" he meant the women (riding the camels)'" (Ṣaḥīḥ Bukhārī 8:73:229). See also Ṣaḥīḥ Bukhārī 8:73:228, 230, and Ṣaḥīḥ Muslim 4287.

19. Niseem J. Dawood, trans., *The Koran* (Harmondsworth, UK: Penguin Classics, 1990).

20. See Eva Baer, *Metalwork in Medieval Islamic Art* (Albany, NY: State University of New York Press, 1983), section "Mosque Lamps and Chandeliers," pp. 34-43.

21. Published in David S. Rice, "Studies in Islamic Metal Work: V," in *Bulletin of the School of Oriental and African Studies* 17, no. 2 (1955), pp. 206-31.

22. Davids Samling (The David Collection), Copenhagen, Inv. no. 17/1970.

23. Great lamp of al-Mu'izz, Kairouan (Museum of Islamic Art, Raqqada, Kairouan, Tunisia). Inventory no. B Z 501.

24. Mosque lamp, gilt bronze worked in repoussé and pierced, made in Konya. Signed by 'Alī b. Muḥammad al-Niṣībīnī, dated 679H/1280-81. This lamp is now in the collection of the Ethnographic Museum, Ankara, Catalogue no. 7591.

25. Rice, "Islamic Metal Work," pp. 212-14.

26. Ibid., pp. 221-23.

27. These bronze objects, found jammed tightly into three large storage jars together with metal scrap prepared for remelting, were exposed in excavations carried out by the Institute of Archaeology of the Hebrew University, Jerusalem in 1998. See Yizhar Hirschfeld, Oren Gutfeld, Elias Khamis, and Roni Amir, "A Hoard of Fatimid Bronze Vessels from Tiberias," in *Al-Usur Al-Wusta* 12, no. 1 (2000) pp. 1-7, 27.

28. See Rice, "Islamic Metal Work," pp. 214-217 and also Mourad Rammah, "Great Lantern of al-Mu'izz," in *Discover Islamic Art: Museum with No Frontiers* (2016), http://www.discoverislamicart.org/database_item.php?id=object;ISL;tn;Mus01;15;en.

29. See Rice, "Islamic Metal Work," p. 218.

30. Rice, "Islamic Metal Work," p. 208. See also Eva Baer, *Islamic Ornament* (Edinburgh: Edinburgh University Press, 1998), p. 3.

31. Louvre Museum Catalogue no. OA 6007. Height 29.5 cm, diameter 27.5 cm.

32. The pattern on the central part of the globular body is an elaboration of the motif shown in Plate 103 in Jules Bourgoin, *Arabic Geometrical Pattern and Design* (New York: Dover Publications, 1973); first published as *Les éléments de l'art arabe: Le trait des entrelacs* (Paris: Firmin-Didot et Cie., 1879).

33. See Esin Atil, *Renaissance of Islam: The Art of the Mamlūks* (Washington DC: Smithsonian Institution Press, 1981), pp. 50-52.

34. Émile Prisse d'Avennes, *Arab Art as Seen through the Monuments of Cairo from the 7th Century to the 18th*, trans. J I. Erythraspis (London: Al Saqi Books, 1983), plate 158.

35. Describing this lamp, Doris Behrens-Abouseif states that the "body is also composed of curved facets—it is not clear whether six or eight" (*Mamluk and Post Mamluk Metal Lamps* [Cairo: Institut Français d'Archeologie Orientale, 1995], p. 27). However, it is evident from the uniform arrangement of the three points of suspension that the number of facets must be a multiple of three and, as the depiction in Prisse d'Avennes' work

indicates, there are nine.

36. Besides the depiction by Prisse d'Avennes, another almost identical lamp is published in Georg Ebers, *Egypt: Descriptive, Historical, and Picturesque*, vol. 1 (New York: Cassell & Company, Limited, 1878), p. 244. The only apparent difference between this and the Prisse d'Avennes example is in the suspension details. The lower hook element is seemingly identical, however, instead of connecting to two elements above (star- and cartouche-shaped in Prisse d'Avennes) there is a single cartouche-shaped element, which instead of tapering to a narrow waist, flares out in the center to a point and terminates top and bottom in elaborate, poly-lobed arch forms. Besides this, the upper domed detail seems somewhat flatter and it lacks the ring from which the lamp is hung. Behrens-Abouseif mentions in *Mamluk Metal Lamps* that Wiet's Catalogue lists two lamps attributable to Sultan al-Ẓāhir Baybars (and a lamp in the name of a daughter of al-Ẓāhir) and it seems possible that the two depictions represent these two different lamps.

37. The six-petaled rosette is thought to be a royal emblem employed by the Ayyubids and the Mamluk house of Qalā'ūn, although it is not clear whether it has this connotation here.

38. Curzon to Cromer, 19 April 1905, quoted in Thomas R. Metcalf, "Past and Present: Towards an Aesthetics of Colonialism," in *Paradigms of Indian Architecture: Space and Time in Representation and Design*, ed. Giles H. R. Tillotson (London: Routledge, 2014), p. 12.

39. See Behrens-Abouseif, *Mamluk Metal Lamps*, p. 27. Also noteworthy is the fact that in 1879, prior to its disappearance, this lamp was depicted in a work of the Spanish orientalist painter Antonio Maria Fabres y Costa (1854-1938), entitled *Arab Sentinel* or *The Palace Guard*.

40. See Rice, "Islamic Metal Work," pp. 228-31.

41. See James W. Allan, "Sha'bān, Barqūq, and the Decline of the Mamluk Metalworking Industry," in *Muqarnas* 2 (1984), pp. 85-94.

42. Madrid, Museo Arqueologico Nacional, item no. 50.519. See Jerrilynn D. Dodds, ed., *Al-Andalus: The Art of Islamic Spain* (Abrams, NY: The Metropolitan Museum of Art, 1992), p. 276.

43. This lamp was earlier displayed at the museum with an inverted bell with four projecting brackets suspended beneath, as seen in the pictorial representation in Leonard Williams, *The Arts and Crafts of Older Spain*, vol. 1 (London: T. N. Foulis, 1907), p. 178. This lower part in fact consists of a separate fourteenth-century bell lamp, attributed to the mosque of Oran, Algeria, the brackets supporting holders for glass oil lamps.

44. See Baer, *Metalwork in Medieval Islamic Art*, pp. 40-43; also Behrens-Abouseif, *Mamluk Metal Lamps*, p. 13. Behrens-Abouseif's terminology differs somewhat from Baer's. Whereas Baer uses the term *thurayya* to describe polygonal, multi-tiered chandeliers, Behrens-Abouseif refers to these by the term *tannūr*. For Behrens-Abouseif the term *thurayya* denotes the single-tiered polycandelon, with a round tray surmounted by a domed shade. In support of this nomenclature she refers to one example of a lamp of this type which carries an inscription describing it as a *thurayya*. Baer also uses the term *tannūr* to refer to the pyramidal type. These differences in terminology seem quite extensive: Flood states that the term *thurayyā* was used as early in the tenth century to describe the largest of the lamps in the Mosque of the Prophet at Medina. Rice also refers to "elaborate many-tiered chandeliers (*thurayya*) and the pyramidally-shaped contraptions (*tannur*)" ("Islamic Metal Work," p. 228).

45. Behrens-Abouseif, *Mamluk Metal Lamps*, p. 12.

46. Rice, "Islamic Metal Work," pp. 227-28. Rice refers to examples of opaque lamps including "two lamps of 726/1326 in Damascus, the Hebron lamp in the Harari Collection, an undecorated and unpublished specimen in the same collection which is attributed to the 16th century, and the lamp of al-Malik an-Nāṣir Ḥasan in the Museum of Islamic Art, Cairo" (p. 227).

47. Atil, *Art of the Mamlūks*, p. 99.

48. See Nurhan Atasoy and Julian Raby, *Iznik: The Pottery of Ottoman Turkey* (London: Laurence King, 1994), section "Pottery associated with religious worship: Lamps (*Kandīl*)," p. 94.

49. See Gülru Necipoglu-Kafadar, "The Süleymaniye Complex in Istanbul: An Interpretation," in *Muqarnas* 3 (1985), pp. 107, 116 n. 74.

50. See Atasoy and Raby, *Iznik*, p. 41.

51. Ibid., p. 41.

52. Sebastian Bock, *The "Egg" of the Pala Montefeltro by Piero della Francesca and Its Symbolic Meaning*, http://archiv.ub.uni-heidelberg.de/volltextserver/3123/1/PieroEgg.pdf. Quoting from the *Rationale Divinorum Officorum* of Giulielmus Durantis (1237-1296), who he says probably refers

to a late version of the Greek *Physiologus*, Bock gives the following interpretation of the symbolic significance of hanging ornaments in the form of ostrich eggs: "some say that the ostrich, as a forgetful bird, forgets its eggs in the sand and only when it sees a certain star is reminded and returns to them and warms them with its gaze. Eggs are thus hung in churches to signify that man, forsaken by God on account of his sins,—when he at last, illuminated by the light of God, remembers, regrets his sins and returns to Him—is warmed by His merciful gaze." See also William R. Lethaby, *Architecture, Mysticism and Myth* (1892; repr., Mineola, NY: Dover Publications, 2004), chapter "The Symbol of Creation," pp. 255-72. "These hanging eggs seem of universal use in the East, alike in church, mosque, and tomb. Still at Constantinople, the frames of lights in the mosque of Achmet are decorated with globes of crystal and ostrich eggs. They are usually stained in bright colours, and have small metal mounts at top and bottom, with a pendant or tassel below" (pp. 255-56).

53. *Siyer-i Nebi*, circa 1595; Istanbul, Topkapi Sarayi Müzesi Library (inv. no. H 1223, fol. 62a)

54. *Falnama* (Book of Divination), illustrated manuscript of text attributed to Imam Ja'far al-Ṣādiq, Iran, Tabriz, c.1550 or Qazwin, c.1555 (Aga Khan Collection; 2005.1.96 / Ir.M.65).

55. See Flood, *Great Mosque of Damascus*, pp. 35-47. Flood notes that numerous ostrich eggs which once hung in the mosques and madrasas of Syria and Palestine have been removed in recent restorations.

56. See Atasoy and Raby, *Iznik*, p. 263.

Notes to Chapter 7

1. Electric lighting was only introduced in the Masjid al-Haram in Mecca in the late 1930s.

2. A study on Mosque Lighting was recently undertaken, in which an attempt was made to simulate with computer graphics the light generated by traditional mosque lamps. See Joseph T. Kider Jr., Rebecca L. Fletcher, Nancy Yu, Renata Holod, Alan Chalmers, and Norman I. Badler, "Recreating Early Islamic Glass Lamp Lighting," in Kurt Debattista, Cinzia Perlingieri, Denis Pitzalis, and Sandro Spina, eds., *VAST 2009: The 10th International Symposium on Virtual Reality, Archaeology, and Cultural Heritage* (Aire-la-Ville, Switzerland: Eurographics Association, 2009), pp. 33-40. A realistic visualization of the lighting in historical mosques

is particularly of interest when considering the lighting ambience appropriate for places of worship.

3. The manuscript was discovered after heavy rains damaged the roof construction of the Western Library in this ancient mosque, established by a companion of Prophet Muhammad. The fragments were found hidden in a ceiling and it is presumed that the manuscript had been placed there as a canonically acceptable means of disposing of a sacred text that had become damaged.

4. Hans-Caspar Graf von Bothmer, "Architekturbilder im Koran: Eine Prachthandschrift der Umayyadenzeit aus dem Yemen," in *Pantheon* 45 (1987), pp. 4-20. See also Finbarr Barry Flood, "The Qur'an," in Helen C. Evans and Brandie Ratliff, eds., *Byzantium and Islam: Age of Transition, 7th-9th Century* (New York: The Metropolitan Museum of Art, 2012), pp. 265-73.

5. Jens Kröger, describing an early glass lamp found at Nishapur, comments on similarities to the lamps depicted in the manuscript from Ṣanʿāʾ. See Jens Kröger, *Nishapur: Glass of the Early Islamic Period* (New York: The Metropolitan Museum of Art, 1995), p. 180.

6. It is not clear whether this is a realistic representation of how such a lamp would have functioned or whether this is a case of "artistic license."

7. Charles Simon Clermont-Ganneau in his article "La lampe et l'olivier dans le Coran" (*Revue de l'Histoire des Religions* 81 [1920]) refutes the claims of another French archaeologist, Longpérier, who had maintained that the perforated copper lamp from the Dome of the Rock that had been donated to the Louvre was to be identified with the *mishkāh* in the Verse of Light. Clermont-Ganneau insists that the lamp described in the Verse of Light was in all likelihood a glass lamp.

8. Avinoam Shalem mentions two Islamic rock crystal vessels that "presumably were originally used as lamps": one is cylindrical, 35 cm long and 17 cm in diameter, the other is boat-shaped; neither of them is of the *qandīl* mosque lamp type. See Shalem, "Fountains of Light: The Meaning of Medieval Islamic Rock Crystal Lamps," in *Muqarnas* 11 (1994), p. 1.

9. Shalem states that "The hollowed cylindrical glass tube affixed to their inner base served as a holder for a candle placed within" (Ibid., p. 4).

10. See for example Glass Mosque lamp, Syria, twelfth-thirteenth century, height 9.0 cm x width 6.7 cm (V&A Museum number: C.903-1936); Mosque lamp, Iran, c. ninth century. Height 11cm, (Metropolitan Museum of Art, *Harris Brisbane Dick Fund* 641-33.1); and two other examples of tenth-century blown glass mosque lamps from Gorgan in the Bazargan Collection, Iran: 1)

Diam. 10.2 cm, Height 14.6 cm and 2) Diam. 5.6 cm, Height 5.7 - 6.0 cm.

11. See Kröger, *Nishapur*, pp. 179, 182.

12. al-Samhūdī's account states that the lamps were hung in the mosque of Medina and *water*, oil and wicks were put in them (see Ibid., p. 9 n. 35). Saint Paulinus of Nola describes how this system was still in use in his time: "As is still done in our oil lamps, the base of the vase was filled with water and the oil floated on top." Quoted in Rohault de Fleury, *La Messe*, p. 5.

13. See Shalem, "Fountains of Light," in which the author discusses the traditional concept that rock crystal was congealed or "petrified" water. To visualize the optical effect with reference to familiar images, one need only picture the appearance of a candle flame, viewed through a wine glass filled with water. An application of a similar principle is seen in the traditional lace maker's lamp and *Schusterkugel*, which used "water lenses" to magnify the light of a single candle.

Notes to Chapter 8

1. In some parts of the world craft traditions for the fabrication of mosque lamps have survived into the present age. But where traditional styled lamps are still made, these are now generally produced for the tourist market and are rarely used in their original context.

2. Doris Behrens-Abouseif, *Mamluk and Post Mamluk Metal Lamps* (Cairo: Institut Français d'Archeologie Orientale, 1995), pp. 106-07. See Ibn al-Haytham, *Optics*, ed. and trans. Abdelhamid I. Sabra, vol. 2 (London: The Warburg Institute, 1989), pp. 200, 202.

3. This was the case in many of the Ottoman mosques, which often had niches in the side walls with windows overlooking gardens surrounding the mosque, although this feature was uncommon in mosques in Arab Islamic architecture, which were typically built into a dense urban fabric and surrounded by other buildings, rather than being free-standing buildings, surrounded by gardens.

4. Junichiro Tanizaki, a Japanese novelist known for his translations into modern Japanese of the eleventh-century classic *The Tale of Genji*, writes in his 1933 essay "In'ei raisan" (In Praise of Shadows) of how the true beauty of traditional Japanese art and architecture can only be appreciated by candlelight rather than by the "brilliance" of modern electric lighting. Published in English as *In Praise of Shadows*, trans. Thomas J. Harper and Edward G. Seidensticker (New Haven, CT: Leete's Island Books, 1977).

5. Titus Burckhardt, *Art of Islam: Language and Meaning* (Bloomington, IN: World Wisdom, 2009), pp. 80-84.

6. See Titus Burckhardt, *Moorish Culture in Spain* (London: George Allen & Unwin, 1972), p. 211. See also Titus Burckhardt: *Alchemy: Science of the Cosmos, Science of the Soul* (Louisville KY: Fons Vitae, 1997).

Notes to Chapter 9

1. There even exists an example of a Mamluk glass lamp (now kept at the Metropolitan Museum of Art, although not on display), on which mosque lamp motifs are used decoratively.

2. Titus Burckhardt notes that prayer-rugs "can be recognized by their relatively small size and by their design, which represents the niche of the *miḥrāb* before which there often hangs a lamp, the *miḥrāb* being thus identified with the 'niche of lights' of which the Koran speaks" (Burckhardt, *Art of Islam: Language and Meaning* [Bloomington, IN: World Wisdom, 2009], p. 118). However, this is not limited to prayer rugs, as demonstrated by such examples as the two large Ardabil carpets, now kept at the Victoria and Albert Museum and the Los Angeles County Museum of Art, on which lamp motifs feature prominently.

3. Inv. no. C52. This coin was minted in Ḥamā, western Syria, in the reign of Nāṣir al-Dīn Muḥammad ibn Qalā'ūn (709-741H/1310-1341), who is known for the beautiful glass lamps he donated to his religious foundations.

4. In 2002 a severe earthquake caused extensive damage to these tomb towers, also renowned for their decorative brickwork; now only two of the seven lamp motifs survive and both of these are damaged: the suspension hook detail is missing from one of them and a large crack runs diagonally through the other. The inscription on one of the surviving examples reads *barakah li-ṣāḥibih*, as stated by David Stronach and T. Cuyler Young Jnr., in "Three Octagonal Seljuq Tomb Towers from Iran," in *IRAN* 4 (1966), p. 10 and by Sheila Blair in *The Monumental Inscriptions from Early Islamic Iran and Transoxiana* (New York: Brill, 1992), p. 136; however the inscription on the other differs and appears to read *barakah wa thamar*.

5. See Martina Rugiadi, "So-called "Mihrab-like" Panel in Marble" in *UNESCO Museums for Intercultural Dialogue* (2013), http://www.unesco.org/culture/museum-for-dialogue/item/en/204/so-called-mihrab-like-panel-in-marble.

6. Finbarr Barry Flood, *The Great Mosque of Damascus: Studies on the Makings of an Umayyad Visual Culture* (Boston: Brill, 2000), pp. 15ff.

7. Ibid., pp. 35-47.

8. Ibid., p. 54.

9. Burckhardt, *Art of Islam*, pp. 93-94.

10. Keppel A. C. Creswell, *The Muslim Architecture of Egypt: Ikshīds and Fāṭimids, A.D. 939-1171* (New York: Hacker Art Books, 1978), p. 243. Referring to Erica C. Dodd's statement that "an earlier Cairene mosque, Al-Aqmar . . . presents a literal representation of the *miḥrāb* on the facade" ("The Image of the Word: Notes on the Religious Iconography of Islam," in *Berytus* 18 [1969], p. 56), Naseem A. Banerji expresses the idea that this motif is intended to indicate the *qibla* direction (see Banerji, *The Architecture of the Adina Mosque In Pandua, India: Medieval Tradition and Innovation* [Lewiston, NY: Edwin Mellen Press, 2002], p. 146). However, this is incorrect, since the façade of the mosque is offset from the *qibla* direction, and follows the street alignment, like many later Cairene mosques. For a plan of the al-Aqmar mosque, see Creswell, *Muslim Architecture of Egypt*, p. 242, fig. 141. Creswell writes: "This little mosque is of great interest, for it is the earliest building in Egypt of which the plan is dominated by the line of the street" (p. 241).

11. Caroline Williams, "The Cult of 'Alid Saints in the Fatimid Monuments of Cairo, Part I: The Mosque of al-Aqmar," in *Muqarnas* 1 (1983), p. 46.

12. It is noteworthy that Creswell describes the "Lamp in the Niche" on the façade of the mosque of al-Aqmar (519H/1125) as "the earliest example I have ever seen of this motif" (*Muslim Architecture of Egypt*, p. 243). Needless to say, Creswell was familiar with the mosque of Ibn Ṭūlūn, describing it in his work *Early Muslim Architecture: Umayyads, Early 'Abbasids, and Tulunids*, vol. 2 (Oxford: Clarendon Press, 1940), pp. 348-49. In note 43 in *"The Cult of 'Alid Saints,"* Caroline Williams refers to this as a tenth-century mihrab in Ibn Ṭūlūn. The flat mihrab of al-Afḍal, adjacent to the flat mihrab described here, was added in 487H/1094.

13. Eva Baer attributes this flat mihrab to the Ṭūlūnid period; however, she remarks that Creswell was of the opinion that it was of early Umayyad origin and that this disk was a later addition. See Baer, "The Mihrab in the Cave of the Dome of the Rock," in *Muqarnas* 3 (1985).

14. See Blair, *Monumental Inscriptions*, p. 191. See also Terry Allen, *Ayyubid Architecture* (Occidental, CA: Solipsist Press, 1999), chapter "Mashhad al-Husayn"; and Stephennie Mulder, "Seeing the Light: Enacting the Divine at Three Medieval Syrian Shrines" in David J. Roxburgh, ed., *Envisioning Islamic Art and Architecture: Essays in Honor of Renata Holod* (Boston: Brill, 2014), pp. 88-108.

15. See Plate II, no. 3, in Clifford E. Bosworth et al., eds., *The Encyclopaedia of Islam: New Edition*, vol. 7 (New York: E. J. Brill, 1993); also Plate CXXXV in Friedrich Sarre and Ernst Herzfeld, *Archäologische Reise im Euphrat- und Tigris-gebiet*, vol. 4 (Berlin: Dietrich Reimer Verlag, 1920).

16. Mosque lamp motifs dominate the design of silver covered doors, made in 1610 for the tomb of Hacı Bektaş Veli at Nevşehir in Turkey. See Gökben Ayhan, "Haci Bektaş Velî Türbesi'nin Gümüş Kapi Kanatlari (The Silver Door Leaves of Haci Bektash Veli's Tomb)," in *Turkish Culture and Haci Bektas Veli Research Quarterly* 69 (2014), pp. 81-99.

17. Naseem A. Banerji, *The Architecture of the Adina Mosque* (Lewiston, NY: Edwin Mellen Press, 2002), pp. 151-52. See also Banerji, "The Mihrabs in the Adina Mosque: Evidence of the Reuse of Late Pala-Sena Remains," in *Marg* 50, no. 3 (1999), pp. 82-93.

18. Banerji, "Connections between the Koranic Sura of Light, Sufi Light Mysticism, and the Motif of the Lamp within a Niche," in *Marg* 50, no. 3 (1999), pp. 69-81.

19. Banerji, *Architecture of the Adina Mosque*, p. 156.

20. "The mosques at Muazzampur (836H/1432), and Khondkartola (886H/1482), both in the Dacca District, the Goaldi Mosque at Sonargaon (925H/1519), and the Jami Mosque at Bagha (930H/1523), all in Bengal, have mihrabs with the motif. . . . Structures with the motif on their façades are the Kotwali Darwaza (925H/1519), and the Qadam Rasul (937H/1530), the Chota Sona Mosque (15th century), the Tantipara Mosque (15th century), the Firoz Minar (15th century), the Dakhil Darwaza (15th-16th century), the Lattan Mosque (early 16th century), in Gaur, the Eklakhi Tomb in Pandua (early 15th century), the mosque of Baba Adam Shahid at Rampal (888 H/1483)" (Ibid., p.

152 n. 322). Also: "Monuments with the motif . . . have been located in the districts of Hugh, Malda, Dhaka, Rajshahi, Bogra, Khulna, and Narayanganj. The motif is also represented on the stone sarcophagus of Sultan Ghais al-Din 'Azam Shah in Sonargaon, Narayanganj district, Bangladesh" (Ibid., p. 156 n. 329).

21. Banerji, "Koranic Sura of Light," n. 59.

22. Khoundkar Alamgir, "Bell and Chain Decoration in Sultanate Architecture of Bengal," in *Journal of Bengal Art 17* (2012). Examples listed by Alamgir of buildings in Sultanate Bengal, involving the re-use of elements from Hindu architecture, such as stone pillars with the Bell and Chain motif, include: Bari Masjid, Chota Pandua, Hooghly (c. 1300); Baba Adam mosque, Munshiganj (1483); Darasbari mosque, Gaur (1479-80); Reza Khoda mosque, Bagerhat (sixteenth century); and Galakata mosque, Barabazar, Jhenidah (sixteenth century). The following examples he describes as abstract or non-figurative adaptations of the Bell and Chain motif found in architecture during the Sultanate period: Mosque of Zafar Khan Ghazi, Tribeni, Hooghly (1298); Tomb of Zafar Khan Ghazi, Tribeni, Hooghly (c. 1300); Adina mosque at Hazrat Pandua, Malda (1375); Eklakhi tomb, Hazrat Pandua, Malda (1414-32); Tomb at Sonargaon (1410-11); Mosques at Bagerhat (fifteenth century); Monuments of Barabazar of Jhenidah district; Monuments of Gaur, Malda and Chapai Nawabganj Bagha mosque, Rajshahi (1523-24); Fakira mosque, Hathazari (1474-81); Mahi Santosh mosque of Naogaon district (built 1463 and rebuilt 1506); Navagram mosque, Sirajganj (1526); and Mohjompur mosque, Sonargaon, Narayanganj (sixteenth century). Also: Sarail Hatkhola mosque, Brahmanbariya (1670)—built in the Mughal period.

23. Muslim narrated in his *Ṣaḥīḥ* a hadith (No. 2113) transmitted by Abū Hurayrah which states that the Prophet said: "The angels do not accompany any group with whom there is a dog or a bell." Another hadith, also from Abū Hurayrah (No. 2114), states that the Prophet said: "Bells are the musical instruments of Shaytan." However, when Islam spread throughout the world it did not look on pre-existing cultures as fundamentally wrong and saw itself not as a radical departure from what came before it, but rather as the renewal of a timeless message that had been sent to man many times before. The Koran relates that there is no nation to whom God has not sent a prophet and that the Prophet Muhammad is the last in a long line of prophets. Islam therefore did not attempt to sweep away all that came before it, in order to establish a new and radically different form. Consequently when the Islamic religion spread to different parts of the world, a process took place whereby erroneous elements of pre-existing cultures were cast aside, but those elements that were seen to be compatible were often integrated into Islamic culture.

24. The same form emerging from the top of the motif is seen in the one case to represent a flame rising from a lamp, but in the other to represent the handle of the lid of an earthenware bowl. See Habiba Khatun, *Iqlim Sonargaon: History, Jurisdiction, Monuments* (Dhaka: Academic Press & Publishers Library, 2006), p. 41.

25. Eva Baer, *Islamic Ornament* (Edinburgh: Edinburgh University Press, 1998), p. 95.

26. Nuha N. N. Khoury, "The Mihrab Image: Commemorative Themes in Medieval Islamic Architecture," in *Muqarnas* 9 (1992), pp. 11-28.

27. Khoury explains that the term "mihrab" has a number of different meanings, which appear in medieval dictionaries, and that both niche and flat types are correctly described as mihrabs.

28. Khoury, "The Mihrab Image," p. 12.

29. This Khoury says is expressed in the phrase: *man dha'lladhī yashfa'u 'indahu illā bi idhnih.* ("Who can intercede with Him except by His permission?").

30. *Sūrat Āl 'Imrān* [3]:169. "Think not of those who are slain in God's way as dead. Nay they live, finding their sustenance in the presence of their Lord."

31. *lammā uṣība ikhwānukum bi uḥudin, ja'ala'llāhu arwāḥahum fī ajwāfi ṭayrin khuḍrin, taridu anhāra'l-jannati wa ta'kulu min thimārihā, wa ta'wīy ilā qanādīla min dhahabin mu'allaqatin fī ẓilli'l'arsh.* Abū Dāwud, hadith no. 2158.

32. Khoury, "Mihrab Image," pp. 18-19. It is noteworthy that the term used here is *qandīl*, which does not appear in the Koran, where only *sirāj* and *miṣbāḥ* are used. Khoury mentions other examples such as the guiding light of the *qandīl* of Shaykh Qadib al-Ban, visible only at a distance and the miraculous lighting of the mashhad of Sayyida Zaynab in Cairo. Another example in which a lamp is associated with the *barakah* of a saint is found in Farīd al-Dīn 'Aṭṭār's *Memorial of the Saints*: "Rabe'a al-Adawiya . . . continually fasted and served God, and by night she worshipped standing until day. One

night her master awoke from sleep and perceived a lantern suspended without any chain above her head, the light whereof filled the whole house" (Arthur J. Arberry, trans., *Muslim Saints and Mystics: Episodes from the Tadhkirat al-Auliya'* [London: Routledge & Kegan Paul, 1966], p. 42).

33. Contrary to her earlier definition of "mihrab images" as flat mihrabs, distinct in function from niche mihrabs, this example given by Khoury is a niche mihrab, which has five hanging lamps depicted on the facets of the niche, although it does feature the Throne Verse. Khoury includes in the category of "mihrabs decorated with hanging lamps and the Throne Verse" examples in shrines in Mosul, including the mausolea of Yaḥyā ibn al-Qasim (1240) and ʿAwn al-Dīn (1248). However it should be noted that in neither case is the Throne Verse used. The inscription on the flat mihrab of Yaḥyā ibn al-Qasim can be identified as *Sūrat al-Insān* [7]:7-9, and that of ʿAwn al-Dīn can be identified as *Sūrat al-Insān* [7]:23-26; furthermore both of these mihrabs were earlier mentioned as examples of directional mihrabs, unusual because the qibla direction faces into the corner and the mihrab consists of two flat panels wrapping around the corner. Therefore they too seem not to fit the definition of "mihrab images."

34. Géza Fehérvári, "Tombstone or Mihrab? A Speculation," in Richard Ettinghausen, ed., *Islamic Art in the Metropolitan Museum of Art* (New York: The Metropolitan Museum of Art, 1972), pp. 241-54. Fehérvári describes "the strong affinity that existed between *miḥrāb*s and tombstones," but nevertheless establishes a number of criteria that can help distinguish them from each other.

35. See Mulder, "Seeing the Light", pp. 88-108, which also describes the similar cenotaph at Mashhad al-Muḥassin (also known as Mashhad al-Dikka), Aleppo.

36. See Murat Çerkez, "Eyüpsultan Mezarlıklarında Kandil Motifleri," in *Tarihi, Kültürü ve Sanatıyla III: Eyüpsultan Sempozyumu Tebliğler*, (Istanbul: Eyüp Belediyesi Kültür ve Turizm Müdürlüğü, 2000), pp. 339-64; and H. Kāmil Biçici, "İznik Müzesindeki Kandil ve Şamdan Motifli Mezar Taşları," in *Turkish*

Studies 7, no. 3 (2012), pp. 655-59.

37. Elizabeth Lambourn, "Carving and Communities: Marble Carving for Muslim Patrons at Khambhat and around the Indian Ocean Rim, Late Thirteenth–Mid-fifteenth Centuries," in *Ars Orientalis* 34 (2004), pp. 99-133.

38. See Elizabeth Lambourn, "The Decoration of the Fakhr al-Din Mosque in Mogadishu and Other Pieces of Gujarati Marble Carving on the East African Coast," in *Azania* 34, vol. 1 (1999), pp. 61-86; and Elizabeth Lambourn, "From Cambay to Samudera-Pasai and Gresik: The Export of Gujarati Grave Memorials to Sumatra and Java in The Fifteenth Century CE," in *Indonesia and the Malay World* 31, no. 90 (2003), pp. 222, 259 fig. 1.

39. On the façades the composition is often flanked by clearly recognizable bell-and-chain motifs at a smaller scale.

40. According to tradition Malik Ibrāhīm was the first Muslim *walī* to bring Islam to eastern Java.

41. See Eva Baer, "Notes on the Iconography of Inspirations and Symbols in the Ulu Cami of Eski Malatya," in Klaus Kreiser et al., eds., *Ars turcica: Akten des VI. Internationalen Kongresses für türkische Kunst*, vol. 1 (Munich: Editio Maris, 1987), pp. 136-43; also Eva Baer, *Islamic Ornament* (Edinburgh: Edinburgh University Press, 1998), p. 95.

42. See Jonathan M. Bloom and Sheila Blair, *The Grove Encyclopedia of Islamic Art and Architecture*, vol. 2, section "Mihrab," p. 517.

43. See Linda Komaroff and Stefano Carboni, eds., *The Legacy of Genghis Khan: Courtly Art and Culture in Western Asia, 1256-1353* (New York: The Metropolitan Museum of Art, 2002), pp. 268-270.

44. See Oliver Watson, *Persian Lustre Ware* (London: Faber & Faber, 1985), p. 149.

45. Sheila Blair and Jonathan M. Bloom, eds., *Images of Paradise in Islamic Art* (Hanover, NH: Hood Museum of Art, 1991), p. 96.

46. René Guénon, *Fundamental Symbols: The Universal Language of Sacred Science* (Cambridge, UK: Quinta Essentia, 1995), chapter "The Holy Grail," p. 29

List of Illustrations

et intellectum dat parvulis . . .". The British Library, Add MS 50000, f.186r.

26. Hagia Sophia: Mosaic above Imperial Gate depicting Jesus enthroned. Written in Greek on the Bible in his hand are the words: *"I am the light of the world."*

27. Moses and the Burning Bush, Byzantine mosaic at St Catherine's Monastery, Sinai.

28. Mosaic mural depicting the Burning Bush, Kykkos Monastery, Cyprus.

29. Depiction of fire altar with priests wearing masks to maintain the purity of the sacred fire, Sogdian Zoroastrian ceramic ossuary, Mulla-Kurgan, Samarkand region, 7th-8th century. Museum of History and Culture of the Peoples of Uzbekistan, Tashkent, Inv. No. A-436-1.

30. Baku Fire Temple, from *A Journey from London to Persepolis: Including Wanderings in Daghestan, Georgia, Armenia,* by John Ussher, 1865. The British Library, Accession number HMNTS 10076.g.6.

31. Cave-temple dedicated to the Greek god Pan, at Banias (Paneas), Caesarea Philippi. Detail from photograph by Patrick Brennan.

32. Depiction of the nativity in a cave, hanging above the altar in the Church of the Nativity in Bethlehem, built over a cave traditionally believed to be the birthplace of Jesus.

33. Greek icon of Elijah (Elias) who returns to the cave on Mount Horeb where Moses received the Ten Commandments. God appears to him, not in the form of a great and strong wind, nor an earthquake, nor a fire, but as a still small voice (see 1 Kings 19:13).

34. Icon depicting St John and his disciple, Prochoros, recording St John's visions. Monastery of St John the Theologian, Patmos, Greece.

35. Miniature painting of the Seven Sleepers in the cave at Ephesus, by Agha Reza, Qazwin, ca. 1590.

36. "Man in prayer at the Zawiyah of Abd el-Rahman Kiahiyah," from *Scenes of Modern Life in Egypt II,* by Emile Prisse d'Avennes. Bibliothèque nationale de France, Department of Manuscripts, NAF 20442.

37. Mosaic depicting the Annunciation, by Jacopo Torriti, 1296, Santa Maria Maggiore, Rome.

38. *Sūrat Āl 'Imrān* [3]:37, from a large-format Timurid Koran, Northern India, 15th-century. Walters Art Museum Ms. W.563, fol. 52b.

39. Epigraphic inscription from the "Verse of the Mihrab" above the mihrab of Hagia Sophia.

40. Mihrab of Hagia Sophia.

41. *Mishkāt al-Masābiḥ,* popular hadith collection by Khatib Al-Tabrizi (d. 741 H/1340).

42. *Sūrat al-Aḥzāb* [33]:45-47, in which the Prophet is compared to a luminous lamp, from a 12th century Maghrebi Koran. Walters Art Museum Ms. W.556, fol. 60a.

43. *"Nūr, sirāj, miṣbāḥ, hudā* ": Some of the noble names of the Prophet Muhammad mentioned in *Dalā'il al-khayrāt,* by Muḥammad al-Jazūlī, from a 17th century Ottoman manuscript. Walters Art Museum, Ms. W.583, f.12a.

44. Psalm 18 [Vulg.17]:28, from the late 13th century "Fieschi Psalter." Walters Art Museum, Ms. W.45, f.36v.

45. Mosaic floor of sixth-century Beth Alpha synagogue, depicting Torah Shrine with hanging lamp suspended from its gabled roof.

46. Aaron the Priest pouring oil in the Menorah, from a miscellany of biblical and other texts, France, 1278-1298. The British Library, Add MS 11639, f.114r.

47. An altar with two candlesticks and a lamp above, detail from late 13th century manuscript of "The Abingdon Apocalypse." The British Library. Add MS 42555, f.28v.

48. Romanesque "crown of light" chandelier, Cathedral of Hildesheim, Germany, 11th-century.

49. Votive candles used in Christian worship.

50. *Dīpa* oil lamps arranged in a *Rangoli* pattern, to celebrate the Hindu festival of *Deepawali.* Photograph by Siddarth Varanasi.

51. Butter lamps used in Tibetan Buddhist worship. Photograph by Yasunori Koide.

52. Fragment of Buddhist sculpture showing a female devotee worshipping a lamp held up by a monk. Photograph taken in Peshawar District by Henry Hardy Cole, ca. 1883. Lahore Museum, from the Archaeological Survey of India Collections.

53. Statue of Amitabha Buddha, Kek Lok Si Temple, Air Itam, Penang, Malaysia.

54. The invocatory formula of the Pure Land school in Sanskrit: *Namo 'mitābhaya Buddhāya* (I take refuge in the Buddha of Infinite Light).

55. Diagram representing the "Five Divine Presences."

56. The "Nimrud Lens," found in excavations at the North West Palace, Nimrud, Iraq, 750-710 B.C. Rock-crystal, ground and polished, diameter 4.2 cm, thickness: 0.25 cm. British Museum, Museum number 90959.

57. Detail from lacquered panel, depicting Bilqis, Queen of Sheba, lifting her dress to cross the crystal floor of Sulayman's palace, mistaking it for a pool of

water, Iran, 15th century. National Gallery, Prague.

58. The olive, illustration from 1819. Olive Tree [Olea Europoea] Plate #87 from *The North American Sylva*, by François Andre Michaux (1770-1855).

59. Angel Holding an Olive Branch, by Hans Memling, 1475-80. Musée du Louvre, Paris.

60. The Dove returning to Noah, from the "Silos Apocalypse," by Beatus of Liébana, commissioned by Abbot Dominicus, illustrated by Petrus, Spain, 1109. The British Library, Add. 11695, f.79v.

61. The Anointing of David by Samuel, from "The Evesham Psalter," 1246-1325. The British Library, Add MS 44874, f.37v.

62. Depiction of the Menorah with olive trees on the right and on the left side, from Jewish Cervera Bible, Joseph Asarfati, 1299. Instituto da Biblioteca Nacional, Lisbon, Portugal, BNP, IL.72, f.316v.

63. Tree of Life mosaic in the courtyard arcade of the Great Mosque, Damascus, Syria, 706-715.

64. Mosaic depicting Adam and Eve, the serpent, and the Tree of the Knowledge of Good and Evil, Monreale Cathedral, Palermo, Sicily.

65. Calligraphic inscription from the *Āyat al-Nūr*, by Yusuf Sezer, Turkey, 1992. Eskenazi Musuem of Art, Indiana University, 75.41.1. Photograph by Kevin Montague.

66. *Sūrat Āl 'Imrān* [3]:7, from a 14th-century Koran, Egypt. Bavarian State Library, Munich, BSB Cod.arab. 6, fol. 40.

67. *Sūrat Ṣād* [38]:29, from volume 7 of an 8-volume 14th century Maghrebi Koran. Bibliothèque nationale de France, Arabe 423, fol.6r.

68. *Āyat al-Nūr* and subsequent verses, from a Koranic manuscript, made in Bust in the year 1111. Bibliothèque nationale de France, MS Arabe 6041, fol 15v, 16r & 16v.

69. Calligraphic inscription of the first line of the *Āyat al-Nūr*, by Nuria Garcia Masip.

70. Calligraphic inscription, *Nūr 'alā nūr*, "Light upon light," by Nuria Garcia Masip, 2008. Based on *jali thuluth* composition by Ismail Hakki Altunbezer (1871-1946).

71A & B. Beginning of the *Āyat al-Nūr*, from an 11th or 12th-century Koran, from Iraq or Persia, written on paper in the Qarmatian style of eastern Kufic script. The British Library, Or 6573, f.216r. & 216v. 71C. The words *nūr 'alā nūr*, from the same manuscript. The British Library, Or. 6573, f.217r.

72. *Āyat al-Nūr*, from a 10th-12th-century Koran manuscript. Brown University Library, Providence, RI, Minassian Collection of Qur'anic manuscripts, Manuscript 22, f.9.

73. Calligraphic inscription of the *Āyat al-Nūr*, by Muhammad Badawi Derani, Damascus, 1360H/1941.

74. Two concentric diagrams representing the Five Divine Presences.

75. Detail of calligraphy at apex of dome, Hagia Sophia, Istanbul.

76A & B. Stained glass window with Verse of Light in qibla wall of Süleymaniye Mosque, Istanbul.

77 Mihrab, height 2.90 m, width: 2.45 m, with epigraphic inscription of *Sūrat al-Nūr* [24]:35-36, Isfahan, Iran, Safavid period, early 17th century. Cleveland Museum of Art, 1962.23.

78. Epigraphic inscription of *Āyat al-Nūr* on the minaret of the congregational mosque at Damghan, Iran. Photograph from the Ernst Herzfeld papers, Freer Gallery of Art and Arthur M. Sackler Gallery Archives, Smithsonian Institution, Washington, D.C./Local Number: FSA A.6 04.GN.3050.

79. Detail of epigraphic inscription of *Āyat al-Nūr* surrounding mihrab, Masjid Ḥaydariyah, Qazwin, Iran. Photograph by Nicholas Stone.

80. Epigraphic inscription from *Āyat al-Nūr*, on ṣahn (courtyard) arches of Al-Aqmar Mosque, Cairo. Photograph by Taha Raja.

81. Lamps in the Treasury of St Mark's, Venice, 10th century; Roman lamps. Plate CDXLI, Ch. Rohault de Fleury, *La Messe*, Paris, 1888.

82. Lamps in St Clement's, Rome, 11th century; Gabathae, 12th century. Plate CDXLV, Ch. Rohault de Fleury, *La Messe*.

83. Lamps from Mount Athos; Glass lamp, Cairo. Plate CDXLVII, Ch. Rohault de Fleury, *La Messe*.

84. Rock crystal lamps from the Treasury of St Mark's, Venice. Plate CDXL, Ch. Rohault de Fleury, *La Messe*.

85. Detail from chromolithograph, showing lighting fixtures in Hagia Sophia, predating the mid-19th century restorations. In *Aya Sofia, Constantinople: As Recently Restored by Order of H.M. the Sultan Abdul Medjid, from the original drawings by Chevalier Gaspard Fossati*. London, Colnaghi & co., 1852, plate 24.

86. Early Byzantine glass lamp with three applied glass handles, height 13cm, width 15.8cm, Syria, 6th century. British Museum; Museum number 1900,0412.1.

87. Glass lamp, height 10.6cm x width 11.1cm, Iran, 10th-11th century. Metropolitan Museum of Art, Accession Number: 64.133.1a.

88. Vase-shaped glass lamp with cobalt trailed glass bands, height 14.7 cm, possibly Iran, 10th-12th century.

Aga Khan Museum Collection, AKM 645.

89. Glass mosque lamp, height 16.5 cm x width 12.2 cm, Gorgan, 10th-11th century. Glass and Ceramics Museum, Tehran, Iran, Museum no. A846.

90. Gilded and enamelled glass mosque lamp, height 34.5 cm x width 29.21 cm, Egypt, mid-14th century. Los Angeles County Museum of Art, William Randolph Hearst Collection, 50.28.4.

91. Glass globe, gilded and enamelled, for suspension with a mosque lamp, Mamluk Egypt, late 14th century. Victoria and Albert Museum, London, 333-1900.

92. Design for a mosque lamp, probably by Sokollu Mehmet Pasha, Istanbul, 1569. Archivio di Stato, Venice.

93. Fatimid carved rock crystal lamp, Iraq (?), 10th century, converted to a vase in 13th century Venice. The Treasury, St Mark's Basilica, Venice; inv. no. 99.

94. Ancient lamp fragments, excavated in Rayy. University of Pennsylvania Museum of Archaeology and Anthropology, Object Number: 37-11-419.

95. Mosque lamp, openwork sheet brass, Iraq or Iran, 10th century. The David Collection, Copenhagen, Inv. no. 17/1970.

96. Great lamp of al-Mu'izz, Qayrawan, 1032-51. Museum of Islamic Art, Raqqada, Qayrawan, Inventory number: B Z 501.

97. Brass mosque lamp from the Umayyad Mosque, Damascus, dated 1090. Museum of Turkish and Islamic Arts, Istanbul, Inv. No. 192. Photograph by Alexander Brey.

98. Pierced bronze mosque lamp, made for the Eşref Süleyman Camii at Beyşehir, Seljuk period, dated 699H/1280. Ankara, Ethnographic Museum, No. 7591. Photograph by Professor Michael Fuller, St Louis Community College.

99. Detail of pierced bronze mosque lamp, showing repoussé treatment, Seljuk period, dated 699H/1280. Ankara, Ethnographic Museum, No. 7591. Photograph by Professor Michael Fuller, St Louis Community College.

100. Mosque lamp, made in Syria or Palestine for Dome of the Rock, Jerusalem, 12th century. Louvre Museum, Inventory number: OA6007.

101. Mosque lamp, made in Syria or Palestine for Dome of the Rock, Jerusalem, 12th century, from Emile Prisse d'Avennes, "Art arabe: Vases." Bibliothèque nationale de France, Department of manuscripts, NAF 20443.

102. Mamluk mosque lamp, made for the mausoleum of Sultan al-Ẓāhir Baybars, ca. 1277, from Emile Prisse d'Avennes, *L'Art Arabe*, published in 1877, Plate: "Lamp from the Tomb of Sultan Baybars II."

103. Brass lamp in the Taj Mahal, above the cenotaph of Mumtaz Mahal

104. Brass lamp in the Taj Mahal, made in imitation of the Sultan Baybars lamp. "Presented to the tomb of Mumtaz Mahal by Lord Curzon, Viceroy of India, 1906."

105. Mosque lamp, made for the mausoleum of Sultan al-Ẓāhir Baybars, Damascus, Syria, ca. 1277. Museum of Islamic Art, Doha, Qatar, MW.117.1999.

106. Perforated brass lamps for sale in the bazaar in Isfahan. Photograph by Nicholas Stone.

107. Perforated brass mosque lamp, designed 2003.

108. Calligraphic inscriptions from *Āyat al-Nūr* on perforated brass mosque lamp, designed 2003.

109. Lamp from Mosque of the Alhambra, Granada, Spain, Nasrid period, 1305. National Archaeological Museum, Madrid, item no. 50.519.

110. Detail of lamp from Mosque of the Alhambra, Granada, Spain, Nasrid period, 1305. National Archaeological Museum, Madrid, item no. 50.519.

111. Polycandelon, Byzantine, 6th-8th century. Harvard Art Museums/Arthur M. Sackler Museum, Object Number 1975.41.145.

112. Perforated *thurayya* type lantern of Sultan Ahmad, 1342. Museum of Islamic Art, Cairo, Museum no. 1482, after Wiet.

113. Brass "pyramidal" lamp inlaid with silver, Egypt, 14th century. The David Collection, Inv. no. 37/1982.

114. "Pyramidal lamp" from the Mosque of 'Asal Bay, Cairo, 1495. The Museum of Islamic Art, Cairo, Inv. no. 3083.

115. "Section and Details of the Lamp of the Sanctuary of the Mosque of Hassan." From Emile Prisse d'Avennes, "Art arabe: Dessins: Mosquées, 2." Bibliothèque nationale de France, Department of Manuscripts, NAF 20443.

116. *Tannūr*-type bronze lantern in Mausoleum of Sultan Barquq, Cairo, from Emile Prisse d'Avennes, *L'Art Arabe*, Plate 18: "Sepuchral Mosque of Sultan Barqūq, Door of the Tomb".

117. Large, multi-tier polycandelon-type lamps, Great Mosque of Qayrawan, Tunisia.

118. Side view of *tannūr*-type bell lamp, Qarawiyyin Mosque, Fez.

119. View from below of *tannūr*-type bell lamp, Qarawiyyin Mosque, Fez.

showing Koran stands in window arches.

154. Muqarnas vault over entrance to Masjid Imam, Isfahan. Photograph by Nicholas Stone.

155. Prayer carpet with lamp motif, Cairo, late 16th century. Al Sabah Collection, Dar al-Athar al-Islami-yyah, Kuwait, LNS 29 R.

156. Mosque lamp detail with inscription from *Āyat al-Nūr* on *sitarah* made for the Prophet's Mosque in Medina by the Ottoman Sultan Selim III, Egypt, 1791-92. Ashmolean Museum, University of Oxford, EA2012.3.

157. Mamluk *fals* coin with lamp motif, Hama, western Syria, 709-741H/1310-1341. The David Collection, Copenhagen, Inv. no. C 52.

158. *Saf* carpet from Selimiye mosque in Edirne, late 16th or early 17th century. Museum of Turkish and Islamic Arts, Istanbul, Inv. No. 474.

159, 160, 161. Mosque lamps, painted on the interior of tomb tower at Kharraqan, Iran, 1067-68. Photograph of 159 courtsey of Hamid Afshar; photographs of 160 and 161 by Nicholas Stone.

162. Mihrab tile, carved marble, Afghanistan, Ghaznavid dynasty, ca. 1100. David Collection, Copenhagen, Inv. no. 74/1979.

163. Detail of mosaics on the western courtyard wall of the Great Umayyad Mosque, Damascus, 706-715, showing pavilions with "pearl-like ovoids suspended on golden chains."

164. Mihrab tile, carved marble, with inscription from *Sūrat al-Tawba* [9]:18, Afghanistan, Ghaznavid, c. 1100. David Collection, Copenhagen, Inv. no. 74/1979.

165. Marble mihrab from Al-Manṣūr Mosque, Baghdad, 766, found in Jāmiʿ al-Khāṣṣaki. Iraq Museum, Baghdad.

166. Mosque lamp motif in tympanum of arch on external façade, Al Aqmar Mosque, Cairo.

167. Flat mihrab, Mosque of Ibn Ṭūlūn, Cairo, Fatimid period, 9th century.

168. Mihrab in the cave of the Dome of the Rock, Jerusalem.

169 & 170. Carved stone mosque lamps in portal to Mashhad al-Husayn, Aleppo, Ayyubid period, 1195-96.

171. Carved stone mosque lamp, mihrab of Masjid-i Jami' of Mir Chaqmaq, Yazd, Iran, dated 840H/1436-37.

172. Mosque lamp motif in mihrab, Yazd, Iran.

173. Mosque lamp motif on mihrab column, Sultan Barquq Mosque Complex, Cairo. Photograph by Nicholas Stone.

174. Mosque lamp motif on minbar, Sultan Barquq Mosque Complex, Cairo, 1399-1412. Photograph by Nicholas Stone.

175. Single block marble mihrab with mosque lamp motifs, Alawi (Ulvi) Sultan Masjid, Konya, 13th century. Stone and Wood Artifacts Museum, located in the İnce Minareli Medrese, Konya.

176. Mosque lamp motifs above mihrab of Ilyas Bey Camii, Milet, Turkey, Seljuk period, 1403.

177. Detail of tiled mihrab, Yeşil Türbe, Bursa.

178. Detail of Secondary Mihrab, Jamali Kamali Masjid, 1528-29, Mehrauli Archaeological Park, Delhi.

179. Main mihrab with mosque lamp motifs, Adina Masjid, Pandua, Bengal, 1375.

180. Mosque lamp motifs in mihrab niche, Adina Masjid, Pandua, Bengal, 1375.

181. Hanging lamp motif in mihrab niche, Baro Sona Masjid, Malda, West Bengal, 1526. Photograph by Asis Kumar Chatterjee.

182. Hindu bell-and-chain motif on temple columns in Qutb Complex, Delhi, India.

183. Pendant motifs within arches dominate façade of Choto Bagha Mosque, Rajshahi, Bangladesh.

184A-E & 185A-E. Terracotta pendant motifs on façades, Adina Masjid, Pandua, Bengal, 1375. Photographs by Asis Kumar Chatterjee.

186. Mihrab, Ulu Camii, Bursa, Turkey.

187. Corner miḥrab in the Mausoleum of Imam Yaḥyā b. Qāsim, Mosul, 13th century. Photograph from *The Encyclopaedia of Islam*, Vol. 7: "Miḥrāb," Plate II, 3.

188. Mihrab, Sitt Zaynab, Sinjar, 1239-59. Photograph from Friedrich Sarre and Ernst Herzfeld, *Archäologische Reise im Euphrat- und Tigrisgebiet*, vol. 3.

189. Side panel of Cenotaph of Fada, Shrine of Khalid Ibn al-Walid, Hims, Syria. Ernst Herzfeld Papers, Series 4: Photographic Files 1903-1947, Freer Gallery of Art and Arthur M. Sackler Gallery Archives/Local Number: FSA A.604.GN.3255.

190. Mihrab, Panja 'Ali, Mosul, 1287-88. Photograph from *Archäologische Reise im Euphrat- und Tigrisgebiet,* vol. 3.

191. Glazed fritware panel with mosque lamp motif and representation of the Prophet's sandals, Darwish Pasha Mosque, Damascus.

192. Stele with lamp motif with inscription from Verse of Light, Budayriyya Madrasa, Cairo, 1357. The Museum of Islamic Art, Cairo, Inv. No. 19.

193. Mosque lamp motif on grave marker. Mosul Museum, Iraq.

194, 195, 196, 197. Mosque lamp motifs on grave markers dating from the Seljuk period in Ahlat, Eastern Anatolia, Turkey. Photographs by Dick Osseman.

198. Lar Mihrab, carved from marble in Cambay, Gujarat, early 14th century. Haft Tanan Stone Museum, Shiraz, Iran.

199. Tomb of 'Umar bin Ahmad Al Kazaruni, Cambay, Gujarat. Detail from photograph by Henry Cousens taken in the 1880s, Archaeological Survey of India.

200. Cenotaph of Sultanah Nahrasiyah, Samudra Pasai, Aceh, Sumatra.

201. Sahar ki Masjid (Bohrani), Champaner, Gujarat.

202. Tomb of Mughali Bibi, Rani Ka Hajira (Tombs of the Queens), Ahmadabad. Detail from photograph taken in 1881, Archaeological Survey of India.

203. Tomb of Ghiyasuddin Azam Shah (d. 1411), Sonargaon, Bangladesh.

204. "Salting" Mihrab, Kashan, Iran, ca. 1300. Victoria and Albert Museum, London, C.1977-1910.

205. Oljaitu ceramic panel, height 63 cm x width 47 cm, late 13th-early 14th century. Gulbenkian Museum, Lisbon, Inv. No. 1567.

206. Glazed mihrab tile, probably Kashan. Singapore Museum of Asian Civilisations. Photograph by Nicholas Stone.

207. Tile with mihrab arch and stylized mosque lamp, height 69 cm x width 41 cm, Iran, 17th-18th century. British Museum, Museum number: OA+.10639.

208. Lamp hanging in mihrab of Muḥammad ibn Qalā'ūn Mosque, Cairo, from Emile Prisse d'Avennes, *L'Art Arabe*, Plate 13: "Muḥammad ibn Qalā'ūn Mosque, View of the Mihrab."

209. "Praise be to God, Who created the heavens and the earth, and made the darkness and the light . . ." *Sūrat al-An'ām* [6]:1, from a Koran manuscript in *Naskh* and *Muhaqqaq* script, dated 1388/790. Bavarian State Library, Munich, BSB Cod.arab. 1113, fol. 80-81.

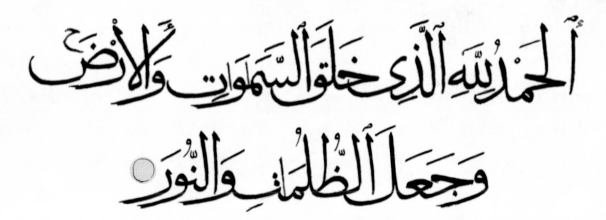

209. "Praise be to God, Who created the heavens and the earth, and made the darkness and the light . . ." *Sūrat al-An'ām* [6]:1, from a Koran manuscript in *Naskh* and *Muhaqqaq* script, dated 1388/790.

Bibliography

'Abdullah Yusuf 'Ali. *The Meaning of the Holy Qur'an: With Revised Translation, Commentary and Index.* 10th ed. Amana, 2004.

Abū Bakr Sirāj ad-Dīn. *The Book of Certainty.* New York: Samuel Weiser Inc., 1970.

Alamgir, Khoundkar. *Bell and Chain Decoration in Sultanate Architecture of Bengal.* Department of Information, Govt. of Sri Lanka, 2012.

Al-Ghazzali, *Mishkāt al-Anwār ("The Niche of Light").* Translated by William Henry Temple Gairdner. Lahore: Sh. Muhammad Ashraf, 1952.

Allan, James. *Persian Metal Technology, 700-1300 A.D.* London: Ithaca Press, 1979.

Allen, Terry. *Ayyubid Architecture.* Occidental, California: Solipsist Press, 1999.

Ardalan, Nader, and Laleh Bakhtiar. *The Sense of Unity: The Sufi Tradition in Persian Architecture.* Chicago: University of Chicago Press, 1973.

Atasoy, Nurhan, and Julian Raby. *Iznik: The Pottery of Ottoman Turkey.* London: Alexandria Press, 1989.

Atil, Esin. *Renaissance of Islam: The Art of the Mamluks.* Washington DC: Smithsonian Institution Press, 1981.

———, ed. *Turkish Art.* Washington, DC: Smithsonian Institution Press, 1980.

Baer, Eva. *Islamic Ornament.* Edinburgh: Edinburgh University Press, 1998.

———. *Metalwork in Medieval Islamic Art.* Albany: State University of New York, 1983.

———. "The Mihrab in the Cave of the Dome of the Rock." In *Muqarnas III: An Annual on Islamic Art and Architecture,* edited by Oleg Grabar. Leiden: E.J. Brill, 1985.

Banerji, Naseem Ahmed. *The Architecture of the Adina Mosque in Pandua, India: Medieval Tradition and Innovation.* New York: Edwin Mellen Press, 2002.

———. [1] "The *Mihrabs* in the Adina Mosque: Evidence of the Reuse of Late Pala-Sena Remains and [2] Connections between the Qur'anic Sura of Light, Sufi Light Mysticism, and the Motif of the 'Lamp within a Niche.'" *Marg: A Magazine of the Arts* 50, no. 3 (March 1999).

———. *The Mihrabs in the 14th Century Adina Mosque in Pandua, India: Evidence of the Reuse of Late Pala-Sena Remains.* In *Studies in Hindu and Buddhist Art,* edited by P. K. Mishra, 207-222. Abhinav Publications, 1999.

Behrens-Abouseif, Doris. *Mamluk and Post-Mamluk Metal Lamps.* Cairo: Institut français d'archéologie orientale, 1995.

Blair, Sheila S. "The Monumental Inscriptions from Early Islamic Iran and Transoxiana." In *Muqarnas Supplements (Book 5).* Leiden: E.J. Brill, 1991.

Blair, Sheila S. and Jonathan M. Bloom. *The Art and Architecture of Islam, 1250-1800.* New Haven: Pelican History of Art, 1994.

———. *Images of Paradise in Islamic Art.* Hanover, NH, 1991.

———. *The Grove Encyclopedia of Islamic Art and Architecture.* Oxford: Oxford University Press, 2009.

Bosworth, C. E. *The Islamic Dynasties.* Edinburgh, 1967.

Bourgoin, Jules. *Arabic Geometric Pattern & Design.* New York: Dover Publications, 1973.

Böwering, Gerhard. "The Light Verse: Qur'anic Text and Sufi Interpretation." *Oriens* 36 (2001): 113-144.

Brend, Barbara. *Islamic Art.* Cambridge, MA: Harvard University Press, 1991.

Burckhardt, Titus. *Art of Islam: Language and Meaning.* Translated by J. Peter Hobson. Westerham, Kent, UK: World of Islam Festival Trust, 1976; Bloomington, IN: World Wisdom, 2009.

———. *Fez: City of Islam.* Translated by William Stoddart. Cambridge, UK: The Islamic Texts Society, 1992.

———. *An Introduction to Sufi Doctrine.* Translated by D. M. Matheson. Lahore: Ashraf, 1968; Bloomington, IN: World Wisdom, 2008.

———. *Mirror of the Intellect: Essays on Traditional Science and Sacred Art.* Translated by William Stoddart. Cambridge, UK: Quinta Essentia, 1987.

———. *Moorish Culture in Spain.* Translated by Alisa Jaffa. London: Allen and Unwin, 1972.

———. "Perennial Values in Islamic Art." *Studies in*

Comparative Religion 1, no. 3.

———. *Sacred Art in East and West: Its Principles and Methods*. Translated by Lord Northbourne. Bedfont, Middlesex: Perennial Books, 1967.

———. "The Spirituality of Islamic Art." In *Islamic Spirituality: Manifestations*, edited by Seyyed Hossein Nasr. London: SCM Press, 1991.

———. "The Void in Islamic Art." *Studies in Comparative Religion* 4, no. 2 (1970).

Carboni, Stefano. "Islamic Glass East and West: A Journey Along the Silk Route from China to Venice." *Arts of Asia* 37, no. 2 (March-April 2007).

———. *Venice and the Islamic World: 828-1797*. New Haven, CT: Yale University Press, 2007.

Carboni, Stefano, and Qamar Adamjee. "Enameled and Gilded Glass from Islamic Lands." In *Heilbrunn Timeline of Art History*. New York: The Metropolitan Museum of Art, 2000-2002.

Carboni, Stefano, and D. Whitehouse. *Glass of the Sultans*. New York: Metropolitan Museum of Art/Yale University Press, 2001.

Carswell, J. *Iznik Pottery*. London: The British Museum Press, 1998.

Chittick, William C. "A Sufi Approach to Religious Diversity: Ibn al-'Arabi on the Metaphysics of Revelation." In *Religion of the Heart*, edited by William Stoddart and Seyyed Hossein Nasr. Washington DC: Foundation for Traditional Studies, 1991.

———. *Sufism: A Short Introduction*. Oxford: Oneworld Publications, 2000.

———. *The Self-Disclosure of God: Principles of Ibn Al-'Arabi's Cosmology*. Albany: State University of New York Press, 1997.

———. *The Sufi Path of Love: The Spiritual Teachings of Rumi*. Albany: State University of New York Press, 1984.

———. *The Sufi Path of Knowledge: Ibn Al-'Arabi's Metaphysics of Imagination*. Albany: State University of New York Press, 1989.

Clermont-Ganneau, Charles Simon. "La lampe et l'olivier dans le Coran." *Revue de l'Histoire des Religions* 81 (1920):213-59.

Clévenot, Dominique, and Gérard Degeorge. *Ornament and Decoration in Islamic Architecture*. London: Thames and Hudson, 2000.

Clévenot, Dominique. *Splendors of Islam: Architecture, Decoration, and Design*. Photographs by Gérard Degeorge. New York: Vendome Press, 2000.

Coomaraswamy, Ananda K. *Selected Papers I: Traditional Art and Symbolism*. Edited by Roger Lipsey. Princeton, NJ: Princeton University Press, 1977.

———. *Selected Papers II: Metaphysics*. Edited by Roger Lipsey. Princeton, NJ: Princeton University Press, 1977.

Cooper, J. C. *An Illustrated Encyclopaedia of Traditional Symbols*. London: Thames & Hudson, 1978.

Corbin, Henry. *The History of Islamic Philosophy: Part I and Part II*. Translated by L. Sherrard & P. Sherrard. London: Kegan Paul International, 1993.

———. *The Man of Light in Iranian Sufism*. Boulder and London: Shambhala, 1978.

Creswell, K. A. C. *A Short Account of Early Muslim Architecture*. Revised and supplemented by James W. Allen. Aldershot: Scholar Press, 1989.

———. *Early Muslim Architecture, Umayyads, Early 'Abbasids and Tulunids, Part I: Umayyads, A.D. 622-750*. Oxford: Clarendon Press, 1932.

———. *Early Muslim Architecture: Umayyads, Early 'Abbasids & Tulunids, Part 2: Early 'Abbasids, Umayyads of Cordova, Aghlabids, Tulunids, and Samanids, A.D. 751-905*. Oxford: Clarendon Press, 1940.

———. *The Muslim Architecture of Egypt: Ikshīds and Fāṭimids, A.D. 939-1171*. New York: Hacker Art Books, 1978.

Critchlow, Keith. *Islamic Patterns: An Analytical and Cosmological Approach*. New York: Schocken Books, 1976.

Diba, Layla, and Ekhtiar, Maryam. *Royal Persian Paintings: The Qajar Epoch 1785-1925*. London: I. B. Tauris Publishers/Brooklyn Museum of Art, 1998.

Dodd, E.C. "The Image of the Word: Notes on the Religious Iconography of Islam." *Berytus: Archaeological Studies* XVIII:35-62. Beirut: American University of Beirut, 1969.

Dodds, Jerrilyn Denise, ed., *Al-Andalus: The Art of Islamic Spain*. New York: Metropolitan Museum of Art, 1992.

El-Sa'id, Issam, and Ayse Parman. *Geometric Concepts in Islamic Art*. London: World of Islam Festival Trust, 1976.

Encyclopaedia of Islam. Leiden: E.J. Brill, 1960-.

Ettinghausen, Richard, and Oleg Grabar. *The Art*

and Architecture of Islam, 650-1250. New Haven and London: Yale University Press, 1994.

Fehévári, Geza. "Tombstone or Mihrab? A Speculation." In *Islamic Art in the Metropolitan Museum of Art*, edited by R. Ettinghausen, 241-54. New York, 1972.

Fitzgerald, Judith and Michael Oren Fitzgerald. *The Sermon of All Creation: Christians on Nature*. Bloomington, IN: World Wisdom, 2005.

Flood, Finbarr Barry. *The Great Mosque of Damascus: Studies on the Makings of an Umayyad Visual Culture*. Leiden: E.J. Brill, 2000.

Fobelli, M. L. "Light and Lighting in Justinian's Hagia Sophia in Constantinople."21st International Congress of Byzantine Studies. London: University of Chieti (Italy), 2006.

Frishman, Martin, and Hasan-Uddin Khan, eds. *The Mosque: History, Architectural Development and Regional Diversity*. New York: Thames and Hudson, 1994.

Geoffroy, Éric. *Introduction to Sufism: The Inner Path of Islam*. Bloomington, IN: World Wisdom, 2010.

Grabar, Oleg. *The Formation of Islamic Art*. Revised and enlarged edition. New Haven, CT: Yale University Press, 1987.

———. *The Mediation of Ornament*. Princeton, NJ: Princeton University Press, 1992.

Gruber, Christiane. "Between Logos (*Kalima*) and Light (*Nūr*): Representations of the Prophet Muhammad in Islamic Painting." *Muqarnas* 26 (2009):229-262.

Grube, Ernst J. *Architecture of the Islamic World: Its History and Social Meaning, With a Complete Survey of Key Monuments*. Edited by George Michell. London: Thames and Hudson, 1978.

Guénon, René. *Fundamental Symbols: The Universal Language of Sacred Science*. Translated by Alvin Moore Jr., revised and edited by Martin Lings. Cambridge, UK: Quinta Essentia, 1995.

———. *Symbolism of the Cross*. Translated by Angus MacNab. London: Luzac, 1958.

———. *The Multiple States of Being*. Translated by Jocelyn Godwin. New York: Larson, 1984.

Hamza, Feras, trans. *Tafsīr al-Jalālayn by: Jalāl al-Dīn al-Maḥallī and Jalāl al-Dīn al-Suyūṭī*. Amman, Jordan: Royal Aal al-Bayt Institute for Islamic Thought, 2007.

Hayes, J. R. *The Genius of Arab Civilization: Source of Renaissance*. New York: New York University Press, 1992.

Hermansen, M. K. "The Prophet Muhammad in Sufi Interpretations of the Light Verse (24:35). *Islamic Quarterly* 42, no. 2 (1998):218-27.

Hillenbrand, Robert. *Islamic Art and Architecture*. London: Thames and Hudson. 1999.

———. *Islamic Architecture: Form, Function and Meaning*. Edinburgh and New York: Edinburgh University Press, 1994.

Hoag, John D. *Islamic Architecture*. New York: Rizzoli, 1987.

Holod, Renata, and Hasan-Uddin Khan. *The Contemporary Mosque, Architecture, Clients and Designs since 1950s*. London: Thames and Hudson, 1997.

Holy Qur'an. *Interpretation of the Meanings of the Noble Qur'an in the English Language: A Summarized Version of At-Tabari, Al-Qurtubi and Ibn Kathir with Comments from Sahih Al-Bukhari. Summarized in One Volume*. Riyadh: Maktabat Dar-Us-Salam.

Hutt, A. *Arab Architecture: Past and Present. An Exhibition Presented by The Arab-British Chamber of Commerce at the Royal Institute of British Architects*. Durham: Centre for Middle Eastern & Islamic Studies, 1984.

Irwin, Robert. *Islamic Art*. London: Laurence King Publishing, 1997.

Jairazbhoy, R. A. *An Outline of Islamic Architecture*. India: Asia Publishing House, 1972.

Khatibi, Abdelkebir, and Mohammed Sijelmassi. *The Splendour of Islamic Calligraphy*. Translated by James Hughes. New York: Rizzoli International Publications, 1977.

Khoury, Nuha N. N. "The Mihrab Image: Commemorative Themes in Medieval Islamic Architecture." *Muqarnas* 9 (1992).

Kister, M. J. "'A Booth Like the Booth of Moses…': A Study of an Early *Ḥadīth*." *Bulletin of the School of Oriental and African Studies* 25 (1962):150-55.

Komaroff, Linda. *The Golden Disk of Heaven: Metalwork of Timurid Iran*. California and New York: Costa Mesa, 1992.

Komaroff, Linda, and Stefano Carboni, eds. *The Legacy of Genghis Khan: Courtly Art and Culture in Western Asia, 1256-1353*. New York: Metropolitan Museum of Art, 2002.

Kroger, Jens. *Nishapur: Glass of the Early Islamic Period*. New York: Metropolitan Museum of Art,

1995.

Kühnel, Ernst. *The Arabesque Meaning and Trans-formation of an Ornament.* Graz, Austria: Verlag für Sammler, 1976.

Lambourn, E. "Carving and Communities: Western India and the Indian Ocean, Eleventh–Fifteenth Centuries." *Ars Orientalis* 34 (2004).

———. "The Decoration of the Fakhr al-Din Mosque in Mogadishu and Other Pieces of Gujarati Marble Carving on the East African Coast." *Azania: Archaeological Research in Africa* 34, no. 1:61-86.

———. "From Cambay to Samudera-Pasai and Gresik: The Export of Gujarati Grave Memorials to Sumatra and Java in The Fifteenth Century CE." *Indonesia and the Malay World* 31, no. 90 (July 2003).

Lamm, Carl Johan. "Glass and Hard Stone Vessels." In *A Survey of Persian Art from Prehistoric Times to the Present. Volume III*, edited by Arthur Upham Pope and Phyllis Ackerman. London & New York: Oxford University Press, 1939.

Lane-Poole, Stanley. *The Art of the Saracens in Egypt.* London: Chapman and Hall, 1886.

Lane-Poole, Stanley, and Arthur Gilman. *The Story of the Moors in Spain.* New York and London: G.P. Putnam's Sons, 1886 .

Laskarina Bouras M. P. *Lighting in Early Byzantium.* Washington, DC: Dumbarton Oaks Research Library and Collection, 2009.

Le Strange, Guy. *Palestine under the Moslems: A Description of Syria and the Holyland From A.D. 650 to 1500.* London: Alexander P. Watt, 1890.

Lethaby, W.R., and H.Swainson. *The Church of Sancta Sophia, Constantinople: A Study of Byzantine Building.* London, New York: Macmillan, 1894.

Lings, Martin. *Mecca: From Before Genesis until Now.* London: Archetype, 2004.

———. *Muhammad: His Life Based on the Earliest Sources.* Cambridge, UK: Islamic Texts Society, 1983.

———. *Splendours of Qur'an Calligraphy and Illumination.* London: Thames & Hudson/Thesaurus Islamicus Foundation, 2005.

———. *Symbol & Archetype: A Study of the Meaning of Existence.* 3rd ed. Louisville: Fons Vitae, 2006.

———. *The Quranic Art of Calligraphy and Illumination.* London: World of Islam Festival Trust, 1976.

Melikian-Chirvani, *Assadullah Souren.* "The Lights of Sufi Shrines." *Islamic Art* II (1987).

Michaud, Roland, and Sabrina Michaud. *Colour and Symbolism in Islamic Architecture.* London: Thames and Hudson. 1995.

———. *Design and Color in Islamic Architecture: Eight Centuries of the Tile-Maker's Art.* New York: Vendome Press, 1996.

Michell, G. *Architecture of the Islamic World: Its History and Social Meaning.* London: Thames and Hudson, 1978.

Michon, Jean-Louis. *Introduction to Traditional Islam: Illustrated.* Bloomington, IN: World Wisdom, 2008.

Muhammad Asad, *The Message of The Qur'an.* Gibraltar: Dar Al-Andalus, 1980.

Naser-e Khosraw. *Naser-e Khusraw's Book of Travels (Safarnama).* Translated and with an introduction by W.M. Thackston. New York: Persian Heritage Association, Bibliotheca Persica, 1986.

Nasr, Seyyed Hossein. *An Introduction to Islamic Cosmological Doctrines.* Albany: State University of New York Press, 1993.

———. *Islamic Art and Spirituality.* Ipswich: Golgonooza Press, 1987.

———, ed. *Islamic Spirituality: Foundations.* New York: Crossroad, 1991.

———. *Knowledge and the Sacred.* New York: State University of New York Press, 1981.

———. *Sufi Essays.* 2nd edition. New York: State University of New York Press, 1991.

———. *Three Muslim Sages: Avicenna-Suhrawardi-Ibn Arabi.* Cambridge, MA: Harvard University Press, 1964.

Necipoglu-Kafadar, Gülru. "The Süleymaniye Complex in Istanbul: An Interpretation." In *Muqarnas III: An Annual on Islamic Art and Architecture*, edited by Oleg Grabar. Leiden: E.J. Brill, 1985.

Necipoglu-Kafadar, Gülru. *The Topkapi Scroll: Geometry and Ornament in Islamic Architecture.* Santa Monica: The Getty Center for the History of Art and the Humanities, 1995.

Newby, Martine S. *Glass of Four Millennia.* Oxford: Ashmolean Museum, 2000.

Nicholson, Reynold A. *The Mathnawī of Jalālu'ddīn Rūmī.* 8 volumes. London: Luzac & Co., 1925-1940.

O'Bannon, G.W. *Oriental Rugs: A Bibliography.* Metuchen, NJ: Scarecrow Press, 1994.

Okada, Amina, and M. C. Joshi. *Taj Mahal.* Photog-

raphy by Jean-Louis Nou. New York: Abbeville Press, 1993.

Papadopoulo, A. *Islam and Muslim Art*. New York: Harry N. Abrams, 1979.

Peerwani, Latimah-Parvin. *On the Hermeneutics of the Light Verse of the Qur'an by Mulla Sadra Shirazi*. London: Islamic College for Advanced Studies (ICAS), 2003.

Perry, Whitall N. *A Treasury of Traditional Wisdom: An Encyclopedia of Humankind's Spiritual Truth*. New York: Simon & Shuster, 1971.

Petsopoulos, Yanni, ed. *Tulips, Arabesques and Turbans: Decorative Arts from the Ottoman Empire*. New York: Abbeville Press, 1982.

Pickthall, Marmaduke. *The Glorious Koran: A Bilingual Edition with English Translation, Introduction, and Notes*. Albany: State University of New York Press, 1976.

Pourjavady, Nasrollah, ed. *The Splendour of Iran*. London: Booth-Clibborn, 2001.

Prisse d'Avennes, Achille-Constant-Théodore-Émile. *Arab Art as Seen Through the Monuments of Cairo from the 7th century to the 18th*. London: Al Saqi Books, 1983.

Rice, D. S. "Studies in Islamic Metal Work-V." *Bulletin of the School of Oriental and African Studies* 17, no. 2 (1955).

Robins, F.W. *The Story of the Lamp (and the Candle)*. London: Oxford University Press, 1939.

Rogers, J. *Problems in the Study of Islamic Glass*. London: I. B. Tauris, 1992.

Rohault de Fleury, Charles. "Lampes." *La Messe, études archéologiques sur ses monuments*, 6. Paris: Librairie des Imprimeries réunies, 1888.

Ross Reat, Noble. "The Tree Symbol in Islam." *Studies in Comparative Religion* 9, no. 3 (Summer, 1975).

Safadi, Yasin Hamid. *Islamic Calligraphy*. Boulder: Shambhala, 1979.

Sands, Kristin Zahra. *Sufi Commentaries on the Quran in Classical Islam*. London: Routledge, 2006.

Schimmel, Annemarie. *And Muhammad Is His Messenger: The Veneration of the Prophet in Islamic Piety*. Chapel Hill, NC: The University of North Carolina Press, 1985.

———. *Calligraphy and Islamic Culture*. New York: New York University Press, 1984.

———. *Deciphering the Signs of God: A Phenomenological Approach to Islam*. Albany: State University of New York Press, 1994.

———. *Islam: An Introduction*. Albany, NY: State University of New York Press, 1992.

———. *Mystical Dimensions of Islam*. Chapel Hill, NC: The University of North Carolina Press, 1986.

———. *The Triumphal Sun: A Study of the Works of Jalaludin Rumi*. Albany, NY: State University of New York Press, 1993.

Schuon, Frithjof. *Adastra & Stella Maris: Poems by Frithjof Schuon*. Bloomington, IN: World Wisdom, 2003.

———. *Art from the Sacred to the Profane: East and West*, edited by Catherine Schuon. Bloomington, IN: World Wisdom, 2007.

———. *Dimensions of Islam*. London: George Allen and Unwin, 1970.

———. *Esoterism as Principle and as Way*. Bedfont: Perennial Books, 1981.

———. *Form and Substance in the Religions*. Bloomington, IN: World Wisdom, 2002.

———. *Gnosis: Divine Wisdom*. Bloomington, IN: World Wisdom, 2006.

———. *In the Face of the Absolute*. Bloomington, IN: World Wisdom, 1989.

———. *Spiritual Perspectives and Human Facts*. Bloomington, IN: World Wisdom, 2007.

———. *Stations of Wisdom*. Bloomington, IN: World Wisdom Books, 1995.

———. *The Eye of the Heart*. Bloomington, IN: World Wisdom, 1997.

———. *The Transcendent Unity of Religions*. Translated by Peter Townsend. New York: Harper & Row, 1975.

———. *Sufism: Veil and Quintessence*. Bloomington, IN: Word Wisdom, 1981.

———. *The Essential Writings of Frithjof Schuon*. Edited by S.H. Nasr. Shaftesbury: Element, 1991.

———. *Understanding Islam*. Bloomington, IN: World Wisdom, 1994.

Scott, Timothy. "The Traditional Doctrine of Symbol." *Sacred Web* 6 (2000).

Shalem, Avinoam. "Fountains of Light: The Meaning of Medieval Islamic Rock Crystal Lamps." *Muqarnas* 11 (1994):1-11.

Shishegar. A. "Glassware." In *The Splendour of Iran, Volume III*. London: Booth-Clibborn, 2001.

Simpson, Marianna Sherve. *Sultan Ibrahim Mirza's Haft Awrang*. New Haven and London: Yale University Press/Freer Gallery of Art/Smithsonian Institution, 1997.

Soudavar, Abolala. *Art of the Persian Courts*. New York: Rizzoli International, 1992.

Stanley, Tim, Mariam Rosser-Owen, and Stephen Vernoit. *Palace and Mosque, Islamic Art from the Middle East*. London: V&A Publications, 2004.

Stierlin, Henri and Anne Stierlin. *Splendors of an Islamic World*. London: Tauris Parke Books, 1997.

Stoddart, William. *Outline of Buddhism*. Oakton, VA: Foundation for Traditional Studies, 1998.

———. *Remembering in a World of Forgetting*. Bloomington, IN: World Wisdom, 2008.

Stronach, David and T. Cuyler Young, Jr. "Three Octagonal Seljuq Tomb Towers from Iran." *IRAN: Journal of the British Institute of Persian Studies* IV (1966).

Tait, H., ed. *Five Thousand Years of Glass*. London: The British Museum Press, 1991.

Tanizaki, Jun'ichirō. *In Praise of Shadows*. Stony Creek, CT: Leete's Island Books, 1977.

Uzdavinys, Algis. "Divine Light in Plotinus and Al-Suhrawardi." *Sacred Web* 10 (2003):73-89.

Ward, R. *Gilded and Enamelled Glass from the Middle East: Origins, Innovations and Influences*. London: British Museum Press, 1998.

Ward, Rachel. *Islamic Metalwork*. London, New York: Thames and Hudson, 1993.

Washington, D.C. Textile Museum. *Rug and Textile Arts: A Periodical Index, 1890-1982*. Boston, 1983.

Watson, Oliver. *Persian Lustre Ware*. London: Faber & Faber, 1985.

Whinfield, E.H. *Gulshan i Raz: The Mystic Rose Garden of Sa'd ud din Mahmud Shabistari*. London: Trübner & Co., 1880.

———. *Masnavi i Ma'navi: Teachings of Rumi, The Spiritual Couplets of Maulana Jalalu-'d-Din Muhammad i Rumi*. Ames, IA: Omphaloskepsis, 2001.

Wiet, Gaston. *Catalogue Général du Musée Arabe du Caire. Objets en Cuivre. Par M. Gaston Wiet, Directeur du Musée Arabe*. Cairo: Imprimerie de l'Institut français d'archéologie orientale, 1932.

Williams, Caroline. "The Cult of 'Alid Saints in the Fatimid Monuments of Cairo, Part I: The Mosque of al-Aqmar." *Muqarnas* I (1983).

Xanthopoulou, Maria. "Les lampes en bronze à l'époque paléochrétienne." *Bibliothèque de l'Antiquité Tardive* 16. Turhout, Belgium: Brepols Publishers, 2010.

Biographical Note

NICHOLAS STONE is an architect, dedicated to using traditional forms and techniques. Early in his career he worked with the Egyptian architect, Abdel Wahed El-Wakil, on projects reviving traditional brickwork techniques—notably at Al-Qiblatain Mosque in Medina, Saudi Arabia. Thereafter he worked on domes for the Prophet's Mosque in Medina, involving Islamic craft work, and further dome projects in Malaysia. There, in partnership with his wife, Nazanin Sheikhi, he established a design company, undertaking the design of the atrium of the Palace of Justice in Putrajaya; the design and construction of the prayer niche (*mihrab*), pulpit (*minbar*) and honeycomb vaults (*muqarnas)* for Al-Bukhary Mosque in Alor Setar; tropical house and Islamic garden designs; as well as the design and fabrication of a perforated brass mosque lamp, which ultimately led to the publication of this book.

Index

For a glossary of all key foreign words used in books published by World Wisdom, including metaphysical terms in English, consult: www.DictionaryofSpiritualTerms.org. This on-line Dictionary of Spiritual Terms provides extensive definitions, examples and related terms in other languages.

Titles in the Sacred Art in Tradition Series